BERLIN
The Twenties

D0252906

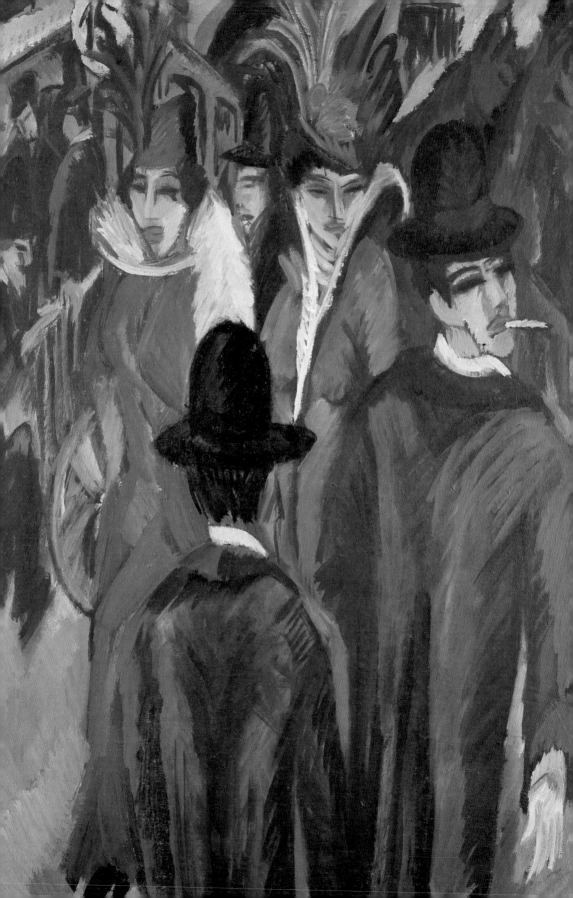

BERLIN
The Twenties

Rainer Metzger
Christian Brandstätter, Picture Editor

Abrams, New York

Translated from the German *Berlin Die Zwanzigerjahre* by Clare Costa

Library of Congress Cataloging-in-Publication Data
Metzger, Rainer.
[Berlin. English]
Berlin : the twenties / by Rainer Metzger ; images selected by Christian Brandstätter.
p. cm.
Translation of: Berlin : die Zwanzigerjahre : Kunst und Kultur 1918-1933.
ISBN-13: 978-0-8109-9329-7 (hardcover)
ISBN-10: 0-8109-9329-5
1. Arts and society—Germany—Berlin—History—20th century. 2. Berlin (Germany)—Civilization—20th century.
3. Berlin (Germany)—History—1918–1945. I. Brandstätter, Christian. II. Title.
DD866.M47 2007
943'.155085—dc22
 2006100746

The publishers and author would like to thank the following people and institutions for their help in obtaining permission to reproduce images: Nikolaus Brandstätter and Gerald Piffl (Imagno, Vienna); Monika Faber (Albertina, Vienna); Frank Frischmuth and Karen Tieth (ullstein bild, Berlin); Erich Lessing, Vienna; Helmut Maurer, Vienna; Hans Petschar (Bildarchiv der Österreichischen Nationalbibliothek, Vienna); Thomas Trabitsch (Österreichisches Theatermuseum, Vienna); and various private collections in Austria and elsewhere. Many thanks also go to all copyright holders for kindly allowing the reproduction of works.

Originally published in German in 2006 by Christian Brandstätter Verlag, Vienna

Published in North America in 2007 by Abrams, an imprint of Harry N. Abrams, Inc.

Printed and bound in the Czech Republic
10 9 8 7 6 5 4 3 2 1

HNA
harry n. abrams, inc.
a subsidiary of La Martinière Groupe

115 West 18th Street
New York, NY 10011
www.hnabooks.com

Frontispiece: Ernst Ludwig Kirchner,
Berlin street scene, 1913. Oil on canvas, 121 x 95 cm
(47⅝ x 37⅜ in.). Brücke-Museum, Berlin

CONTENTS

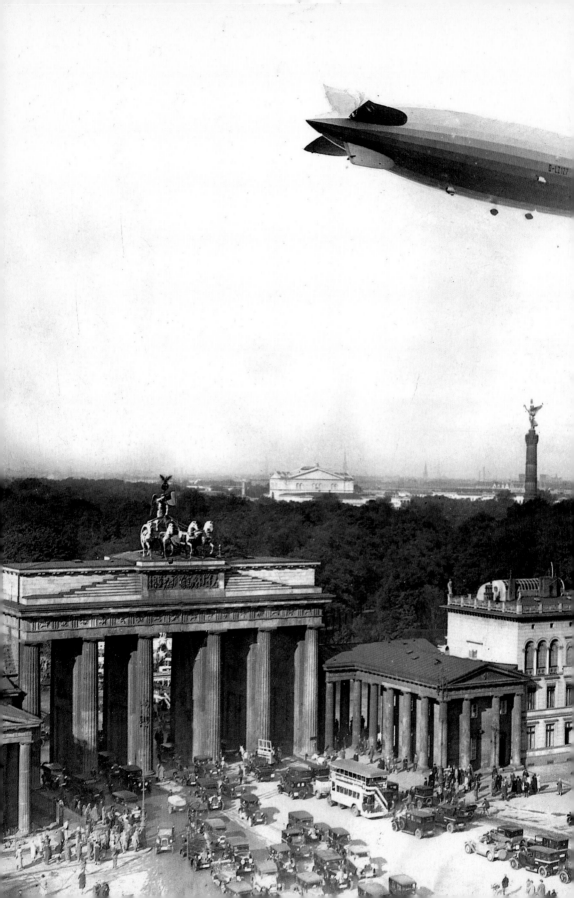

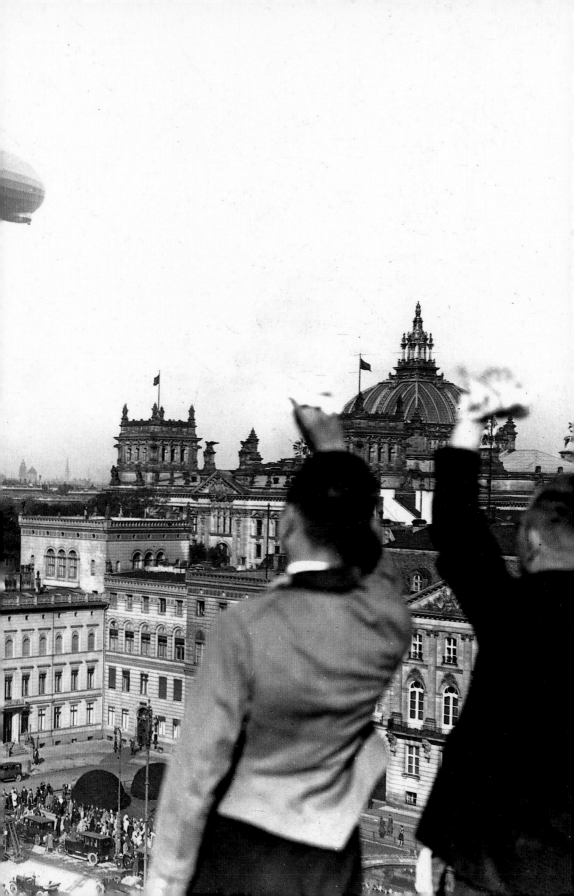

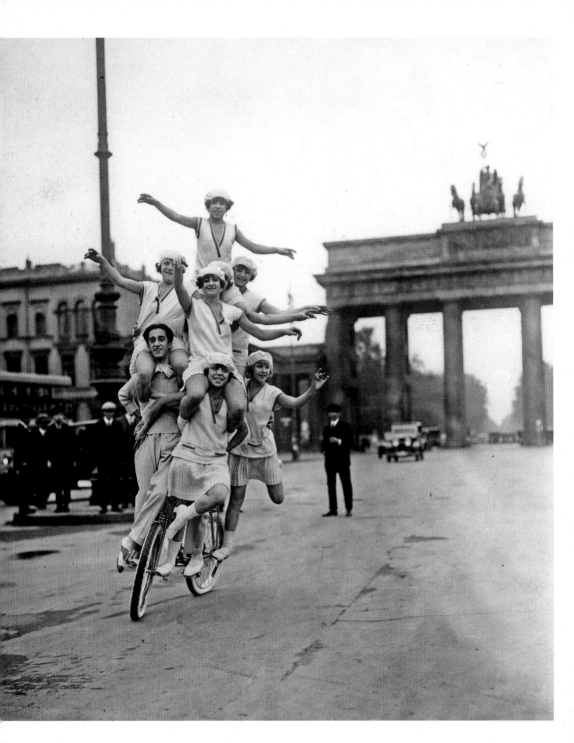

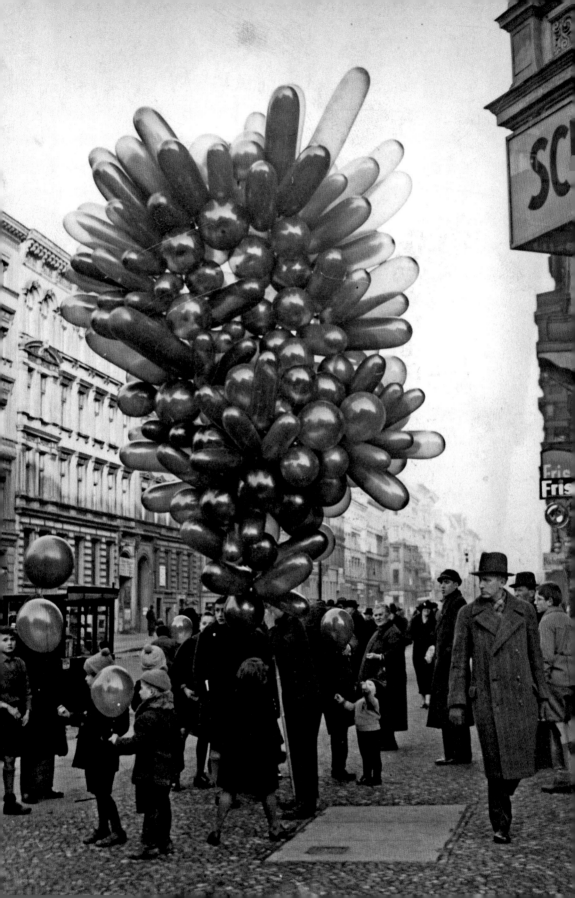

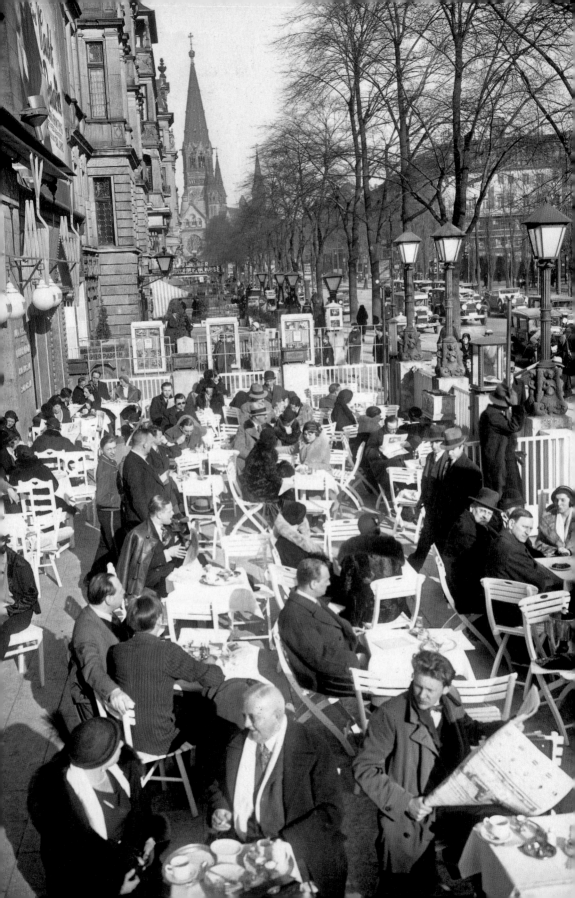

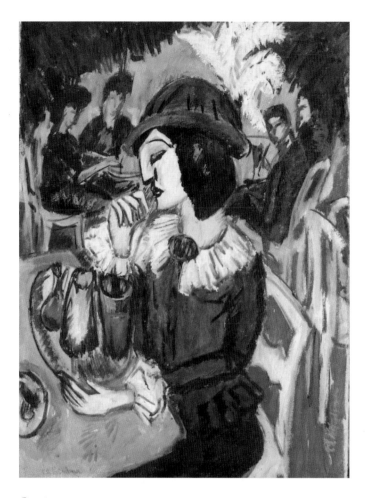

Opposite:
Street café on the Kurfürstendamm, with the Kaiser Wilhelm Memorial Church in the
background, c. 1930. Photograph.

Above:
Ernst Ludwig Kirchner, Green Lady at Garden Café, 1912. Oil on canvas,
89.5 x 66.5 cm (35¼ x 26¼ in.). Kunstsammlung North Rhine-Westphalia, Düsseldorf.

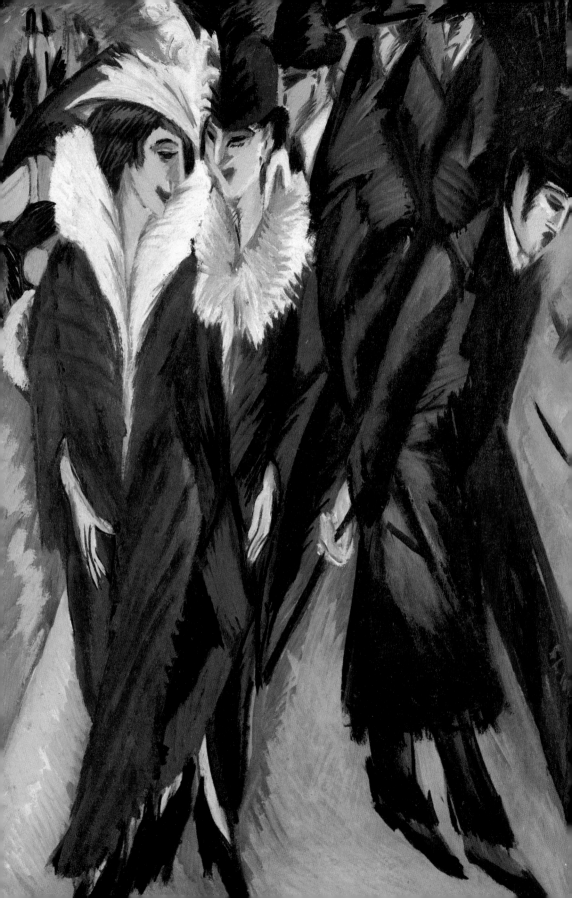

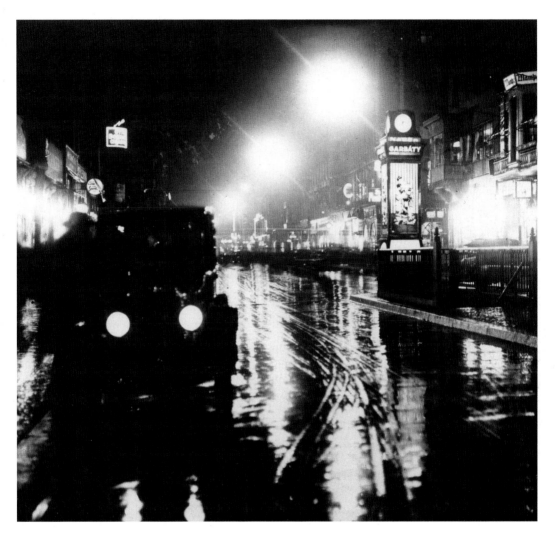

Opposite:
Ernst Ludwig Kirchner, The Street, *1913. Oil on canvas, 120.6 x 91.1 cm*
(47⅛ x 35⅞ in.). Museum of Modern Art, New York.

Above:
Friedrichstraße at night, 1929. Photograph.

Overleaf:
Demonstration by the KPD (German Communist Party) against the toppled government
of Hermann Müller, May 1930. Photograph.

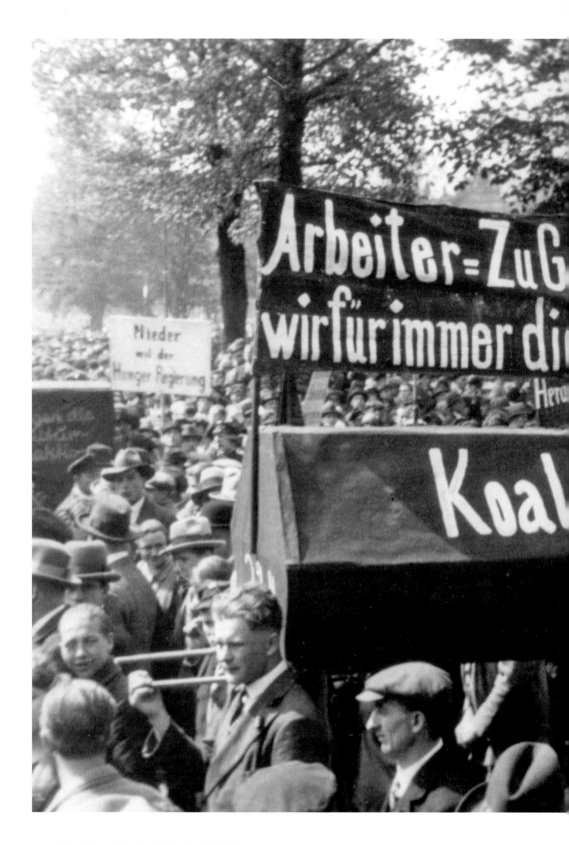

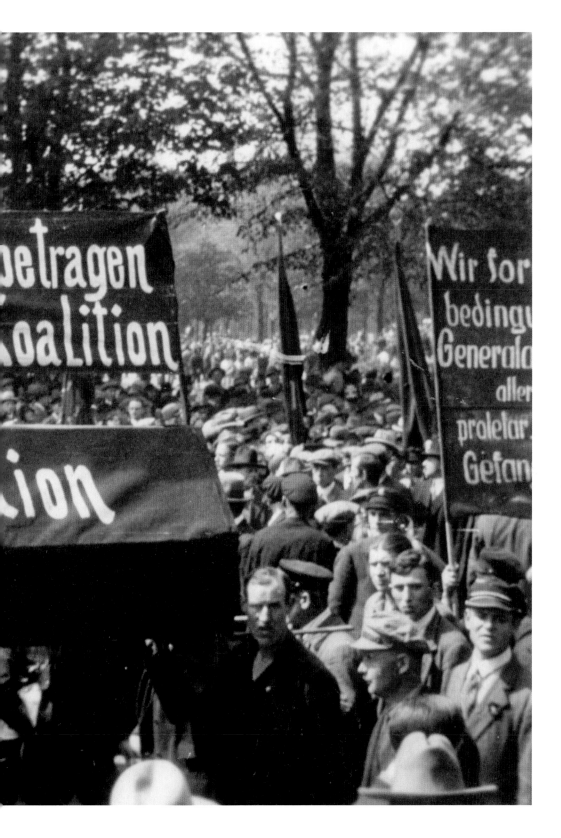

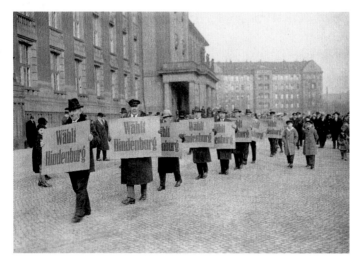

Top left, centre and below:
Demonstrations and election posters
canvassing support for Paul von Hindenburg
during the presidential elections in Berlin,
1932, 1930 and 1925 respectively.
Photographs.

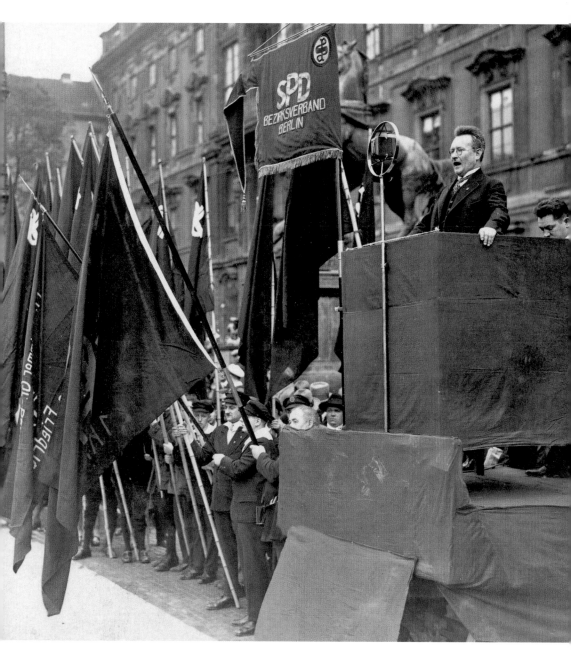

Above:
President of the Reichstag Paul Löbe speaking at a demonstration by the Social Democrats in
the Pleasure Garden, 1930. Photograph.

Overleaf:
Demonstration by the Artists' Colony in
Breitenbachplatz, Berlin-Wilmersdorf, c. 1925.
Photograph.

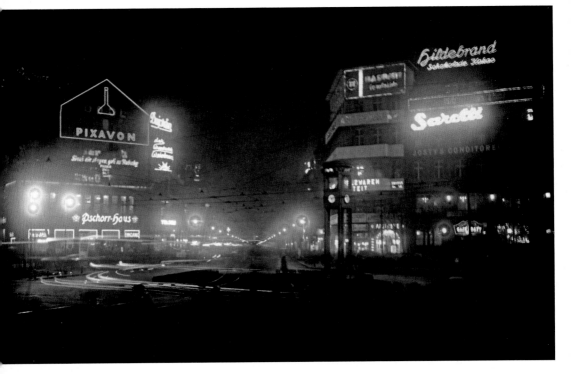

Above:
Potsdamer Platz at night, c. 1930. Photograph.

Opposite:
George Grosz, City-Metropolis (Berlin), *1916–17. Oil on canvas, 100 x 102 cm (39⅜ x 40⅛ in.). Thyssen-Bornemisza Museum, Madrid.*

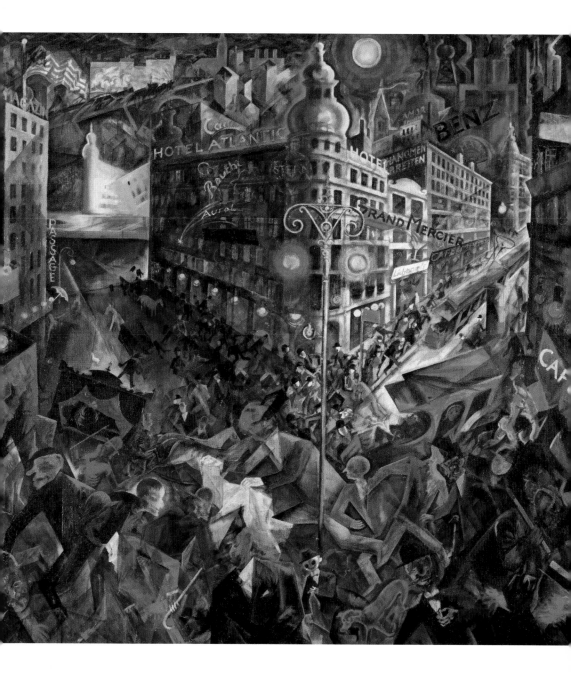

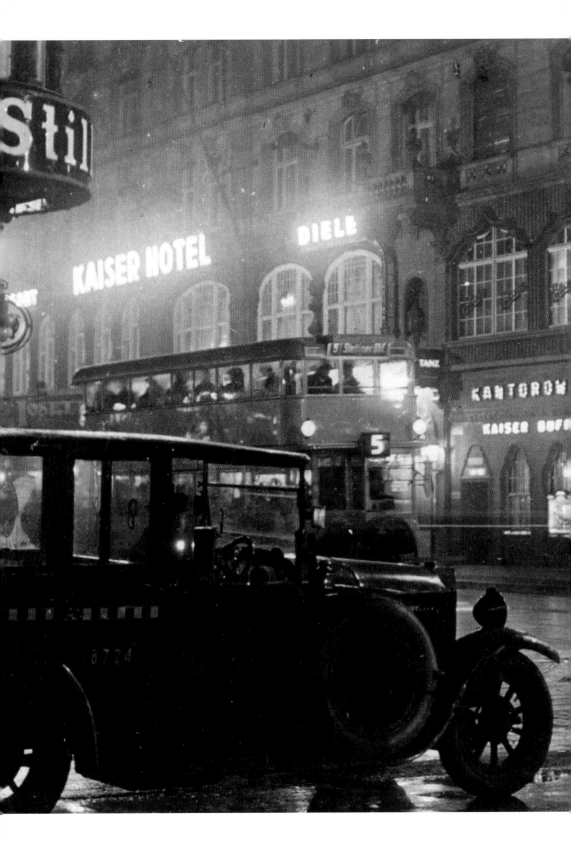

THE CHANGING FACE OF BERLIN

CHAPTER 1
THE CHANGING FACE OF BERLIN: A DECADE OF RAPID EXPANSION

Berlin is all hustle and bustle. Loud, hectic and chaotic, it is a muddle, a cacophony, a whirl of the senses. Such was the description of Berlin in the 1928 novel *Emil and the Detectives* by Erich Kästner, seen through the eyes of a child, a newcomer to the city: 'Motor cars rushed past with horns honking and screeching brakes. They signalled right-hand turns and left-hand turns, and swung off down side streets while other cars came swooping up behind them. The noise was indescribable, and on the pavements crowds of people kept hurrying by. Out of every turning vans and lorries, trams and double-decker buses swarmed into the main thoroughfare. There were newspaper stands at every corner, with men shouting the latest headlines…there were gay shop windows filled with flowers and fruit, books, clothes, fine silk underwear, gold watches and clocks. And all the buildings stretched up and up into the sky. So this was Berlin!' These words of wonder can scarcely fail to convey the buzz of the city, albeit from a youngster's perspective of the adult world.

When cosmopolitan Bulgarian-born writer Elias Canetti found himself in Berlin in 1928, he also reflected on this 'golden age': 'What exactly defines a golden age? It is an era full of famous names, one following on after the other, and yet not eclipsing each other, although they may indeed be in competition. What is important is that there is a continual impetus and a continual collision, adding to the golden glow, rather than extinguishing it. It is a lack of sensitivity towards such collisions, and yet a sense of yearning for them, and the desire to abandon oneself to them.' Canetti writes more knowingly than Kästner, and his observations revolve around physical encounters, giving the impression that he is perhaps about to launch into some trashy story, an eye-witness account of the world of celebrities and the demi-monde of fortune-hunters. But here too there is that sense of commotion, with the city like a bubbling melting pot that will inevitably boil over. Anyone who talks of Berlin in the Twenties is irresistibly drawn into a discussion about the unification of impossibly disparate elements, and the surprisingly different facets of a city that never slept. The simultaneous co-existence of incongruous elements was not just a chance occurrence in Berlin; it actually came to define the city, both in terms of the dynamism of life and in the words, pictures, films and symphonies that formed a commentary on this life. This book will look at both these aspects.

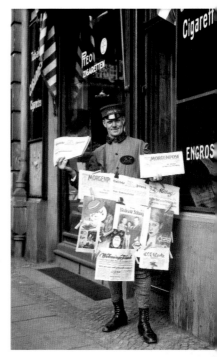

Opposite:
Kaiser Hotel on Friedrichstraße, c. 1930.
Photograph.

Above:
Newsvendor outside a tobacco shop, 1926.
Photograph.

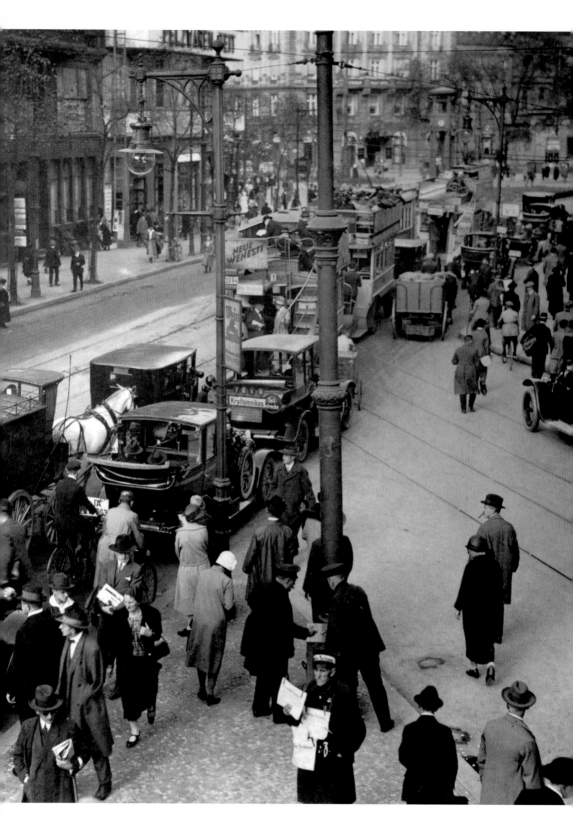

Berlin is a kaleidoscopic world. Berliners themselves describe it as *Betrieb*, an ambiguous word in German which can mean both 'bustle' and 'business'. In Irmgard Keun's novel *The Artificial Silk Girl*, the heroine describes the city as follows: 'Berlin is an Easter that comes at Christmas and everything is a whirl of life.' Written in 1932, at the height of the glitz and glamour, the story is narrated in the first person by a young girl who abandons herself to the world's voracious appetite in order 'to become glittering myself.' In that same year, the description of Berlin as *Betrieb* appeared in an essay by mentor, gallerist and impresario of the Expressionists Herwarth Walden. The essay was published in the very last issue of *Der Sturm*, the magazine that had made him famous. It folded the very next year, a victim of the changing city. Berlin was driving itself relentlessly towards its own end.

Contemporaries all agreed that Berlin was unique. It was quite different from the other two great European cities, Paris and London. As an urban conglomeration, Berlin was more grey and uniform in appearance than its counterparts, rather like an endless torrent of monotony streaming across the land. Unlike the two other great capitals, Berlin had no museums to speak of and very few significant monuments. Nowadays if you go in search of a church in Berlin, you

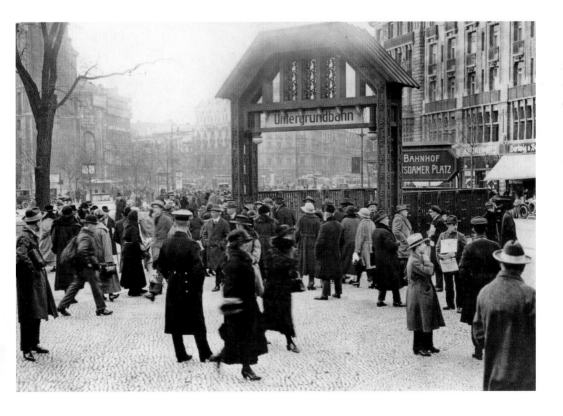

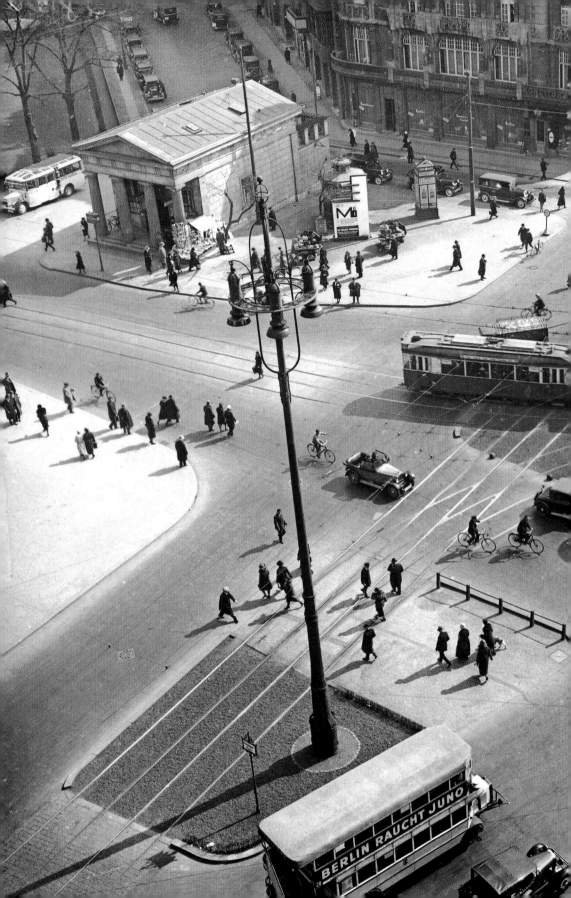

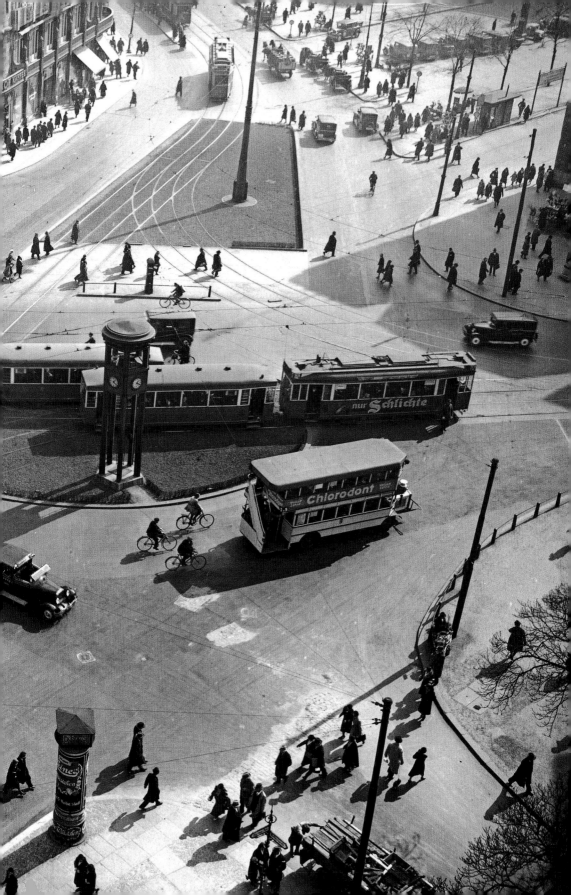

are likely to be directed to the Kaiser Wilhelm Memorial Church on the Kurfürstendamm, and it was the same in the Twenties, although at that time the building was barely a quarter of a century old. What Berlin did possess in abundance, however, was youth.

The city had expanded dramatically. When the German Reich was founded in 1871, its newly established capital had a population of 800,000. Twenty years on and the figure had doubled. By 1910 it was well over 2 million, and it reached its peak in 1929 with a population of 4.3 million. The population explosion was due not only to an exodus from the surrounding countryside and a high birth rate among the city's inhabitants, but also to political policy. Old Berlin consisted of six different boroughs: Mitte, Friedrichshain, Prenzlauer Berg, Kreuzberg, Tiergarten and Wedding. In 1920, seven surrounding towns were incorporated: Charlottenburg, Spandau, Schöneberg, Wilmersdorf, Lichtenberg, Neukölln and Köpenick. 'Greater Berlin' was thus formed by artificially uniting the existing, established eastern sector with a new area of land. The resulting caesura remained visible and tangible, both in terms of the social structure of the city and the mentality of its inhabitants.

Alfred Döblin gained recognition for his book, *Alexander-Platz, Berlin: The Story of Franz Biberkopf*, because he did not look at Berlin through the eyes of an observer from the west, but also had experience of the central and eastern sectors of the city, according to a contemporary report by Axel Eggebrecht in 1929. The existence of an affluent West End and an impoverished East End is common in much of urban history. In 1929 the critic Balder Olden, with the ill-concealed malice of a 'westerner', commented that the Berlin described in Döblin's book reminded him of the Congo. The division that was later enforced during the Cold War was prefigured in the Twenties.

Thus Berlin in its heyday became Greater Berlin, manifesting the parvenu mentality of *Wilhelminismus*, or 'Wilhelmism'. Since the foundation of the Reich, there had been a desire to transform Berlin into a world-class city, in the same way that the Hohenzollern dynasty had wanted the state to evolve into a world power, and the industrialist Krupp family had endeavoured to turn it into an international brand. The ambitions and the short-term vision of the latter-day state were concentrated in Berlin, produced by a blend of arrogance and an urgency to make up for lost time. As that chapter later drew to a close, grasping the attention of the world through the events of the First World War, there was no longer any cause for arrogance, and the need to overcompensate seemed all the more pressing.

Alongside all the administrative and logistical issues that come with almost doubling the population of a city overnight, there is another factor to take into consideration – the psychological dimension – without which the creation of Greater Berlin in 1920 would have been unthinkable. In the aftermath of the First World War the Reich had been left utterly dejected, with all its hopes dashed and its self-confidence in tatters. The capital had a great deal of reconstruction work to do. In 1929 the city architect Martin Wagner, reflecting

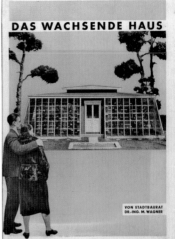

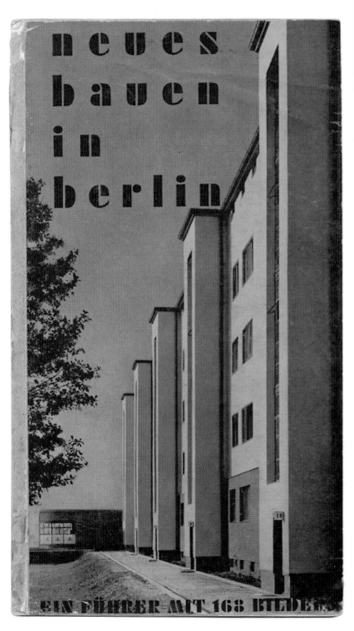

Left:
Johannes Heinz, Neues Bauen in Berlin: Ein Führer. *Anonymous cover designer. Berlin: Deutscher Kunstbuchverlag, 1931.*

Above:
Martin Wagner, Das Wachsende Haus, *solutions to the critical housing shortage within the city. Cover design by Ellen Gerda Schöndorff. Berlin/Leipzig: Deutsches Verlagshaus Bong & Co, 1932.*

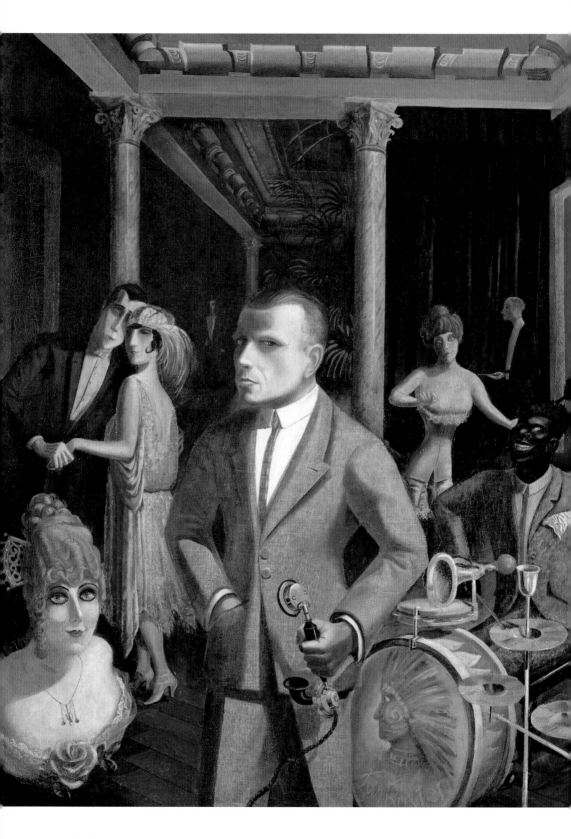

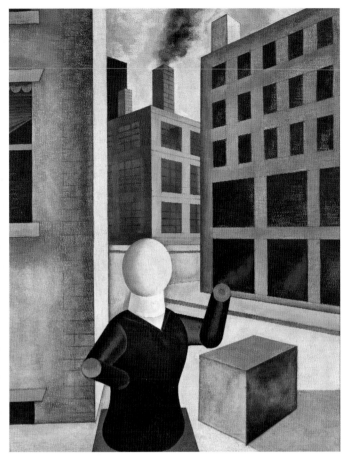

Opposite:
Otto Dix, To Beauty, *1922. Oil on canvas,*
140 x 122 cm (55⅛ x 48 in.). Von-der-Heydt
Museum, Wuppertal.

Left:
George Grosz, Untitled, *1920. Oil on canvas,*
81 x 61 cm (31⅞ x 24 in.). Kunstsammlung
North Rhine-Westphalia, Düsseldorf.

on the achievements of that decade, proudly entitled his book *Das Neue Berlin: Die Weltstadt Berlin* ('New Berlin: The Cosmopolitan Berlin'). The capital city of Berlin reflects on Germany and its government. This metonymy can glorify the city in one's mind, but it also helps to define the role of culture, creating a form of symbolism. Berlin succeeded in this role beyond all expectations during the Twenties.

The creation of Greater Berlin primarily involved a process of modernization. The city and its entire infrastructure needed to be brought up to date in order to keep up with the perpetual flow of people and goods. Many different factors demanded a city that was capable of change and innovation: the telephone, electricity, motor cars, underground and overground trains, a new class of employees, the peaks and troughs of sudden riches and poverty during the inflation crisis, the politicization of the population, the advent of mass communication due largely to cinema and radio, a greater range of leisure activities, technical innovations, changes in the quantity and quality of inhabitants, different ways of relating to one another....

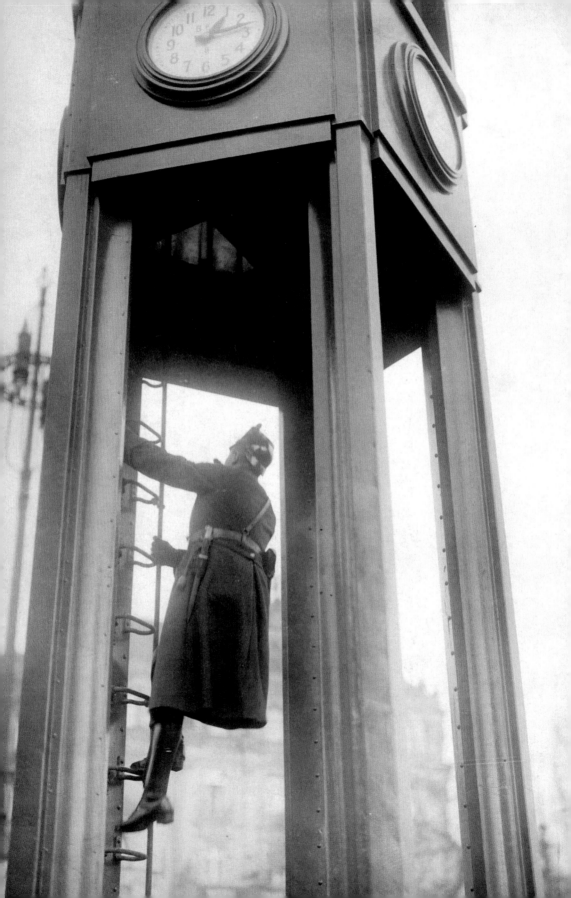

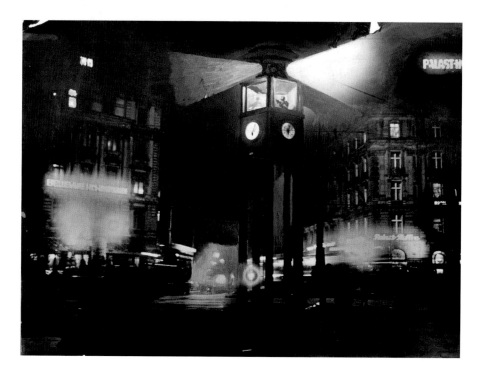

Above:
Traffic tower at night, Potsdamer Platz, 1924. Photograph.

Below:
Friedrichstraße S-bahn station, 1925. Photograph.

Opposite:
A policeman climbs the traffic tower in Potsdamer Platz, 1925. Photograph.

Overleaf:
'Nord-Süd' underground station on Friedrichstraße, 1926. Photograph by Theo Rockenfeller.

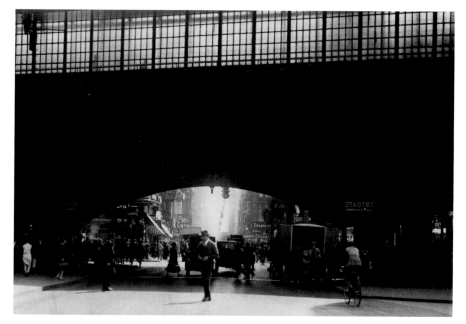

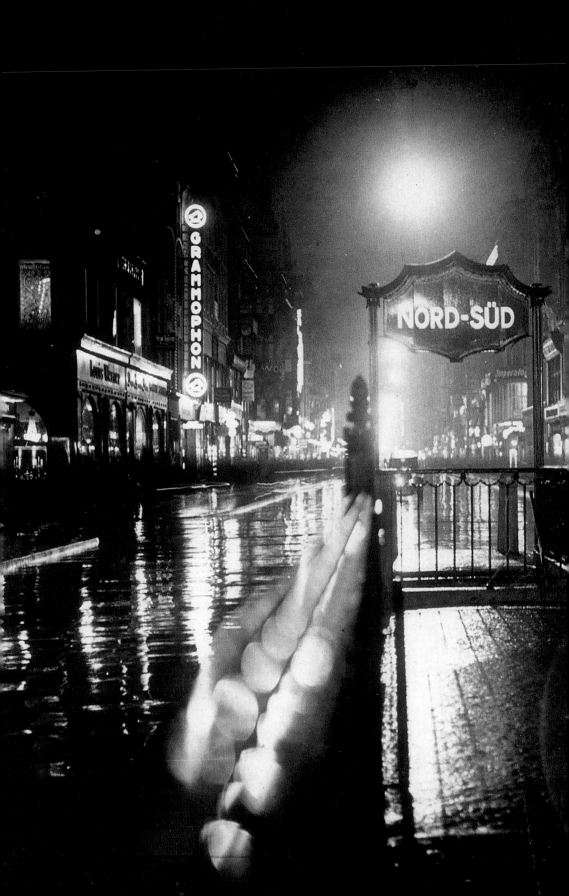

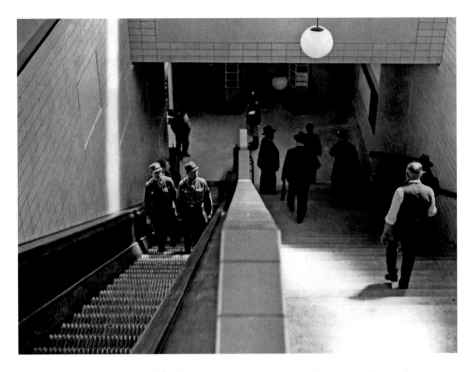

Above: Escalator linking the underground and overground stations in Innsbrucker Platz, c. 1930. Photograph.

Below: Taxis in the courtyard of the Traffic Bureau on Blücherstraße, March 1929. Photograph.

Opposite: The first electric stop signs on the Berlin tram system, October 1928. Photograph.

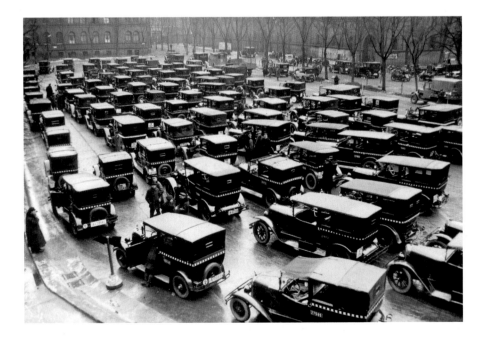

Nächste Haltestelle

Mariendf. Rennbahn

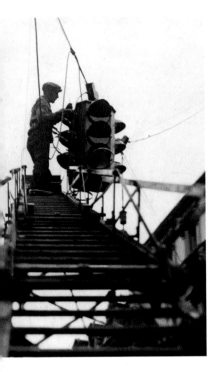

Above:
A worker cleans a set of traffic lights,
c. 1925. Photograph.

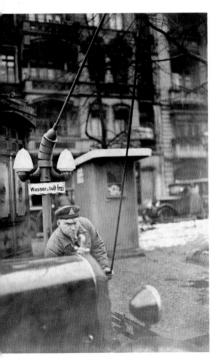

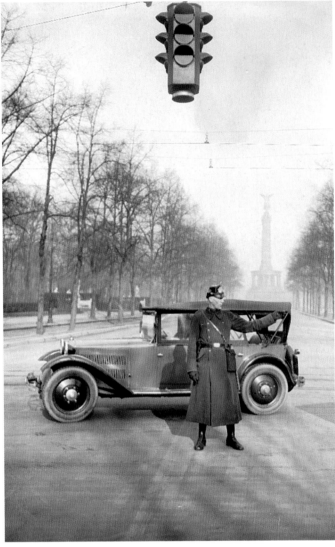

Above:
Traffic lights in Berlin, c. 1930. The signal change was indicated with the stroke of a gong,
replacing the previous system of chimes. Photograph.

Left:
Free air and water at a petrol station, c. 1930. Photograph.

Opposite:
Berlin's 100,000th motor car leaving the Traffic Bureau on Blücherstraße,
c. 1930. Photograph.

DER
100 000. Wagen
Berlins

IA-75075

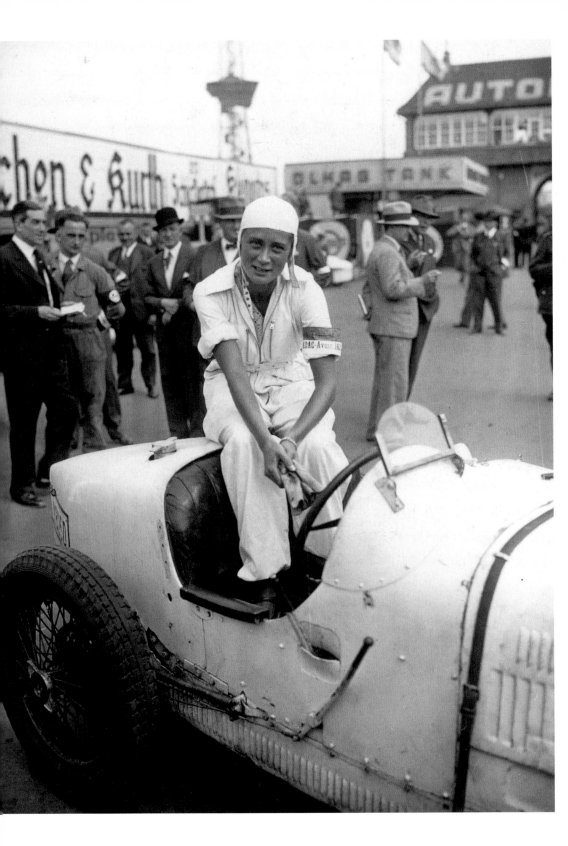

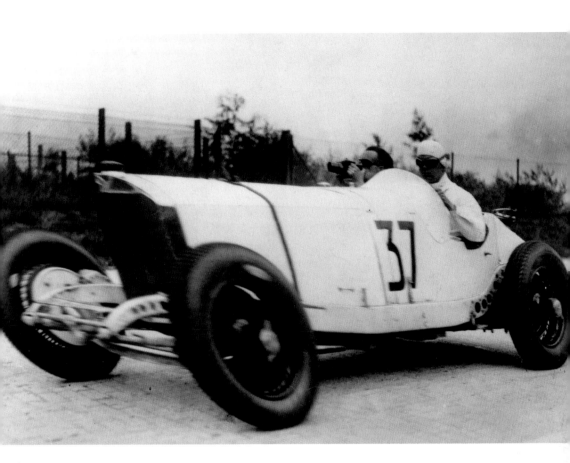

Opposite:
Training for the international ADAC Race on the Avus track, May 1932. The racing driver was Miss Gilka. Photograph.

Above:
Rudolf Caracciola with a photographer, racing along the northern curve of the Avus track, 1931. Photograph.

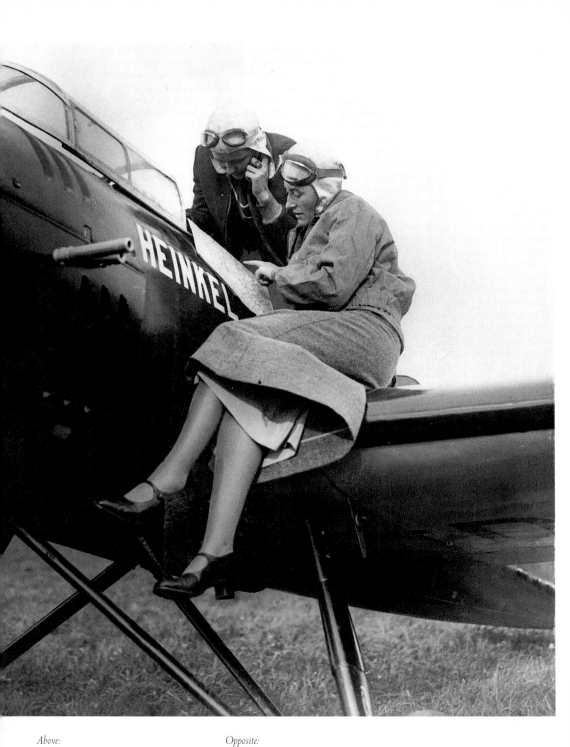

Above:
Hertha Mirow and Elli Beinhorn study the flight route before the race, 1920–30. Photograph.

Opposite:
Minister of the Interior Carl Severing seated in a Junkers plane for the official opening of the public flying competition at the Tempelhof Airfield, 12 August 1929. Photograph.

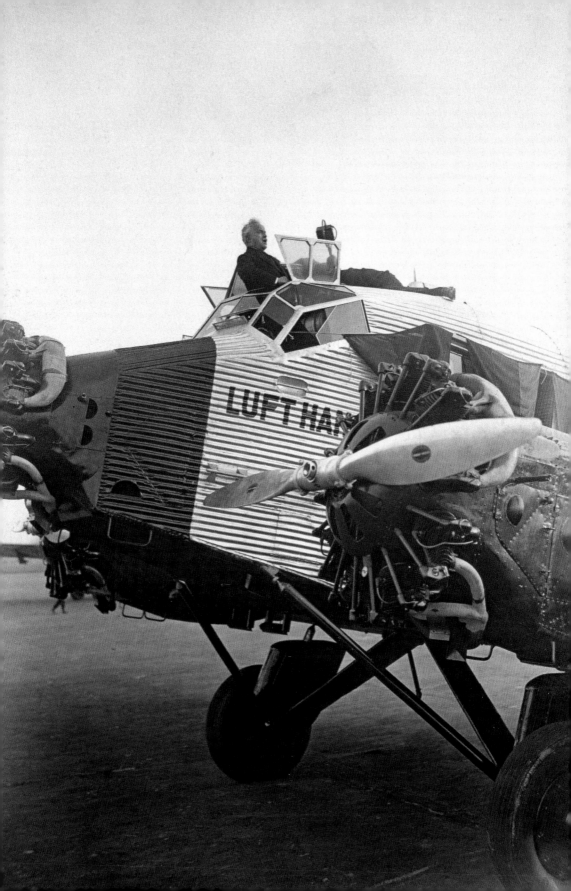

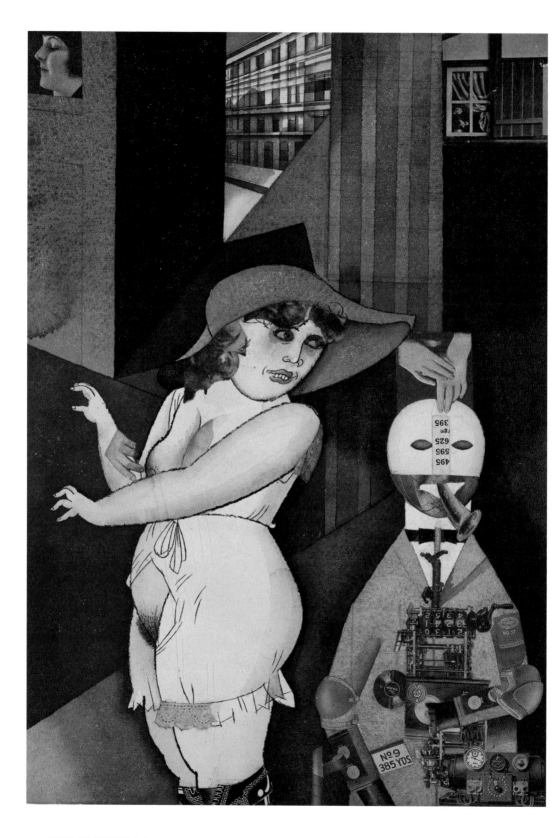

THE CHANGING FACE OF BERLIN

There was a good role model for the integration of urbanity and modernization: the factory. In the decades either side of 1900, family businesses had become public limited companies, industrial capital had become bank capital, regional establishments had become international concerns, and work *in situ* to produce end products from raw materials had been replaced by the assembly line. The city needed to function like a factory and be able to respond rapidly to change.

Siegfried Kracauer, a correspondent for the *Frankfurter Zeitung*, took his journalism so seriously that it turned into a form of cultural theory. In 1926 he wrote of the complicity between city life and work life in the book *The Mass Ornament*. While the Berliners were reproached by some people for being too keen on seeking entertainment, Kracauer thought otherwise: 'Critics chide Berliners for being *addicted to distraction*, but this is a petit bourgeois reproach. Certainly, the addiction to distraction is greater in Berlin than in the provinces, but the tension to which the working masses are subjected is also greater and more tangible; it is an essentially formal tension, which fills their day fully without making it fulfilling. Such a lack demands to be compensated, but this need can be articulated only in terms of the same surface sphere that imposed the lack in

Opposite:
George Gosz, Daum Marries Her Pedantic Automaton George in May 1920. John Heartfield is Very Glad of It, *1920. Watercolour, pencil, ink, collage/cartoon, 42 x 30.2 cm (16½ x 11⅞ in.). Courtesy Galerie Nierendorf, Berlin.*

Below:
Robert Seitz and Heinz Zucker (ed.), Um uns die Stadt: Eine Anthologie neuer Großstadtdichtung. *Cover design by Martin Weinberg. Berlin: Sieben-Stäbe-Verlag, 1931.*

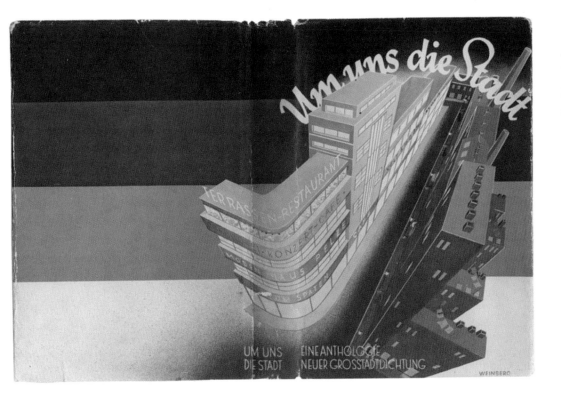

the first place. The form of free-time busy-ness necessarily corresponds to the form of business.'

The secret of Berlin's success as a 'business' was easy to identify; culture was necessarily swept along with it. In the all-encompassing tendency to follow the principle of anonymous activity, the aesthetic side of the city particularly flourished. In this respect, the cultural life of Berlin in the Twenties was modern, even capitalist. There were those who were professionals, like theatre director Max Reinhardt, film producer Erich Pommer, agitprop pioneer Erwin Piscator, and magazine editor Siegfried Jacobsohn, who promoted talent, harnessed individuality and idiosyncrasy in pursuit of a common task, and gave particular character to the cultural scene in

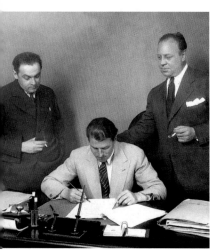

Above:
Carl Zuckmayer signing a contract; to his left, Erich Pommer, director of the German national film company Ufa; to his right, actor Emil Jannings, 1925. Photograph.

Right:
Carl Zuckmayer, The Captain of Köpenick. *Cover design by Werner Beucke. Berlin: Propyläen Verlag, 1930.*

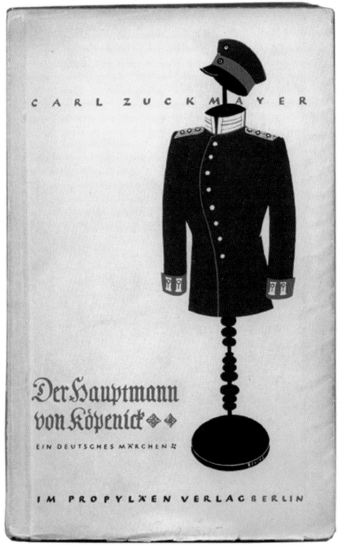

Berlin. There was no longer anything patriarchal about their work – they were responsible for themselves alone, and for their own money. It also seems that these ideas and temperaments were frequently quite left wing, speaking out in favour of a socialist heart and socialist ideals. In sharp contrast to today, when almost every cultural endeavour could qualify for public funding, both the top-class productions and the more mainstream output were subject to the economic law of supply and demand. In the light of this, the existence of such a prodigious avant-garde cultural movement during Berlin's heyday is even more astonishing.

Berlin's culture was political, but not only in terms of advocating a classless society. It was also aware of its own mortality, and this is perhaps the motif that comes across most powerfully in the pictures, words, plays and songs of the Twenties. In 1961 *Magnum* magazine posed a question to some of the participants in the Berlin scene during that era, asking them to sum up what the Twenties really meant to them. Carl Zuckmayer, who lived in Berlin between 1920 and 1933, and celebrated his greatest success there with the plays *Der fröhliche Weinberg* ('The Merry Vineyard') and *The Captain of Köpenick*, emphasized the fragile structure of state and society, threatened from within: 'The arts blossomed like a field awaiting the harvest. Hence the charm of the tragic genius that characterized the epoch and the works of many poets and artists cut off in their prime…. I remember well how Max Reinhardt…once said: "What I love is this taste of transience on the tongue – every year might be the last year." In my own memories I can sense that strangely pleasing

Above:
Siegfried Jacobsohn, c. 1930. Photograph.

Below:
Max Reinhardt rehearsing for a play with Helene and Hermann Thimig, c. 1930. Photograph.

Overleaf:
Box office of the Reinhardt Playhouse on the Kurfürstendamm, 1928, with advertisements for The Phantom Lover *by Georg Kaiser and* The Live Corpse *by Leo Tolstoy. Photograph.*

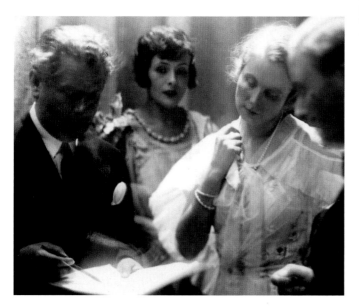

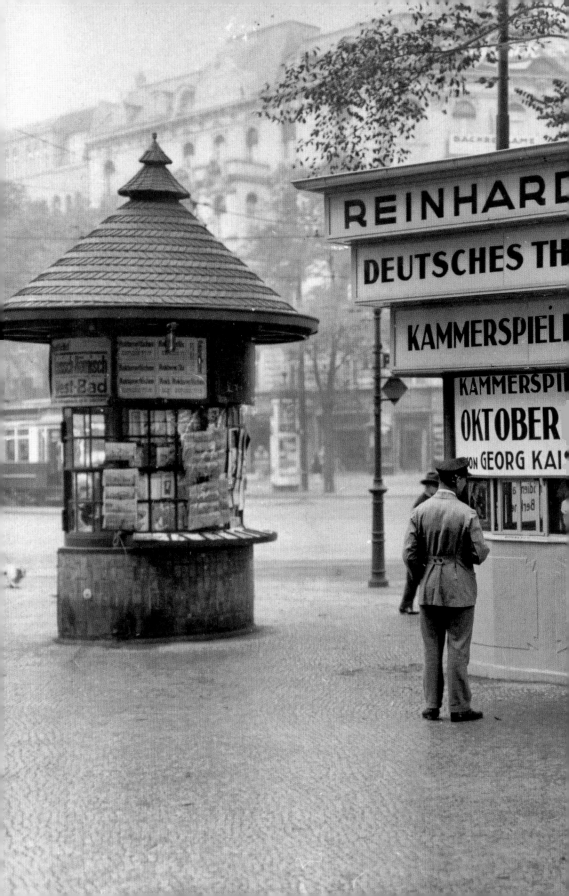

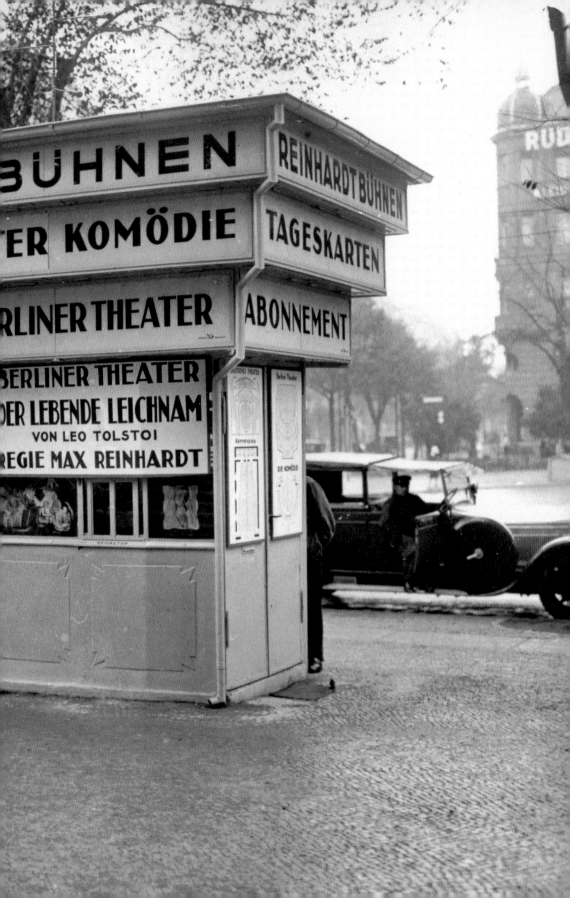

taste, mixed with the smell of blood and fire, heralding barbarity and the dawning of catastrophe.'

As a city, and as a social construct based on ambition and necessity, Berlin had something forced about it, and it was tainted with excess – the precariousness of its creation and existence were all too evident. The great advantage of historical portrayals is the beauty of hindsight, the knowledge of the subsequent turn of events. Today it is clear just how accurate, vigilant and prophetic this awareness of its own fragility, prior to the events of 1933, turned out to be. There was a deeper truth to be gleaned from cultural life in 1920s Berlin – one that now seems more easily identifiable than in any other epoch or combination of circumstances. It touched every aspect of life, and was unaffected by the fluctuations in quality of the many diverse forms of artistic expression.

The Berlin of that era had been torn apart by violence. On 9 November 1918, with the abdication of Kaiser Wilhelm II, the Weimar Republic had bestowed the German crown upon the city, but everyone recognized that, in reality, the Republic existed at the grace of Berlin. Philipp Scheidemann, who had proclaimed the new democratic government from the Reichstag on that inauspicious day, later wrote in his memoirs of 1928 that they had chosen to go to Weimar to call the National Assembly, not because it had been the home of Goethe and Schiller, but simply because they were afraid that Berlin had become too dangerous. Thus from the very

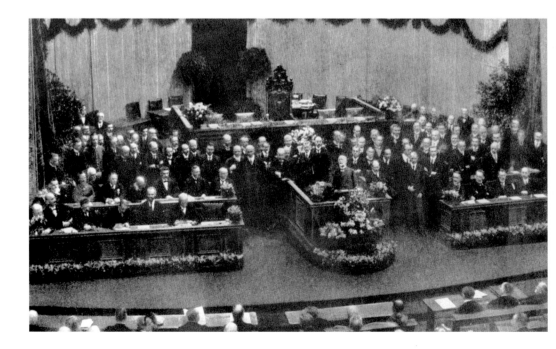

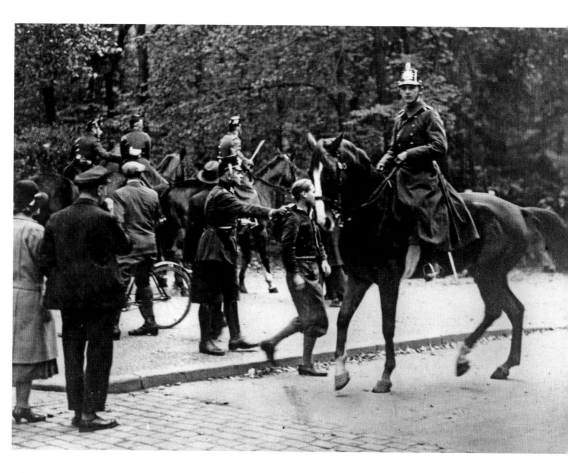

beginning there had been an uneasiness associated with cultural life, an ever-present sense of reality, which never disappeared. It was this pervasive sense of reality that gave the cultural life of Berlin its particular character. Yes, it was possible to lose oneself in the various expressions of the avant-garde, the paintings of Cubism, Futurism and the Russian Collectivists, and yet somehow the focus always remained on the concrete elements of a concrete reality, with its magical expressions of the simultaneous and the aesthetics of machinery. The art of the time was rarely abstract, and it celebrated the sovereign flourishing of Formalism. The simultaneous played itself out on the streets of Berlin: the inspiration for Cubist distortion was not to be found in a guitar, or a bunch of flowers, but in the wounded survivors of the First World War. The virtuoso style of the avant-garde may have been adopted, but it was subjected to the imperative task of revealing to the world what it had become, and the heart-rending pain it had caused. Literature served the same function. Most of the key figures in Berlin during that time were not just writers; they were reporters, essayists and columnists, who had

Above:
Arrest of a National Socialist in Siegesallee during unrest after the opening of the Reichstag, October 1930. Photograph.

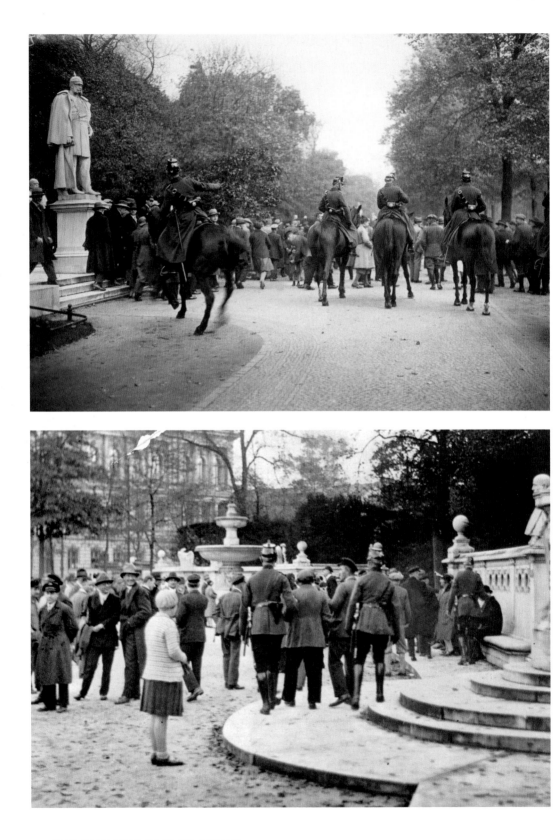

THE CHANGING FACE OF BERLIN

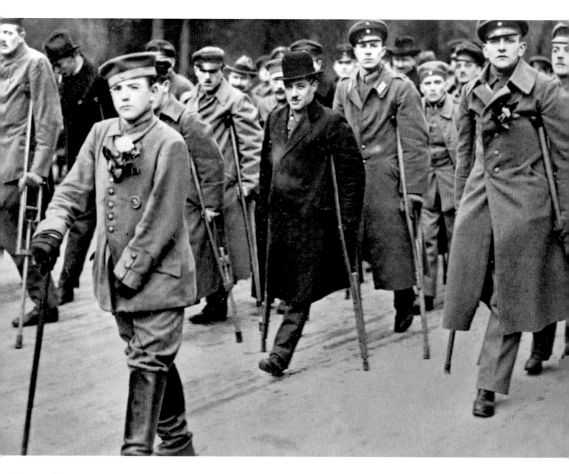

Opposite, above:
National Socialist terror in Berlin: Nazi demonstrators are forcibly dispersed by mounted troops from the area surrounding the Reichstag into the Tiergarten, 1930. Photograph.

Opposite, below:
National Socialist riot during the opening of the Reichstag, with the arrest of one participant at the Brandenburg Gate, 13 October 1930. Photograph.

Above:
Demonstration for compensation by disabled survivors of the First World War, on their way to the War Ministry, December 1918. Photograph.

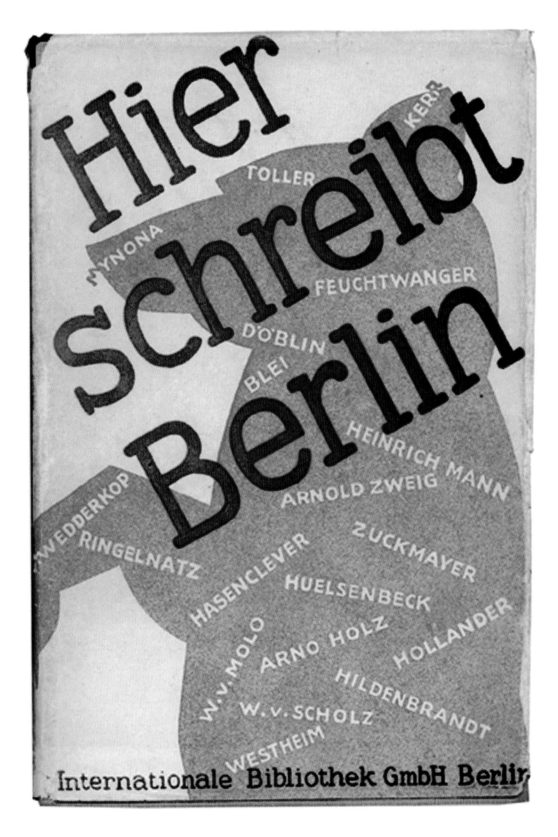

THE CHANGING FACE OF BERLIN

as good a knowledge of the selling-power of newspapers as they had of the private sanctum between the covers of a book: journalism went hand in hand with belletrism in the name of a commitment to reality.

After the war, art picked up where it had left off, quietly and unashamedly pursuing the Expressionism that had been launched around 1910. However devastating and appalling people's personal experiences may have been on the Western Front, Eastern Front or at home, the artificial language of art re-attached itself to what had been achieved and established before the war. The more traumatized and disturbed the war survivors were, the less the artistic language felt the need to balance its reactions. It seemed that the war served as a confirmation of what had already been formulated, rather than as a reason to review artistic methods or formulate new questions. It was as if art already knew it all.

If there was any discernible caesura in the aesthetics of the Twenties, it happened not in 1918 but in 1924–25: Expressionism was thrown out, and instead of its trademark naturalistic style (which sought to express the raw, the earthy and the natural) and the high rhetoric and soaring rhapsody it employed, the stage was now set for the entrance of streetwise slang and a city-slicker style. Expressionism was replaced by a genuine city-jargon, an urban style that was fundamentally peaceful, and yet it contained elements of a deep, inherent despair. Violent figures and depictions of violent acts manifest themselves in its art. Clearly the artistic expressions of the avant-garde were militant enough to incorporate the experience of war. The avant-garde language was not so pacifist as to refuse to let elements of horror and devastation appear amongst the normal and peripheral. The city's culture was brimming with ideas.

One of the greatest commercial successes of the time was the war novel *All Quiet on the Western Front* by Erich Maria Remarque, which was

Opposite:
Herbert Günther (ed.), Hier schreibt Berlin: Eine Anthologie von Heute. *Cover design by Ernst Ullmann. Berlin: Internationale Bibliothek, 1929.*

Below:
George Grosz, The Lovesick Man, *c. 1925. Oil on canvas, 100 x 78 cm (39⅜ x 30¾ in.). Kunstsammlung North Rhine-Westphalia, Düsseldorf.*

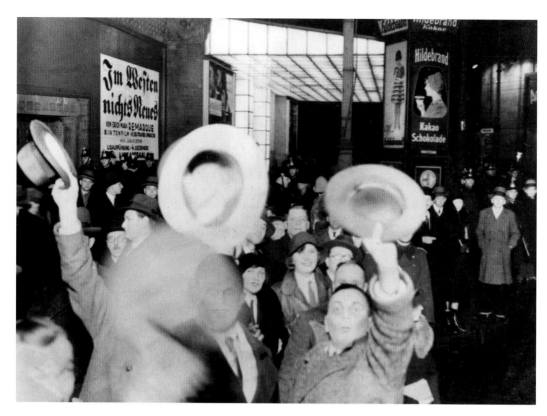

Above:
National Socialists protest against the film All Quiet on the Western Front, *based on the book by Erich Maria Remarque, early December 1930. Photograph.*

Below:
Conspicuous police presence to ensure security and avert National Socialist disturbances in Nollendorfplatz for the screening of All Quiet on the Western Front *in the Mozart Hall, early December 1930. Photograph.*

published in 1929 and sold more than a million copies in a single year. It was made into a film by the Hollywood director Lewis Milestone, and was premiered in December 1930 at the Mozart Hall in Berlin. Two months earlier Thomas Mann had made his famous speech 'An Appeal to Reason' in the Beethoven Hall – an attempt to respond to the events of 14 September, ten weeks before

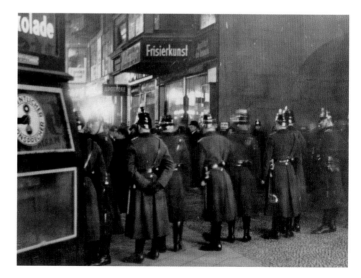

the premiere, when votes for the NSDAP (National Socialist German Workers' Party) had increased ten-fold in the parliamentary elections. The result went to their heads, and Hitler and his henchmen stormed the premiere, giving a foretaste of the cultural changes to come.

Carl von Ossietzky, editor-in-chief of *Die Weltbühne* (the most prominent cultural magazine of the Weimar Republic), who was later to be detained in concentration camps by the Nazis and was awarded the 1935 Nobel Peace Prize, wrote of the events in his publication, describing in these extracts the only way out that he could envisage: 'Fascism has won its first victory since 14 September. Today it was a film, tomorrow it will be something else.... Fascism must be attacked on the streets. The only logical way to fight this party of National Socialist vermin is to wield a heavy truncheon, there is only one method of controlling it: *à un corsaire – corsaire et demi.*'

One of the most convinced and convincing of all pacifists was actually advocating violence against the Nazis. Today it is easy to praise his intuition and his ability to perceive the true dangers embodied in those events, and yet he was expressing a common truth as well a cultural and historic one. He was right. Nothing else could have helped but resistance and violence; the death of all culture. This is the ultimate tragedy of Berlin in the Twenties: for all the intellectualism and sensibility, the path had already been set.

Above:
Writers and journalists bid farewell to Carl von Ossietzky at the gateway of Tegel Prison, Berlin.

Below:
Carl von Ossietzky with his defence lawyers Rudolf Olden (left) and Alfred Apfel (right) during the Die Weltbühne *trial, standing before the imperial court in Leipzig, November 1931. Photograph.*

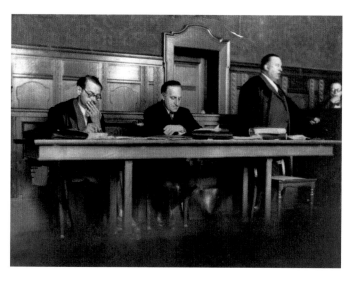

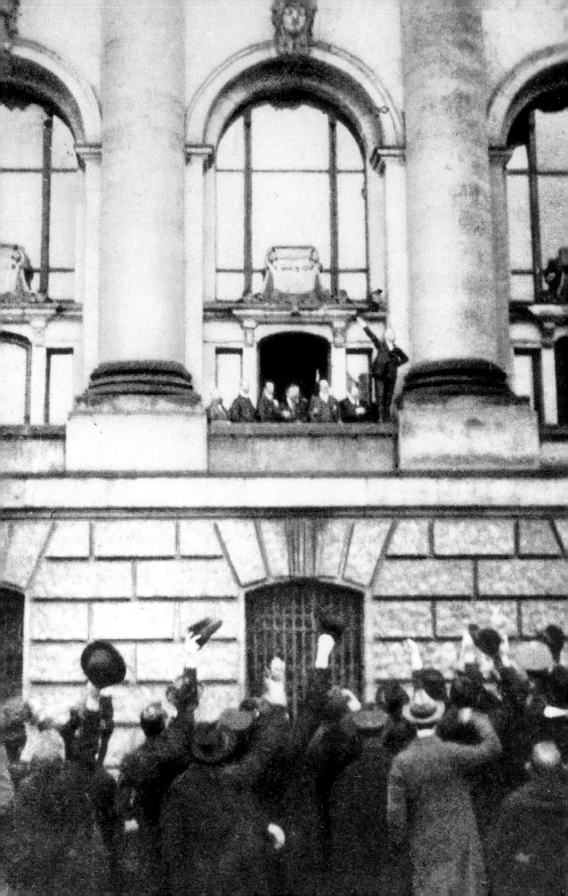

CHAPTER 2
THE NOVEMBER VANISHING POINT:
REVOLUTION AND REACTION

Never before in history had a defeat been suffered so far away. When the Reich surrendered unconditionally in the autumn of 1918, bringing the First World War to an end, their armies were hundreds of kilometres away on enemy territory. This hitherto inconceivable situation gave rise to a number of conspiracy theories, especially an obsessive notion that the army had remained 'undefeated' in the field, and that the soldiers had been stabbed in the back by some of their own fellow countrymen. Of course the decision to surrender, which had been taken by the supreme command, under the leadership of the Quartermaster General Erich Ludendorff, was a rational one because the Front was on the verge of collapse and would have done so had they resisted. However, that fact was not widely understood at home, and there was still a strong belief in the ability of Germany to rescue the world.

People still carried the euphoria of August 1914 in their hearts: in that month a wave of patriotism had swept across the land; with shining eyes Kaiser Wilhelm II had declared that there were no longer different political parties, but one German people; there was an endless stream of men wanting to enlist in the army and go to war. There was a widespread conviction that victory would be won in a matter of weeks, but the war dragged on endlessly and exhaustingly. Instead of advancing, the army was stuck in positional warfare. To use Remarque's succinct phrase, it was not only 'all quiet on the Western Front', but on the Eastern Front too. The offensive had evaporated, and with it the euphoria.

One of the most interesting chapters in the history of war culture was marked by Kaiser Wilhelm's attempt to hide the increasingly harsh reality of the war, substituting it instead with heroic symbolism. In 1815 Field Marshal Gebhard Leberecht von Blücher had been awarded the highest military honours that Prussia could bestow in the aftermath of the Battle of Waterloo, and the subsequent victory over Napoleon. In 1918 Field Marshal Paul von Hindenburg was decorated with exactly the same award, only this time there was a difference: the great spring offensive instigated by von Hindenburg did not go according to plan; events took an unexpected turn, and the whole thing ground to a halt within a few days. The award had nothing to do with the effectiveness of the campaign, but everything to do with the symbolism of success and wider recognition.

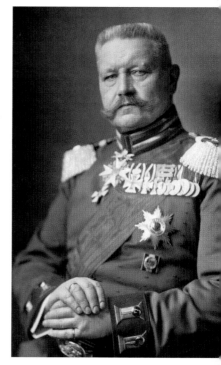

Opposite:
Philipp Scheidemann proclaiming the Republic from the balcony of the Reichstag building, 9 November 1918. Photograph.

Above:
Paul von Hindenburg as colonel general in the First World War, c. 1915. He was President of Germany between 1925 and 1934. Photograph by Emil Bieber.

The French writer Stendhal coined a good phrase to describe art, calling it a 'promesse de bonheur' – something that holds the promise of happiness. The same symbolism can be seen at work during the last days of imperial Germany: it served to increase motivation, and to fuel the euphoria that had been so prevalent four years earlier but had long since subsided. The pictures and the rhetoric that expressed this symbolism were designed to embody this promise of happiness. The symbolism endured long after the defeat.

One date, 9 November, has been particularly significant in the fate of the German people: the Berlin Wall fell on 9 November 1989; Kristallnacht, a pogrom against Jews by the Nazis in which synagogues were ransacked and set on fire, took place on 9 November 1938; Hitler staged a failed *coup d'état* on 9 November 1923, which has gone down in history as the Beer Hall Putsch (or Munich Putsch); and on 9 November 1918 Germany was liberated from its monarchy. Count Harry Kessler, an aristocratic convert to democracy, a playboy and an aesthete who documented the days of the

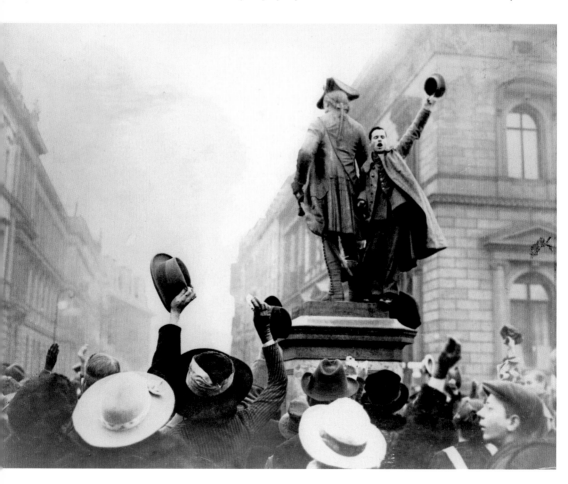

Weimar Republic with the understanding and nobility of an insider, wrote about the events of 9 November 1918 in his diary (*The Diaries of a Cosmopolitan, 1918–1937*): 'So closes this first day of revolution which has witnessed in a few hours the downfall of the Hohenzollerns, the dissolution of the German Army, and the end of the old order of society in Germany. One of the most memorable and dreadful days in German history.'

It has remained a memorable date for the sheer power that was felt on the streets, when Philipp Scheidemann proclaimed the Republic from the Reichstag and Karl Liebknecht declared the formation of a 'free socialist republic' from Berlin Castle. As everyone knows, for a brief period during the next fourteen years the liberal rather than socialist form of government held power, but the institutions created in those first few months were built on very unstable foundations. On 2 February 1919 Count Kessler wrote the following perceptive words: 'I said that it was precisely on account of this sort of thing that I give the present state of affairs short shrift. It is all too flimsy and untenable. The paradox whereby a Social Democratic Government allows itself and the capitalist cash-boxes to be defended by royalist officers and unemployed on the dole is altogether too crazy.'

Was it a revolution? It was a German version of one, carried out by the type of subversive agents who, as Lenin remarked cuttingly, would fail because they did not have enough change in their pockets to board the revolution train. By 1933, a fundamental change would have taken place in society, and the Nazis would have learnt from the mistakes of 1918. The revolutionaries who brought down the Kaiser regime contented themselves with taking over legislative powers, installing a freely elected parliament, and drawing up a new constitution. The administration of justice and the executive remained unchanged, and in this way the Weimar Republic had laid a number of cuckoo's eggs in its own nest, to say the least. The efficiency of the previous administration was simply too firmly lodged in the imperial Prussian memory for it to be pensioned off, and so the convictions of those organs of the new Republic remained thoroughly authoritarian. Revolutions are markedly different.

That experience was a valuable lesson in the prerequisites for a successful revolution. Germany had a capital city, where the general unrest that had been stirring in the provinces and had started with the sailors' mutiny in Kiel could take root. Without the capital's backing there could be no revolution, but the revolutionary success stories of Paris in 1789 and St Petersburg in 1917 were not repeated in Berlin. Another entry in Count Harry Kessler's diary, on 17

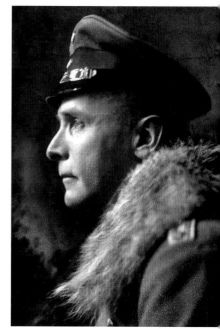

Above:
Count Harry Kessler, 1917. Photograph by Rudolf Dührkoop.

Overleaf:
Spartacist barricades on Karlstraße, 1918. Photograph.

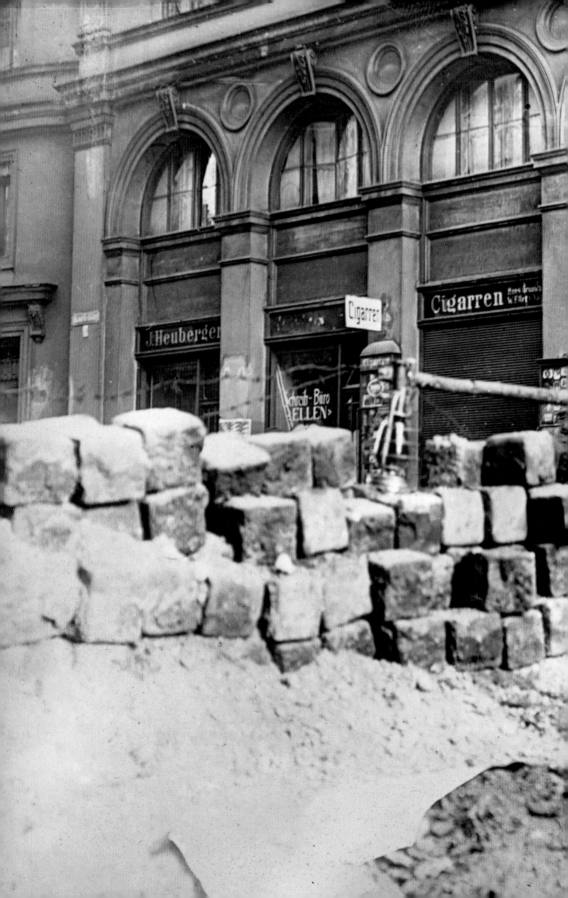

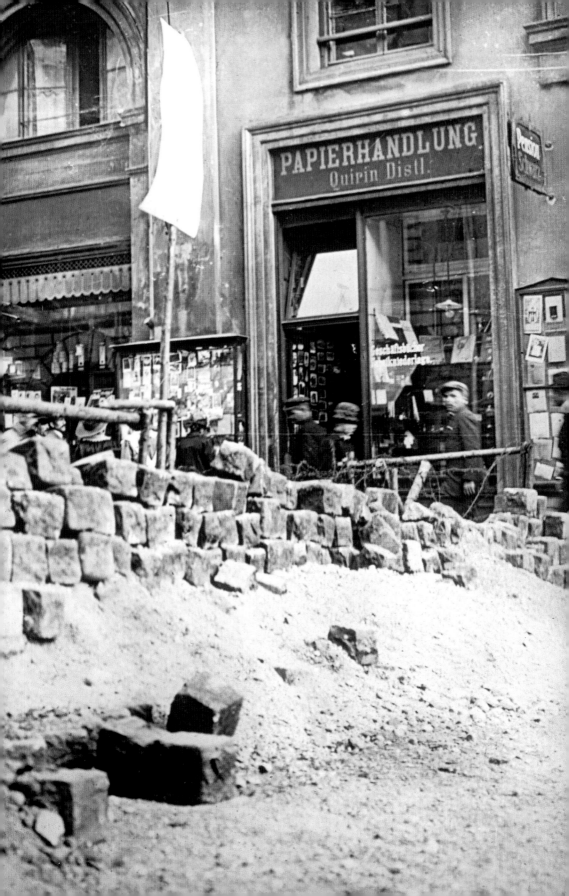

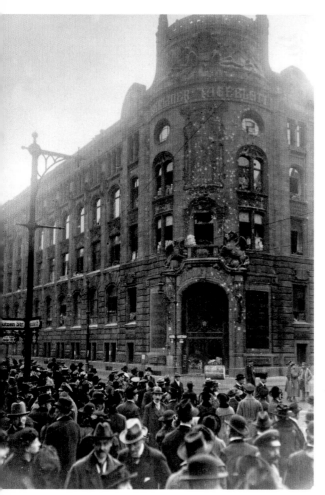

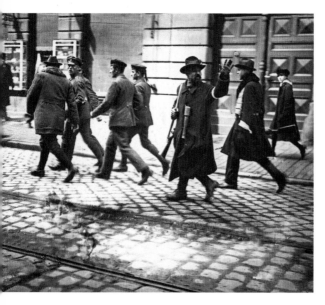

Above left:
The façade of the Rudolf Mosse publishing house, riddled with machine-gun fire, January 1919. Photograph.

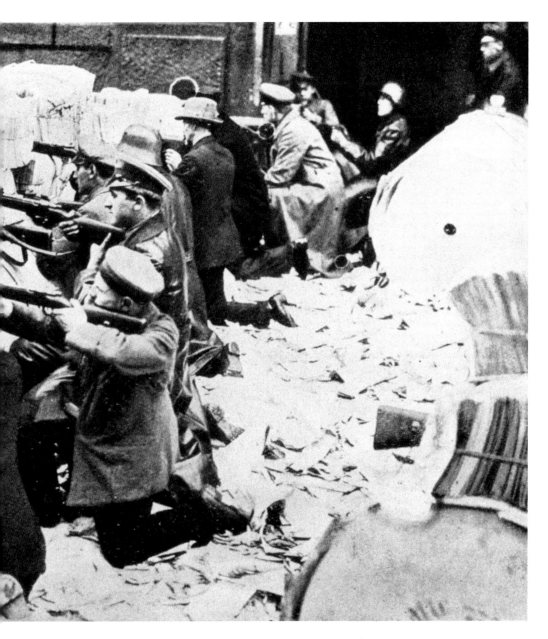

Opposite, below left:
Spartacist captives being led away by a vigilante group, 1918. Photograph.

Above:
Spartacist combatants in the newspaper district of Berlin, 1918. Photograph.

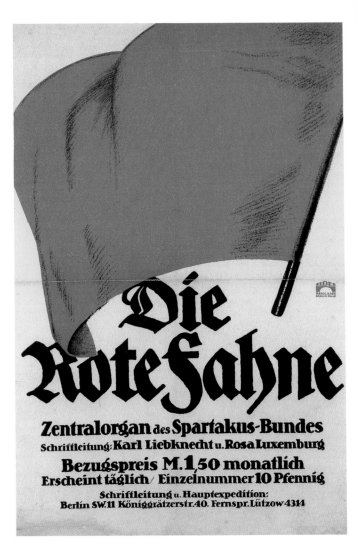

January 1919, offers an explanation: 'It underlined the slight impression that the revolution has made on metropolitan life. I only began to appreciate the Babylonian, unfathomably deep, primordial and titanic quality of Berlin when I saw how this historic, colossal event has caused no more than local ripples on the even more colossally eddying movement of Berlin existence. An elephant stabbed with a penknife shakes itself and strides on as if nothing has happened.'

These grandiose sentences seem to contradict our historical experience of the revolutionary role of capital cities, and yet the truth contained within them cannot be denied. Berlin had become too much of a giant, with a voracious appetite; it was too busily concerned with its own metropolitan Ferris wheel of life to see anything unusual in all the upheavals going on around it or the political ambi-

tions taking root. Berlin did not feel a need to react strongly to what was happening: in fact, normality would have been a far more disturbing prospect, and the subversive activities were absorbed in the buzz of city life. This might lead one to conclude that a city needs to be a certain size for a revolution to be successful, neither too small nor too big.

However, there was one segment of society that, sensitive to all types of chaos and violence, took the revolution to heart and reacted to it: the artistic community. Its members reacted primarily in a political fashion and tried to form themselves into interest groups. Indeed, on 8 November 1918 – the day before that fateful date – the most illustrious figures of the city's cultural scene came together with a view to founding an organization: writers, publishers, painters, architects and actors such as Heinrich Mann, Kurt Wolff, Ludwig Meidner, Bruno Taut and Gustav von Wangenheim, respectively, banded together to form the Rat geistiger Arbeiter ('Council of Intellectual Workers'), whose name alone suggests their leftist tendencies. In 1914 great cultural giants such as Gerhart Hauptmann, Peter Behrens, Max Reinhardt and Max Liebermann had subscribed to a

Below:
Representatives of workers' and soldiers' unions in front of the Garde-Ulanen barracks in Berlin, which was surrendered to them without a struggle, 1918. Photograph.

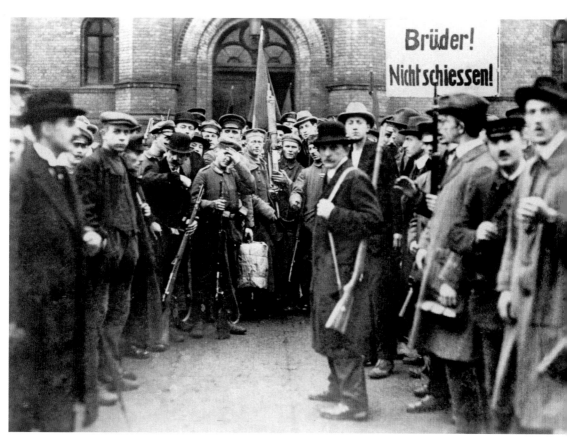

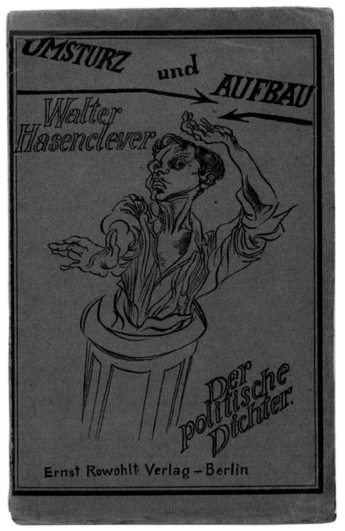

Left:
Walter Hasenclever, Der politische Dichter: Umsturz und Aufbau, *Pamphlet 2. Cover drawing by Ludwig Meidner. Berlin: Ernst Rowohlt Verlag, 1919.*

Opposite:
An alle Künstler!, woodcut by Max Pechstein. Berlin: Kunstanstalt Willi Simon, 1919.

'manifesto', which culminated in the slogan 'The German Army and the German People are One'. Such extreme, intoxicated narrow-mindedness evaporated after their first experiences of war. The internationalist, socialist commitment to the Rat geistiger Arbeiter swiftly ended in fiasco, showing itself to be ideologically held together by little more than a widespread sympathy for a Republic composed of proletarian councils.

The Novembergruppe ('November Group') proved more successful, as it put a greater emphasis on the here and now. Taking its name from the month of the Weimar Revolution, this group was primarily formed by artists and architects, and included Die Brücke ('The Bridge') veterans Otto Mueller and Max Pechstein, Erich Mendelsohn (the pioneer of the new building methods), and more

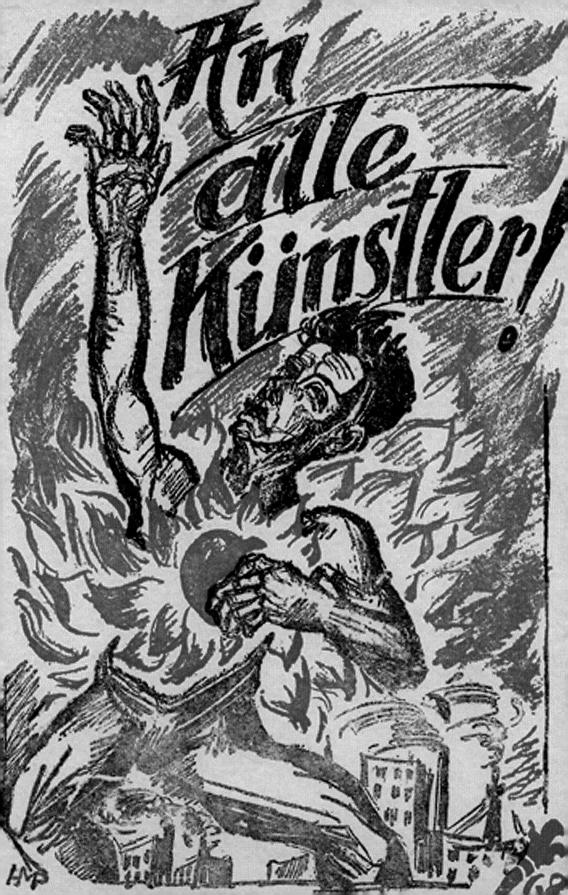

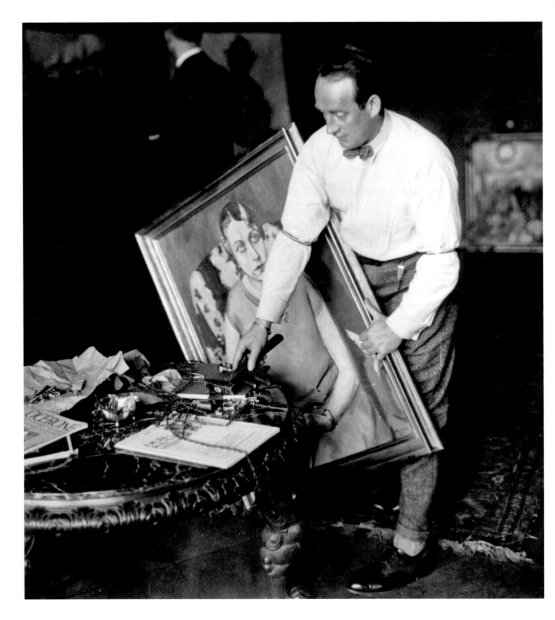

moderate representatives of the modern style such as Otto Freund-
lich and Rudolf Belling. Soon the group attracted most of the
well-known Berlin artists of the day. The Novembergruppe wanted
to exploit the political situation by offering themselves as a kind of
pool of potential artists willing to work for the state, should the new
Republic find itself in need of them. In addition, they demanded to
have their say at every political-cultural opportunity, be it on art edu-
cation, the foundation of museums or the design of public spaces.
The group was allocated its own spaces in the annual Berlin art exhi-
bition, and increasingly became a professional association.

The political euphoria soon faded. The catalyst came in 1921, when two paintings by group members Otto Dix and Rudolf Schlichter were banned from the Berlin exhibition, on the usual grounds of impropriety. This gave them the opportunity to form an opposition group, which included George Grosz, Hannah Höch and Raoul Hausmann as well as the two disallowed painters. The official branch of the Novembergruppe countered with the weak argument that it had merely advocated radicalism in artistic spheres, not in political matters. A schism became inevitable, as has so often happened when artists try to form institutions (as with the Berlin Secession in the blissful days of 1898). It was yet another group that had evolved and then fizzled out, its ideology defeated by the trench-warfare of the Isms.

In 1929 Kurt Tucholsky wrote a poem entitled 'Ideal and Reality', in which he reflected on the true spirit of those November days: 'You wanted to buy a light-coloured pipe / And bought yourself a dark one – there were no others. / You wanted to go for a jog each morning / But you didn't. Next time…next time / Under the

Opposite:
Max Pechstein at work in his Berlin studio,
1927. Photograph.

Below:
Max Pechstein, Hammock I, *1919.*
Oil on canvas, 80 x 106 cm (31¼ x 41¼ in.).
Henri Nannen Collection, Emden.

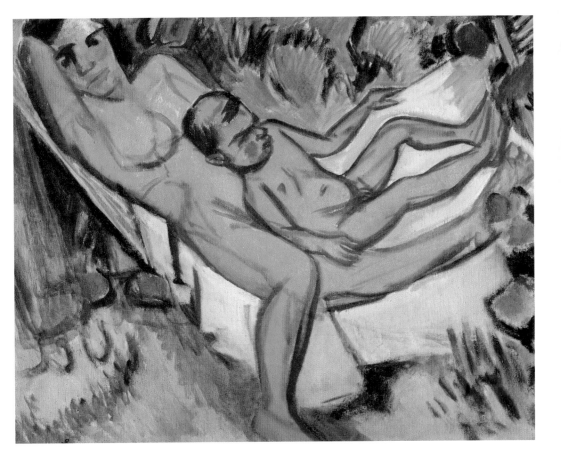

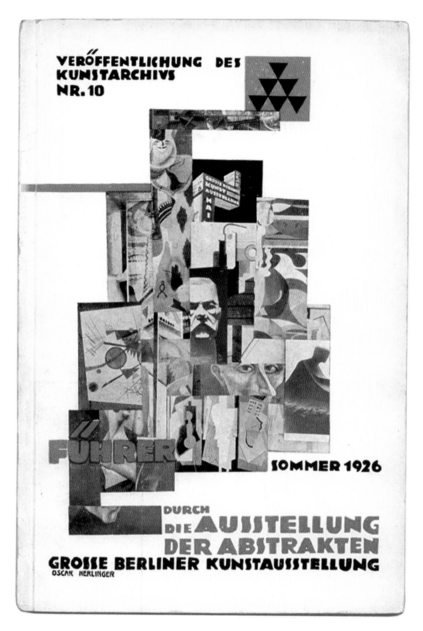

VERÖFFENTLICHUNG DES KUNSTARCHIVS NR. 10

FÜHRER SOMMER 1926

DURCH DIE AUSSTELLUNG DER ABSTRAKTEN

GROSSE BERLINER KUNSTAUSSTELLUNG

OSCAR NERLINGER

Left:
Gustav Eugen Diehl, 'Great Berlin Art Exhibition', 1926, guide to the exhibition of abstracts, booklet no. 10. Cover design by Oscar Nerlinger. Berlin: Kunstarchiv-Verlag, 1926.

Opposite:
Gustav Eugen Diehl, 'Great Berlin Art Exhibition', 1927, booklet no. 41/42. Anonymous cover designer. Berlin: Kunstarchiv-Verlag, 1927.

GROSSE BERLINER
KUNSTAUSSTELLUNG
VERANSTALTET VOM
KARTELL 1927
DER VEREINIGTEN VERBÄNDE BIL:
DENDER KÜNSTLER BERLINS E. V.

VERÖFFENTLICHUNGEN DES KUNSTARCHIVS NR. 41–42

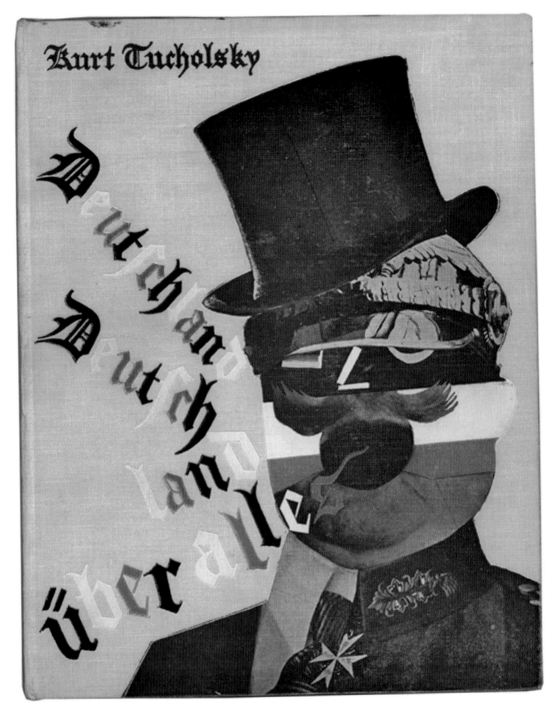

Above:
Kurt Tucholsky, Deutschland, Deutschland über alles, *a picture book by Kurt Tucholsky with many photographs, and assembled by John Heartfield. Cover design by John Heartfield. Berlin: Neuer Deutscher Verlag, 1929.*

authoritarianism of the Kaiser / We dreamed of a republic and now we have one! / You wanted a tall, thin one / And got a short, fat one – / C'est la vie'. It all passed far too quickly: a few days after the ill-fated revolution, everything had quietly slipped back to the agenda of the establishment. Yet the various arts have continued to bear the torch of November 1918, which has inspired some of the most significant masterpieces in literature, film and sculpture. That torch was inspirational in two senses: on the one hand, it cast its light on reality and looked it mercilessly in the eye, refusing to believe that this is all there is to life; and on the other, it continued to dream the dreams of the revolutionaries, fanning the flames of idealism and an idyllic belief in a better world. Against the backdrop of that November there was a fine artistic balance, characterized by two very different creative veins – the heated, angry, audacious language of Expressionism, and the renunciation of language associated predominantly with Dada.

Kurt Tucholsky with his wife Mary, c. 1925. Photograph.

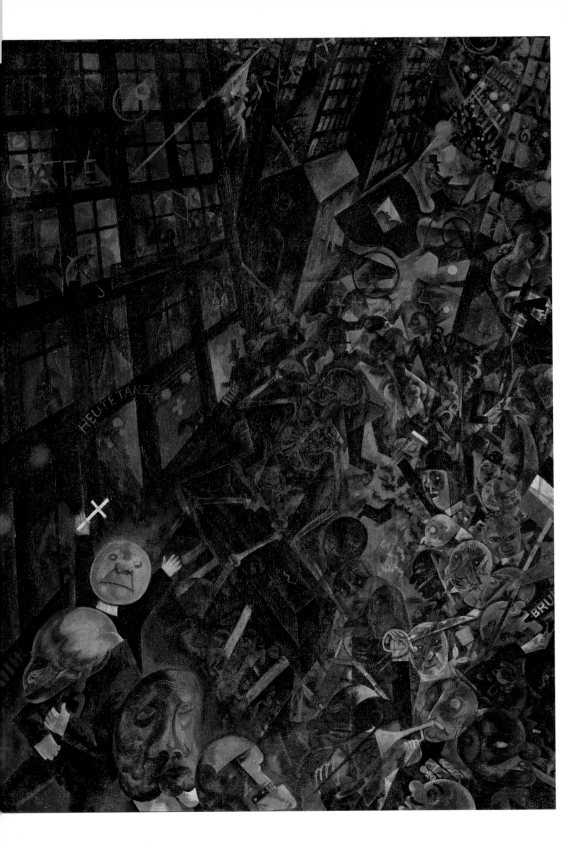

CHAPTER 3
WAR AND PEACE:
EXPRESSIONISM AND DADA

The city is an almighty being demanding human sacrifice. To use a metaphor from religious history, the city is Moloch, the Canaanite and Phoenician god to whom children were sacrificed. Perhaps such a personalized and metaphysical analogy does not seem appropriate for the hustle and bustle of the modern city. Yet it says such a great deal about the peculiar penchant of Expressionism for heightened emotion and distortion that it was adopted as an apt metaphor. The Semitic religions of Phoenicia and the Mesopotamian lands – where Moloch is believed to have originated – had another word for their deity, Baal, and it was under this strange guise, shrouded in myth, that Expressionism chose to elevate the subject of the metaphor.

A good example of this is found in the work of Georg Heym, one of the progenitors of expressionistic lyricism, who lived in Berlin from 1908 and fulfilled his prophetic 'live fast, die young' lifestyle in a skating accident on the Havel in 1912. He wrote a poem entitled 'Der Gott der Stadt' ('The God of the City'): 'From evening the red belly of Baal glows, / The cities kneel at his feet. / A sea of countless church bells surges towards him from black towers.' Ten years later, in 1922, the sinister deity attracted attention once again in the poetry ('Das späte Ich') of Gottfried Benn, who had arrived in Berlin in 1905 and was working both as a doctor and a poet. In the same year, Baal stepped into the limelight in a play by Bertolt Brecht, who embraces him with fervour in the introduction to the play *Baal*, placing him at the beginning of all things: 'In the white womb of his mother Baal did lie. / Huge already, calm, and pallid was the sky, / Young and naked and immensely marvelous / As Baal loved it when Baal came to us.'

Heym, Benn and Brecht – three writers whose lives were intimately bound up with Berlin – were all born in the provinces and attracted by the magnetism of the big city. They embodied their experiences of artistic awakening in the persona of a deity who was historically and culturally distant, but for this reason he could also be perceived as someone hieratic, monumental and sacrosanct. The Expressionists loved such all-encompassing, universal figures, combining pathos with ethos, raising themselves up onto lofty stylistic plateaus. Another cantus firmus, the virtuoso poem 'Der Mensch steht auf!' ('Man Arises!') by Johannes R. Becher, published in 1921, reads as follows: 'Tell me, o man, my brother – who are you? / Starry heavens sparkle immaculately over the poor man. / Wounds

Opposite:
George Grosz, Dedication to Oskar Panizza, *1917–18. Oil on canvas, 140 x 110 cm (55⅛ x 43¼ in.). Staatsgalerie, Stuttgart.*

of flaming fire are soothed by the cool balsam of friendship – / Shining dew bedecks the wild tangle of thorn bushes where the tiger lurks – / Mild Jerusalem of fanatical crusades – / Hope that is never extinguished.' From the poetry of the *Song of Songs* in the Bible to the dithyrambs of Nietzsche, there is nothing that Becher leaves out here in his pursuit of a characteristic prophetic voice. Becher's prophetic voice largely applied to politics: as a member of the Spartacist League, he was at the forefront of the November Revolution in 1918, and after the Second World War became Minister of Culture in the GDR. One of the central experiences of the modern movement has shown how the tendency towards totality can mutate into a tendency towards totalitarianism, which was certainly discernible in Berlin.

As can be seen from the literary figure of Baal and the vocabulary surrounding him, Expressionism was able to seamlessly span the years prior to 1914 and after 1918, naturally encompassing the war itself. It always set its sights on tumultuousness and fragmentation, on separation and collision, and right until the last moment it poured out its heart and soul in the search for a language to convey violent and nervous emotion. Expressionism gave a voice to inner expression, drawing out deep feelings from the overwrought psyche and exposing them to the gaze of a militant, suspicious world. For

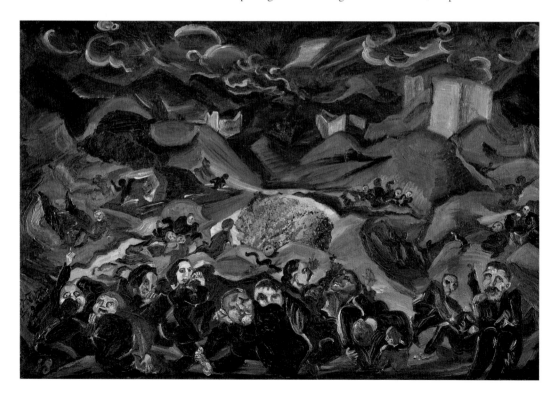

example, in 1912 and 1913 Ludwig Meidner created a series of 'Apocalyptic Landscapes' on canvas and paper, prophetic panoramas of battlefields, slaughter, death and decay that live up to their title. In the pictures there are gaping chasms everywhere, like the craters blasted out by bombs. Meidner must be admired on two counts: firstly for his prophetic oeuvre, in which he was proven right only two years later, and secondly for his intention to provide an explicit portrayal of a world torn apart, like a gaping wound, a portrayal that bears all the hallmarks of Expressionism. Meidner participates in the inscrutable archaeology of expression, the art of exposing inner thoughts and feelings. In his work, the earth spills forth her entrails in the same way that the dying spill forth theirs throughout the entire Expressionist oeuvre.

In 1914 Meidner put together his *Anleitung zum Malen von Groß-stadtbildern* ('Guide to Painting City Landscapes'), in which he reflected on his experiences of living in Berlin since 1907: 'We couldn't carry our easels into the turmoil of the streets in order to stare in bemusement at subtle hues. A street does not consist of subtle hues; it is a bombardment of rows of shop windows whizzing by, of glowing headlights from all kinds of transport rushing past, of bouncing balls, of scraps of people, of advertising billboards and roaring, formless masses of colour.' The particular modernity of the metropolitan reality demanded a style that could express the idea of 'bombardment', would take these 'scraps' of people seriously, and impact the roaring 'masses of colour'.

In its need for constant existential recharging, the spirit of Expressionism is more like a hail of bullets during a war than the blasé simultaneity and literal indifference of all that a city can offer in sensual and consumer gratification. The enduring relevance and contemporaneity of Expressionism and its achievements lie in its breathtaking correspondence to the inexorable horrors that were soon to be played out at Langemarck, Verdun and Tannenberg. From the beginning, it chose not to deal with the reality of urban indifference that was prevalent in Berlin, which allowed each person to engage in his own way, some for the better and others for the worse, without devaluing the Modern in any way.

Ernst Ludwig Kirchner, a veteran member of Die Brücke, came to Berlin from Dresden in 1911 and set his sights on the colourful street life. He painted city scenes, but primarily tried to find his own Expressionist language to convey the truth about humanity, often choosing prostitutes as a subject matter in his paintings. However, beneath the prostitutes' veneer of nonchalance, there is a sense of dejection and isolation: seemingly out of place on the

streets or in the late-night bars, they look like they should be at home rather than in the city. In such ways, Expressionism imparted something irredeemably provincial to the detrimental way of life.

George Grosz, on the other hand, was a Berliner through and through: he was born and bred in the city, and he died there. When he threw himself into tumultuous paintings such as *Metropolis*, he embraced the full breadth of the city with a million inhabitants, whereas Kirchner's closer scrutiny seemed to reduce the city's stature and wag a cautious finger at the canvas. Yet, with Grosz also, morality is always lurking around the corner, for the myriads of people populating his canvases have something compulsive and alien about them; they are isolated, abandoned to and driven by manias which flow as unceasingly as the traffic around them. In his Expressionist phase, which lasted until 1919, Grosz's works were chaotic and teeming with life. They are reminiscent of old master depictions of the grotesque and the monstrous, with puppet-like caricatures, and particularly hark back to the work of Belgian artist James Ensor and his *Christ's Entry into Jerusalem*. Even in paintings by Grosz, the defini-

Opposite:
George Grosz in his Berlin studio, c. 1920. Photograph.

Below:
George Grosz, Untitled, 1919. Watercolour, 39.8 x 29.2 cm (15⅝ x 11½ in.). Henri Nannen Collection, Emden.

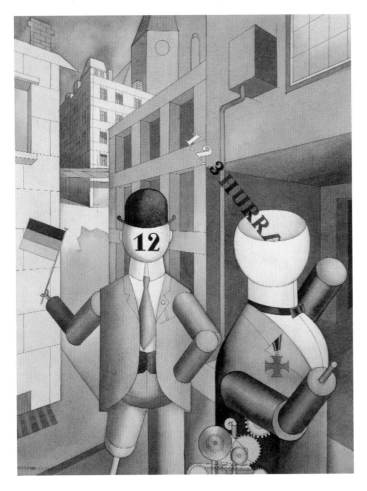

tive city-dweller, there is a trace of the Passion motif – the elegiac knowledge of the road to suffering that lies ahead.

This anti-Modernism accounts for the success of Expressionism during the years following the First World War, and it seemed appropriate for society to adopt it as a sort of national style. Expressionism was entirely relevant to that time; its language seemed to have been created especially as a means of articulating the harrowing experiences of war. Furthermore, its humanitarian pathos seemed to suit the mood of a country licking its wounds after a humiliating defeat and coming to terms with a new state government based on a democracy of rapprochement and obligation. Thus Expressionism became much more than the whim of a salon, and the artists' careers followed suit.

The figurehead for this development was Herwarth Walden, who in 1910 had taken over publication of the magazine *Der Sturm*, and from 1912 had managed the working gallery of the same name. The

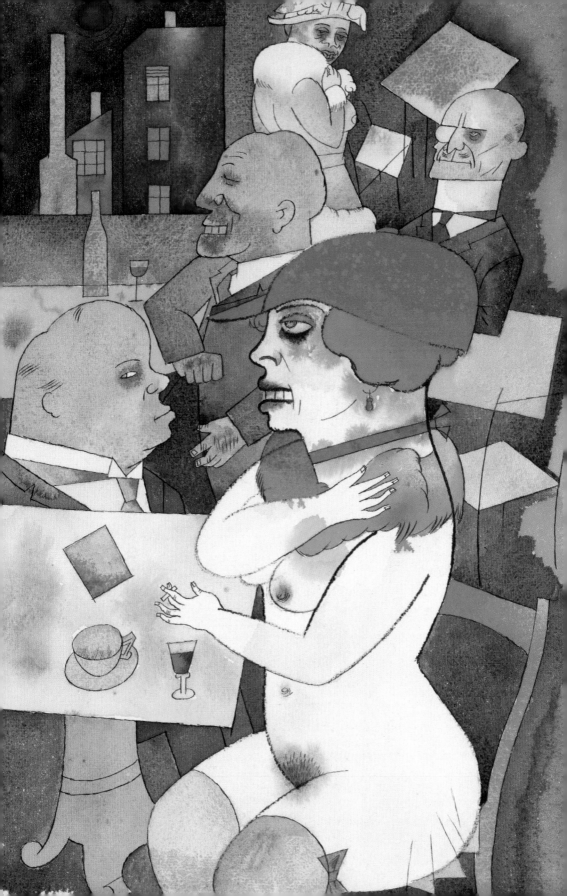

Above:
Herwarth Walden with his wife Nell in
their Berlin home, 1920. Photograph.

Opposite:
Oskar Kokoschka, Portrait of
Herwarth Walden, *1910. Oil on*
canvas, 100 x 69.3 cm (39⅜ x 27¼ in.).
Staatsgalerie, Stuttgart.

name naturally described the Expressionist agenda: it was aggressive, audacious, disturbing. It was undoubtedly due to his influence that the German exponents of Expressionism achieved lasting recognition in both artistic and literary spheres. Even more importantly, however, he connected this genuine, national idiom with the international movement. Whilst countries were sparring with each other in their naive chauvinism, Walden's activities established cross-border communication through the avant-garde movement. He exhibited the Italian and Russian Futurists, the Paris-based (with the notable exception of Picasso) and Czech Cubists, and the works of Paul Klee, Marc Chagall and Robert Delaunay, arguably the most influential figure of all.

In 1920 the Hungarian painter and photographer László Moholy-Nagy visited Berlin and called on the famous impresario Walden shortly after his arrival. What he witnessed and described then is none other than the luxurious existence afforded to those who have really managed to achieve something: 'Herwarth Walden has

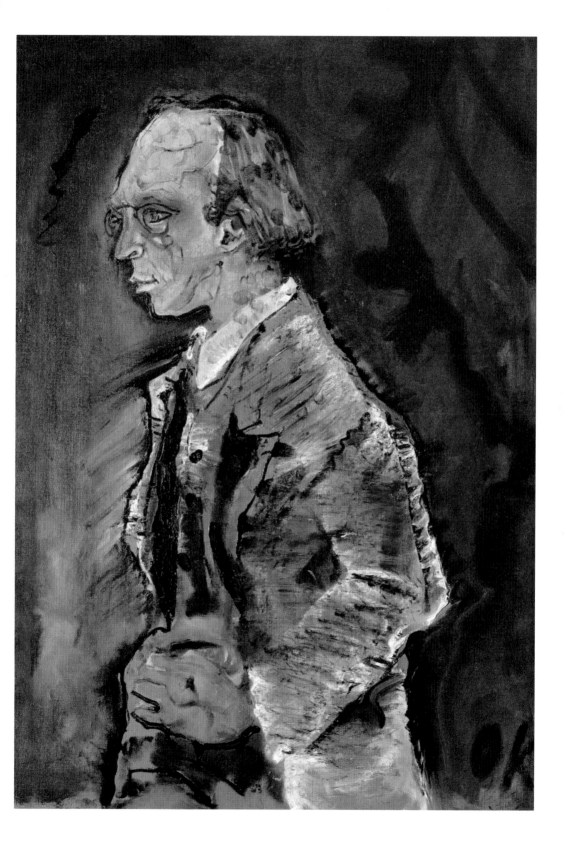

become a millionaire; he has an amazing collection, which he picked up for next to nothing, and the imperial airs and graces to match. You have to make an appointment to see him through his secretary. When it is your turn to view the collection, your name is called out by a lackey.'

Expressionism had made itself indispensable, and its influence was soon to be felt throughout the cultural scene. In films such as *The Cabinet of Dr Caligari* by Robert Wiene and *The Golem* by Paul Wegener, it spoke through the rough-and-ready decor and the rudely formed clay scenery, which harked back to primitive times. It left its mark on architecture, on Hans Poelzig's Großes Schauspielhaus in Berlin's Friedrichstraße, a cave of stalactites with over 5,000 seats, built for Max Reinhardt. An established repertoire took over the façades, consisting of triangular arcades and diamond-shaped trellis-work, lofty, swirling circles and pointed arches. This was an exulted language beloved of history, reminiscent of the Middle Ages and of craftsmanship. It was like a cloak of silence thrown over the bustle of the city. Soon Expressionism was adopted by the theatre itself. The Berlin critic and literary figure Ludwig Marcuse referred

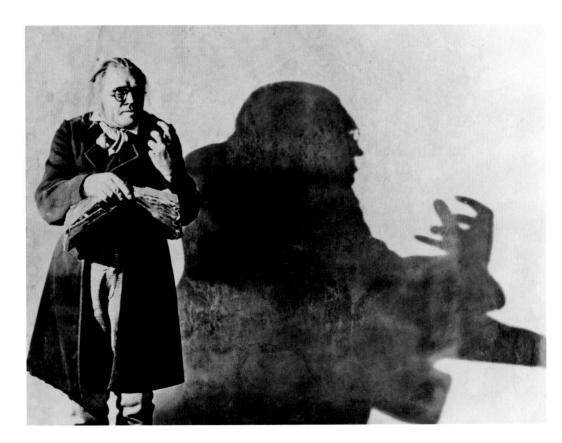

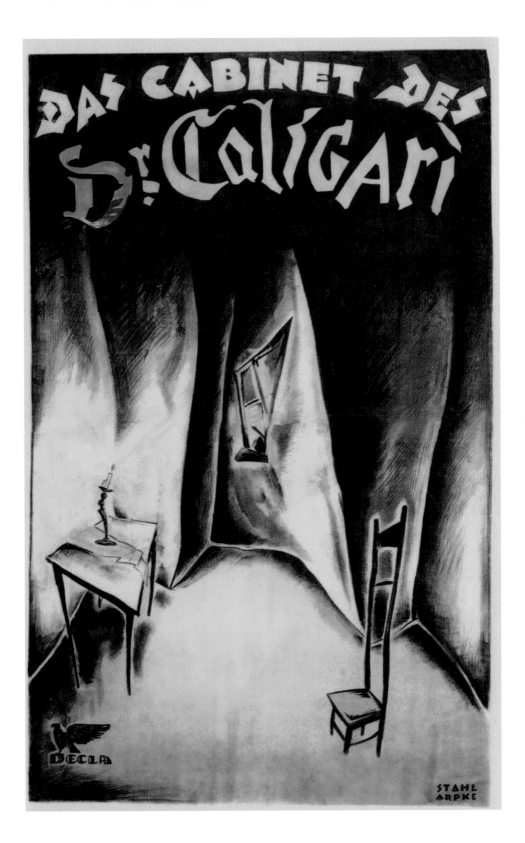

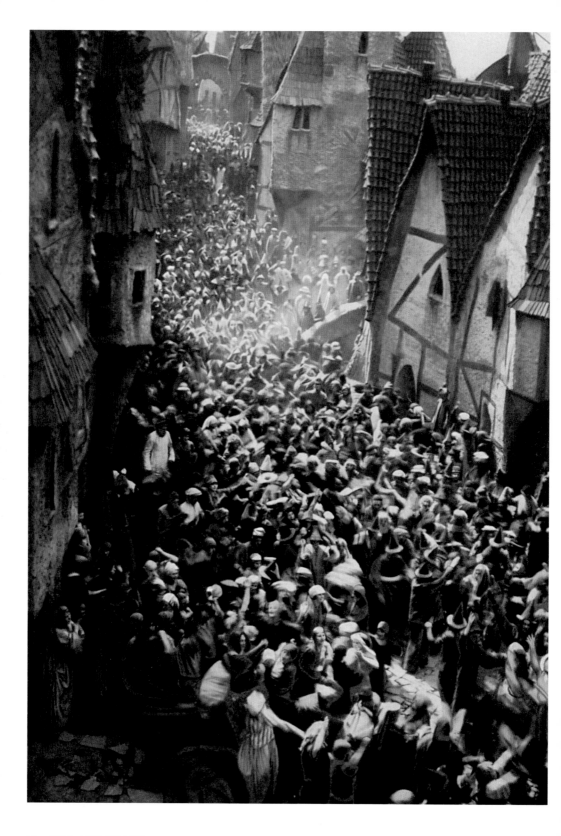

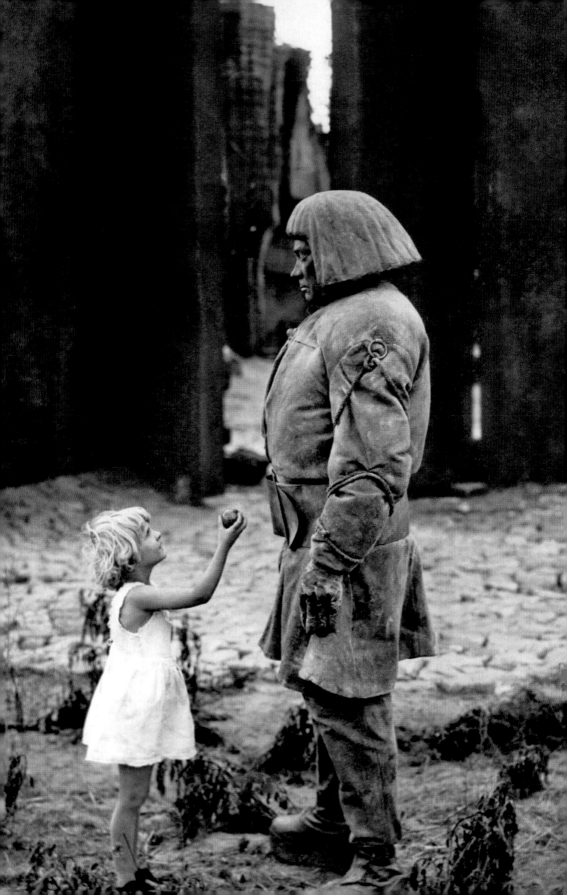

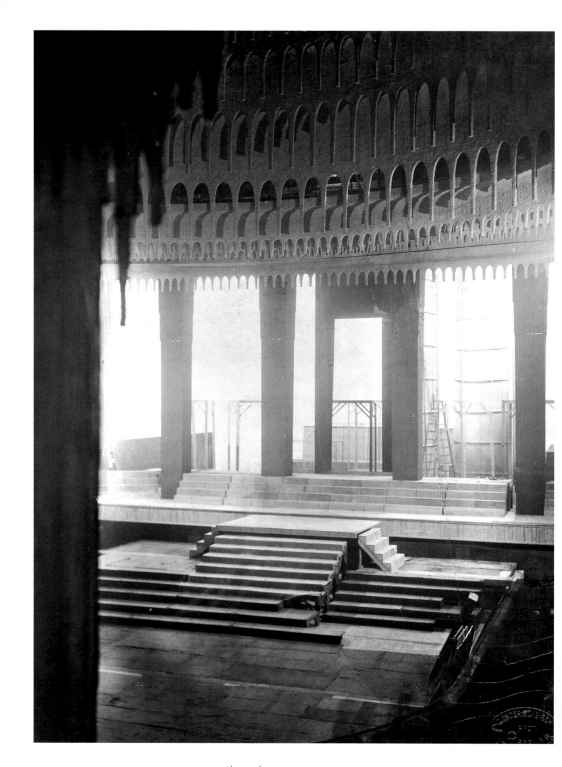

Above and opposite:
The Großes Schauspielhaus in 1919, designed by Hans Poelzig: part of the cupola over the
stage and view of the auditorium. Photograph courtesy of Zander & Labisch.

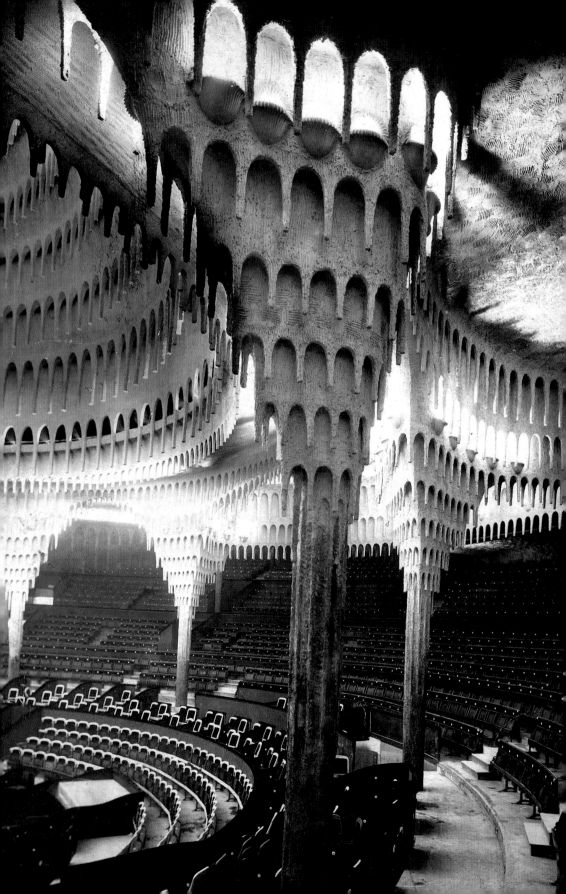

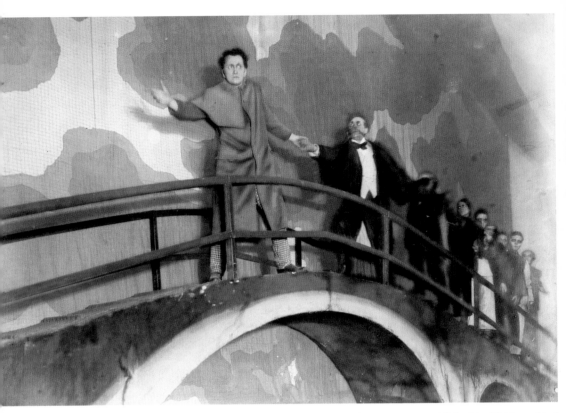

Above:
Scene from the play Hölle, Weg, Erde by
Georg Kaiser, at the Lessing Theatre, 1920.
Photograph courtesy of Zander & Labisch.

Opposite:
Agnes Straub as 'Public Opinion' in the operetta
Orpheus in the Underworld by Offenbach,
at the Volkstheater in Bülowplatz, 1928.
Photograph courtesy of Photo-Schmidt.

to this distinctive epoch in his memoirs, published in 1960, entitled *Mein Zwanstiges Jahrhundert* ('My Twentieth Century'): 'The actors could do nothing else but run onto the stage and engage with their audience: to enchant them, goad them, and mock them.'

This mocking of the audience to which Marcuse refers was one of the intentions of 'the revolutions in the theatre, which were pacifist-socialist, if not in fact rather eschatological'. Mockery was the guiding impulse of a particular group – the Dadaists – which hardly anyone took notice of whilst Expressionism was at its peak, but which has long since held a place of honour in art history for the simple reason that it is light years closer to where we find ourselves today. In its day Dada caused the occasional stir by provoking and attacking a society that considered itself to be highly civilized and yet failed to prevent a world war. It was, to borrow Marcuse's phrase, pacifist-socialist, but it certainly was not eschatological. It was not interested in the notion of saving the world, or in the visionary warnings of apocalyptic overkill, which were rejected by *Oberdada* ('President of the Earth') Johannes Baader and his companions Raoul Hausmann, Hannah Höch and Richard Huelsenbeck, who were soon joined by George Grosz.

Dada would have been unthinkable without some kind of associated controversy, and so it was that the Dada movement in Berlin began

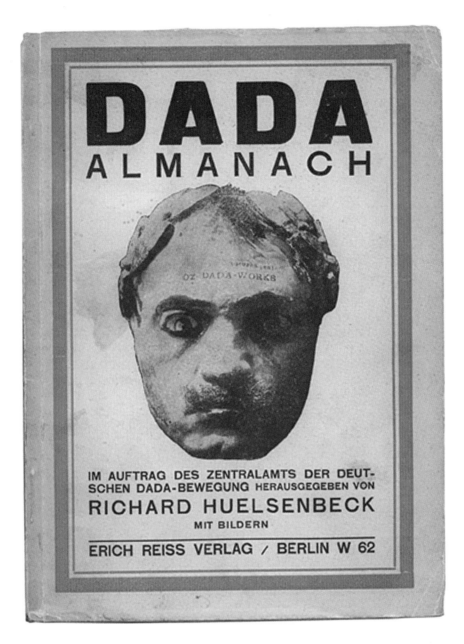

DADA
ALMANACH

IM AUFTRAG DES ZENTRALAMTS DER DEUT-
SCHEN DADA-BEWEGUNG HERAUSGEGEBEN VON
RICHARD HUELSENBECK
MIT BILDERN

ERICH REISS VERLAG / BERLIN W 62

Above:
Richard Huelsenbeck (ed.), The Dada Almanac, *commissioned by the Central Office of the Dada Movement.*
Anonymous cover designer: Dadaist bust. Published by the Erich Reiss Verlag, Berlin, 1920.

Opposite:
Raoul Hausmann, L'esprit de notre temps, *mechanical head, 1921. Centre Pompidou, Musée d'Art*
Moderne, Paris.

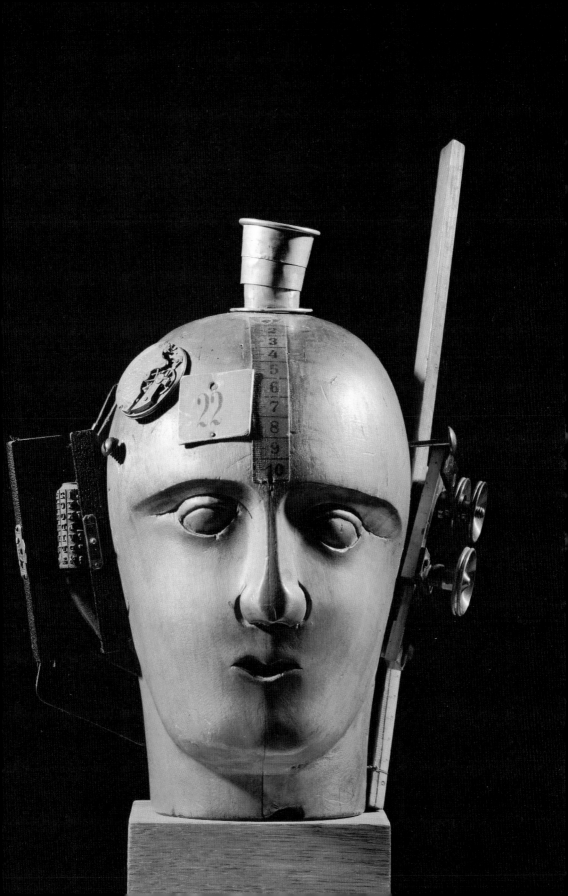

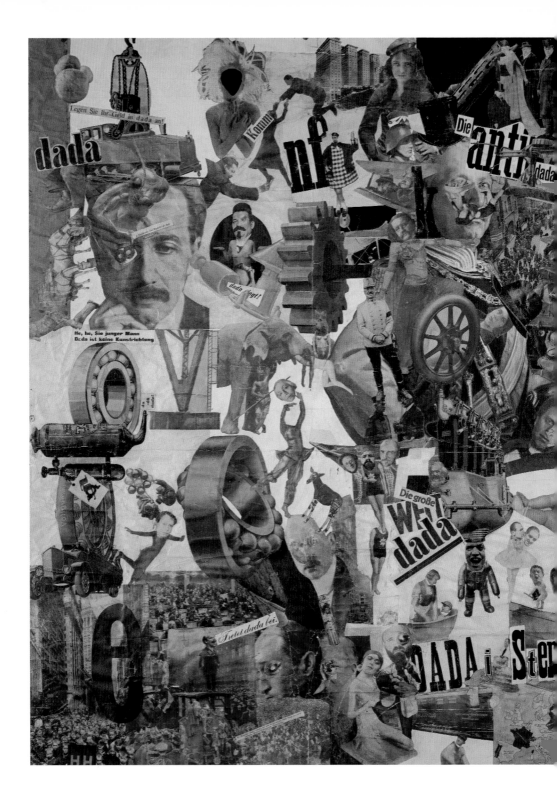

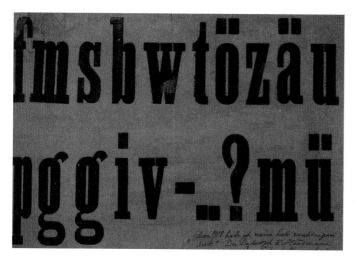

in a refreshingly dim-witted manner. During a service in Berlin Cathedral on 17 November 1918, Baader shouted out: 'We don't give a toss about Jesus Christ', only to be swiftly and predictably removed. The matter did not end there, but entered into the public domain through various readers' letters to publications. Dada was the first manifestation

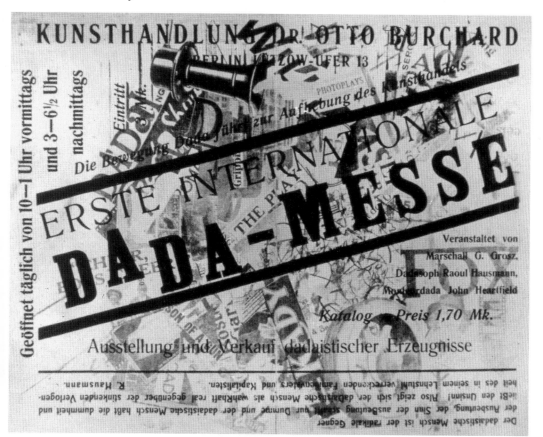

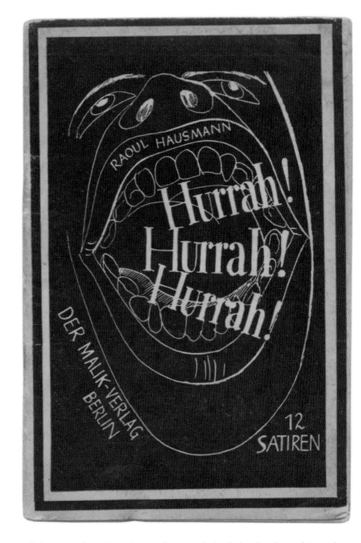

of the view that the culture of spectacle had absolutely nothing whatsoever to do with the quality of the potential protagonists, but everything to do with their assertion: 'This is me, and I am the important one around here.' Dada constructed its own particular mechanisms in order to achieve this, just as all prominent people do today. Nowadays it would be regarded as undesirable were those mechanisms to produce more nonsense than sense, but for the Dadaists it was a prerequisite of their work.

This was the incentive behind Raoul Hausmann's *Plakatgedichte* ('Poster Poems') of 1918: printed paper, on which rows of letters of the alphabet and sentences had been assembled in no particular order and with no logical meaning. It offered a primitive version of orthography and the printed word, an invitation to a form of communication whose message lay in the protest against conventionality.

The same incentive lay behind the many different magazines published by Wieland Herzfelde, the founder and manager of the publishing house Malik-Verlag. The strangest title to be found amongst all of them was the completely nonsensical *Jeder Mensch sein eigener Fussball* ('Every Man His Own Football'). This artistic tendency culminated in the 'First International Dada Fair', which was nothing more than an exhibition displaying the works of the Dadaists in a conventional manner, including photomontages by Hannah Höch and collages by Raoul Hausmann. But it was also important for them to raise the public profile of the movement, hence their forays into the arsenal of the mass media, writing poems on posters, and flooding the market with different magazines, all the while disguising the banality of the hard sell with the highfalutin language of the capitalist sales pitch. All that Dada needed now was the trial of 1921, which was caused once again by the activities of Baader, the gallery owner Burchard, Grosz, Herzfelde and his brother, the journalist and art historian who went by the pseudonym John Heartfield. The authorities believed that the Dada Fair had caused offence by 'insulting the armed forces' and 'inciting class hatred', with the result that Herzfelde and Grosz were fined 600 and 300 marks respectively. Yet such notorious court appearances served only to boost the success of the avant-garde – everyone remembers the names of the artists, but no one can recall the judges. Dada was well aware of this fact.

The enduring relevance of Dada is not just to be found in momentary scandals. From the start, Dada was an international movement, with its most important groups based in Zurich, Paris, New York and Cologne. The Berlin Dada was more like a subsidiary branch – the international Dada movement put more emphasis on nonsense through its scorn, derision and bare-faced cheek. It was clear that such a subordinate ideology would soon run aground, precisely because Dada, whether it wanted to or not, failed to fulfil the expectation that makes art 'real art'; in other words, that art can provide meaning and have an intrinsic value. As an artistic movement, it did not celebrate nonsense for its own sake, but proclaimed the greater cause of rejecting the status quo: Dada signified protest, and it was highly successful at that.

Those responsible realized this early on, and so Dada settled into the ruthless and hair-splitting aesthetic attitude that characterized Berlin in the early Twenties like no other. Herzfelde referred to this in the catalogue accompanying the Dada Fair: 'The Dadaists recognize that the single task facing them is their duty here and now to make current events the subjects of their paintings.' They therefore

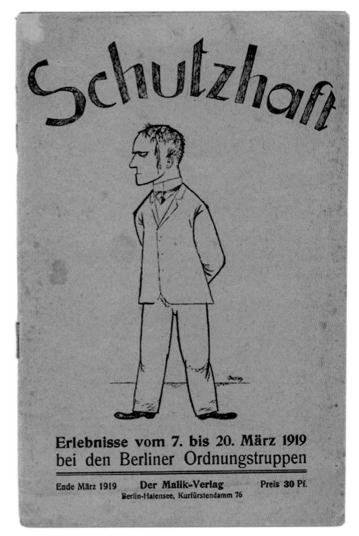

Schutzhaft

Erlebnisse vom 7. bis 20. März 1919 bei den Berliner Ordnungstruppen

Ende März 1919 Der Malik-Verlag Preis 30 Pf.
Berlin-Halensee, Kurfürstendamm 76

needed to have an unclouded perception of the status quo and its flipside, with the ability to convey this clarity of vision, and so Dada became a type of Verism.

Meanwhile, Expressionism clearly foresaw its own demise. Perhaps the best-known representation of its aesthetic is the anthology *Menschheitsdämmerung* ('The Twilight of Humanity'), which was first published in 1919. Its editor, Kurt Pinthus, collected 278 poems; the title of the volume was as evocative as its subject matter was relevant. It was illustrated with paintings by Ludwig Meidner, that 'ecstatic lover of painting', as Pinthus enthused. Corresponding to the spirit of the age, the book was a great success. By 1922 it was already in its fourth edition. This time the editor took it upon himself to add a foreword, but the prologue turned into an epilogue with the title 'Nachklang' ('Reverberation'). The jargon is somewhat over-heated, but he does make one pertinent observation: 'Let us honour this horde of poets in our memory; poets who yearned for wholeness and a future, confidently believing that they would be the first in a new epoch of humanity. We should neither mock them nor blame them, that in fact they turned out instead to be the final clamour; the last ones to turn away from the sunset towards the glow of the new dawn, only to find themselves too weary to lead their contemporaries into the cleansing light awaiting them.'

Expressionism entered into a period of rest, and in the light of such sentences, it would seem long overdue. Even today it remains the artistic language of consternation. Berlin, with all its hustle and bustle, had no time for such authenticity.

VILE CIRCUMSTANCES

CHAPTER 4
VILE CIRCUMSTANCES:
THE AESTHETICS OF VERISM

'It is rather quiet in the small exhibition,' reported Kurt Tucholsky during the 'First Berlin Dada Fair', 'and hardly anyone is outraged any longer. Dada – oh well. But there is one artist who really puts the cat among the pigeons, and it's worth the visit just for him: George Grosz, a great chap, and very caustic. If drawings could kill, then the Prussian military would surely be dead by now. No respectable family home should be without a copy of his portfolio *God for Us* – the hideous faces of majors and sergeants seem to be the infernal ghouls of reality. He alone embodies *Sturm und Drang*, turmoil, scorn and – as so rarely happens – revolution.'

Those nine sheets from Grosz's portfolio *God for Us*, which had so affected Tucholsky, would cause the organizers of and participants in the Dada Fair to be hauled before the court. Indeed, in these pages he had perfected the dramatic effect of the grotesque, fat-cheeked, bull-necked, monocle-wearing, spike-helmeted figures. In one illustration (*The Faith Healers*, 1918) a medical officer examines a half-mummified corpse and then pronounces him fit for action on

Opposite:
George Grosz, The End of the Day's Work, *1919, from* Die Gezeichneten: 60 Blätter aus 15 Jahren. *Berlin: Malik-Verlag, 1930.*

Below:
George Grosz, The Faith Healers, *1918, from* Die Gezeichneten: 60 Blätter aus 15 Jahren. *Berlin: Malik-Verlag, 1930.*

Below:
George Grosz, Toads of Property, *1921, from* Die Gezeichneten: 60 Blätter aus 15 Jahren. *Berlin: Malik-Verlag, 1930.*

Opposite:
George Grosz, Das Gesicht der herrschenden Klasse, *57 political drawings. Cover design by George Grosz. Berlin: Malik-Verlag, 1921.*

the battlefield. In another picture from the following year, a soldier is taking a stroll along the river and stumbles across the drowned corpse of one of his comrades washed up on the bank: there was no other way out of the mess of the services. The picture is called *The End of the Day's Work* – the end of the day indeed.

Grosz was proclaiming the end of bourgeois society, of militarism, the black market and state-funded crime. Dada no longer represented these things, and in place of nihilism and a meaningless world came aggression, accusation and blunt observation. Hannah Arendt, the philosopher and theorist, reflected on her university years during the Twenties, as recorded in Peter Gay's *Weimar Culture: The Outsider as Insider*: 'We young students did not read the newspapers in those years…. George Grosz's cartoons seemed to us not satires but realistic reportage: we knew those types; they were all around us.'

The 'pillars of society' captured by Grosz on paper and on canvas are the smirking, slobbering faces of a society for which nothing is sacred, but who have made a pact with the clergy in order to keep their own power; a clique of the most influential figures, who know the price of everything but the value of nothing. Grosz

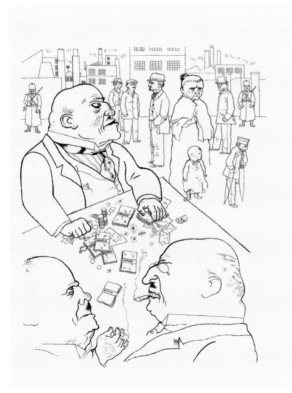

portrays a world governed solely by the rule of saleability, where the grimaces of men and prostitutes express the same gnawing greed for money. For the public at large, like Hannah Arendt or Kurt Tucholsky, his pictures seemed to represent the naked truth; they were like eye-witness accounts of the harsh realities of that period.

In 1924 Tucholsky published an article entitled 'Gesicht' ('Countenance'), in which he described one such contemporary figure: 'He feels himself to be in complete harmony with his country, with majority rule, with a national community spirit…yet is punctiliously correct and polite, utterly petite bourgeoisie on the surface, but feels noble deep down. Well-connected. Good career. Would like to become a key player, perhaps a special envoy, a ministerial post, state secretary, whatever. Germany? Germany.' Tucholsky's short piece about the contemporary countenance has a dedication: 'To George Grosz, who taught us to see.'

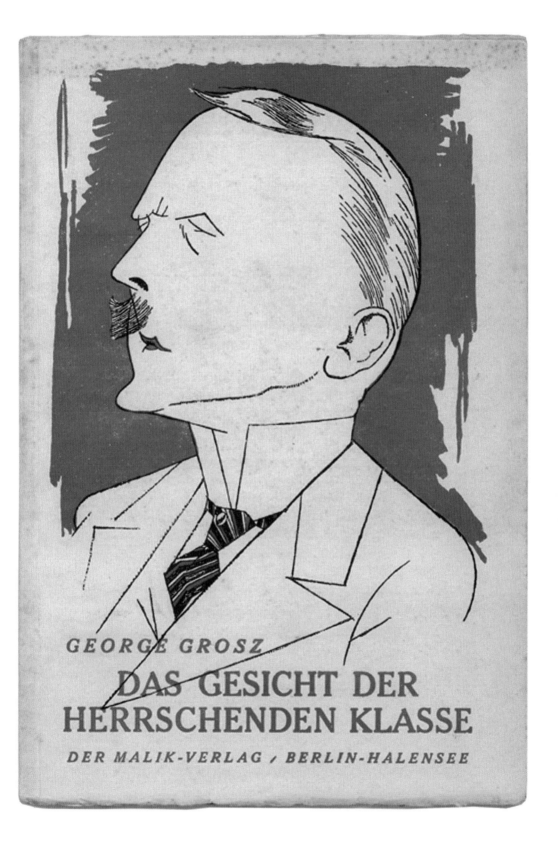

GEORGE GROSZ

DAS GESICHT DER
HERRSCHENDEN KLASSE

DER MALIK-VERLAG / BERLIN-HALENSEE

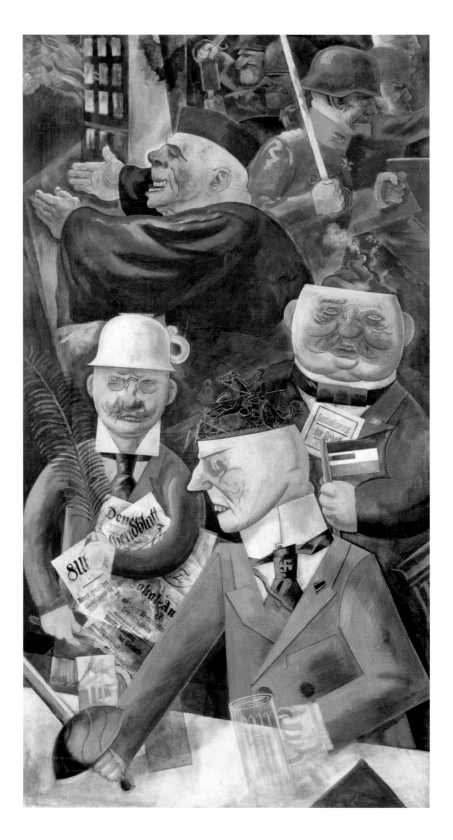

Opposite:
George Grosz, Pillars of Society, 1926.
Oil on canvas, 200 x 108 cm (78¾ x 42½
in.). Neue Nationalgalerie, Berlin.

Left:
George Grosz, The White General, 1922,
from Die Gezeichneten: 60 Blätter aus
15 Jahren. *Berlin: Malik-Verlag, 1930.*

Below:
George Grosz at his easel, 1930. Photograph by
Lotte Jacobi.

Grosz's characters are found on the streets, in brothels and in bars. He was exemplary as a caricaturist, but unlike the caricatures to be found in the pages of satirical magazines, his were not aimed at a particular person, or at a specific situation, but rather at the state of the world in general. Of course his figures are exaggerated, with ugly features that are designed to be repulsive, but they are meant to portray types, classified by physiognomy. Every detail of the neck, ears and eyes represents a character trait: rapacity, hypocrisy, betrayal. The ugliness of Grosz's menagerie is the antithesis of touched-up, cosmetic beauty. The repulsive appearance of his figures corresponds with the hideousness of the world in which they live; he is showing their faces as they really are, without any artistic beautification. In this respect his work is both documentary and photographic.

From the very beginning Grosz was one of those artists, like the Herzfelde brothers and the impresario of agitprop Erwin Piscator, who also expressed their political opinions outside the artistic sphere. He was a member of the Communist Party and chairman of the Rote Gruppe ('Red Group'), which had recruited its members from within the party and had established itself as a Communist artists' group. Grosz wanted people to see clearly how dissatisfied he was with the world around him.

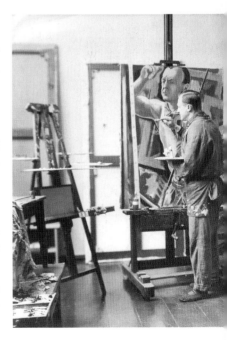

Right:
Max Beckmann, The Night, *1919. Oil on canvas,*
133 x 154 cm (52⅜ x 60⅝ in.). Kunstsammlung
Nordrhein-Westfalen, Düsseldorf.

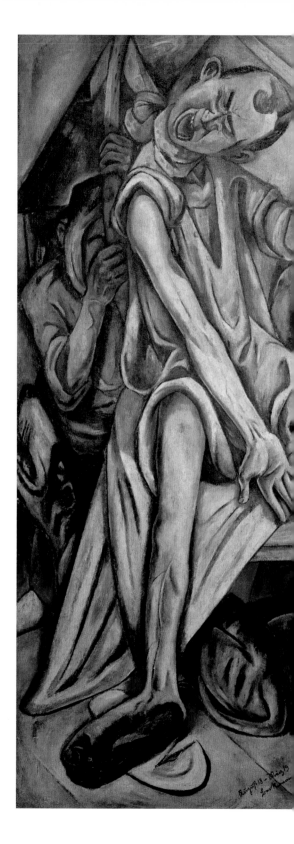

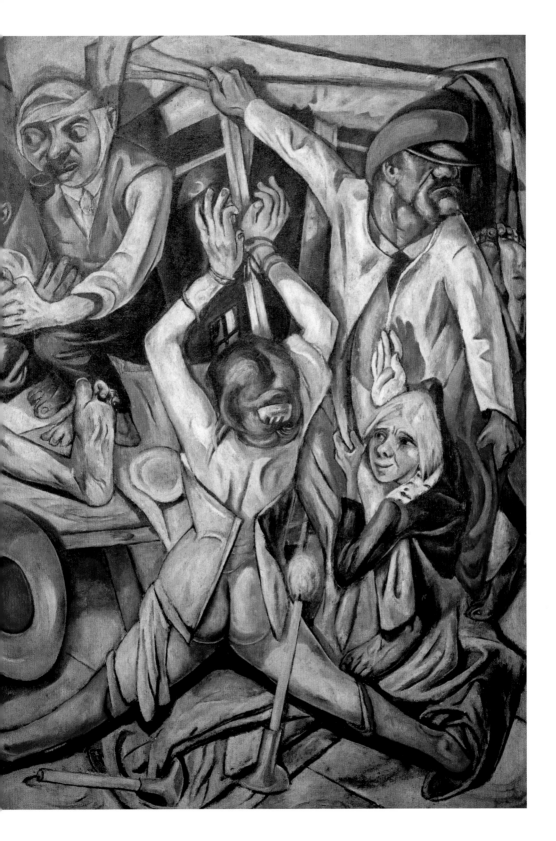

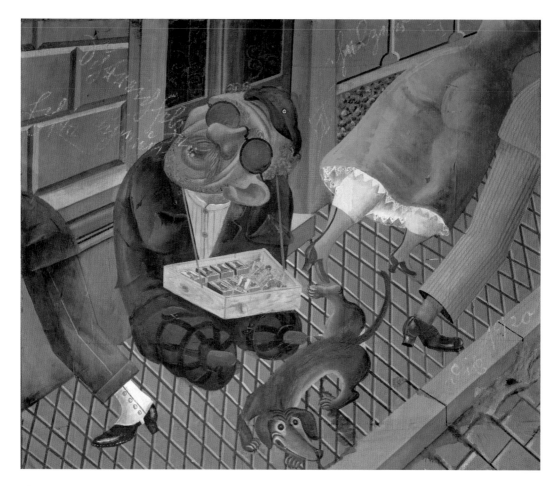

Grosz was not the only one to express such radical clarity in his pictures, of course; there were at least two others who worked in a similar vein from time to time, making significant contributions to art history. After the First World War, Max Beckmann experimented with reality in shocking scenes such as *The Night* (1919). This picture gives a brutal view of a room where everything has been flooded with grey. It shows a group of people torturing each other: limbs are twisted and faces distorted. What is most horrifying, however, is the strange air of normality about the sinister scene. The man in the centre has a bandaged head and is concentrating on twisting the arm of a pitiful figure who looks to be screaming out in pain. But the man in the centre, both victim and torturer, is interesting for another reason: he is puffing away contentedly on a pipe. Thus Beckmann makes something abnormal seem normal, as if this scene could be played out calmly every night.

Beckmann's background in Expressionism is evident, and *The Night* certainly gives the impression that he is laying it on thick

here. However, in the years immediately after the war, he was also a ruthless portraitist of a world turned upside down. Beckmann had been living in Berlin since 1904, but moved to Frankfurt at the beginning of the Twenties, where his style became progressively calmer. The darkness of a world perpetrating horrors transmutes into a shadowy, abstract kind of world, strangely enclosed, secretive and unapproachable.

Alongside Grosz, the other painter who best represented the realism of Berlin at that time was Otto Dix. Unlike Grosz, who plumbs the depths of the shadows by scrutinizing the hypocritical glare of daily life, Dix stares starkly into the abyss. *The Match Vendor I*, painted in 1920, is a pitiable character: clearly mutilated by the war, he is severely disabled, having lost his legs and arms, and, as if that were not enough, he is also blind. People rush past him heedlessly, for they are used to such pitiful figures. Only a dachshund takes notice of him, but only because he provides him with a place to stop and lift his leg. Dix comes from an Expressionist background, but his style also tends towards unusual clarity. Over the years he was to become a portrait painter, capturing actors and writers, Bohemians and entrepreneurs for future generations, for the sake of art. He did caricatures, but unlike Grosz he used the technique to portray individuals and their eccentricities. Dix makes characters out of contemporaries, whereas Grosz makes contemporaries out of characters.

Dix was also a member of the Rote Gruppe. This group of party artists was responsible for bringing together no fewer than 126 painters, sculptors and draughtsmen, with more than 500 works of art between them. They were all taken to Moscow, where the 'German Art Exhibition' opened in October 1924. The Dadaist Raoul Hausmann, in his usual impertinent manner, had once raved about

Below:
Otto Dix in his Berlin studio, 1927.
Photograph.

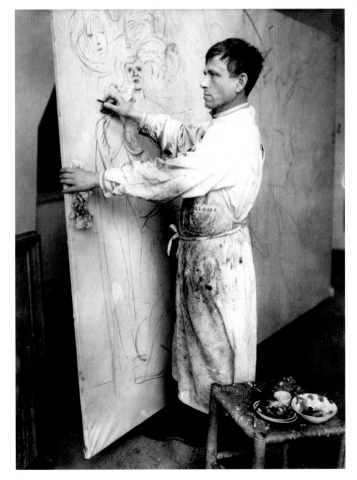

the 'Proktatur des Diletariats' (a play on words, along the lines of 'the proctatorship of the diletariat') which his movement (Dada) had been pushing for. Now German art found itself in a real, existing dictatorship of the proletariat.

The Soviet People's Commissar of Enlightenment, Anatoliy Lunacharsky, who was responsible for culture and education, did not want a repeat of the exhibition. He wrote: 'In his aversion to reality, the German Expressionist is often very difficult to understand. His drawings are smudged, his colours are gaudy but muddy, and his figures misty and symbolical. The paintings are meant to represent inner suffering, and the intellectual search for God, with a prophetic voice.'

Referring to Grosz and his group, Lunacharsky added: 'The German artists of the new "Verist" style, which aims to produce meaningful, propagandist art, handle this much more successfully. It is as if the reflection of the outer forms of reality change aspect in the artist's mirror, and take on the appearance of their inner meaning and content, and this appeals both to our reason and to our empathy. That is what gives them a huge power to agitate.'

With these words, Lunacharsky succeeded in capturing the true artistic impetus behind Grosz's work. He also alluded to the concept of 'Verism', which had come to describe this grasp of reality. Verism makes truth into an 'ism', into an agenda, a manifesto, an irrefutable movement. As was shown the following year in an exhibition in Mannheim, Verism came to embody the 'left wing' of representational painting, whilst the 'classicists' were to the right. The collective term for both groups became known as *Neue Sachlichkeit*, or New Objectivity.

In order to make the truth stand out, it is better not just to speak it but also to demonstrate it. Verism involved artistic endeavours that illustrated, revealed, taught and demonstrated. After the plastic arts, theatre possessed those dramaturgical qualities in the greatest quantity. The figurehead of the Verist theatre was Grosz's Party comrade and fellow member of the Rote Gruppe, Erwin Piscator. He came to Berlin in 1918 and is considered one of the most exemplary figures in the city during the Twenties: exemplary in his dedication to the Party, where his heart and, he believed, the truth lay; exemplary in his conviction that culture should be open to everyone, and that elitism should be eradicated; and exemplary in his belief that aesthetic progress belonged to the less gifted, a belief that had been rare in history. In 1920 he founded his Proletarian Theatre, underlining its ethos and function: 'Whatever is said must be said in a manner that is uncontrived, non-experimental, not

"expressionistic", not distorted; it should be determined by simple, straightforward revolutionary purpose and will.'

Like Lunacharsky, but four years ahead of him, he found Expressionism to be an adversary, and along with Grosz he believed that revolution would come by means of a clear and ruthless portrayal of reality. The Proletarian Theatre found its *raison d'être* in the genuine Marxist conviction that something taken as a 'given' could become a 'possible'; or, as Piscator put it, the 'Seienden' ('that which exists') could change into the 'Sein-Sollenden' ('that which should exist').

Piscator's theatre group performed in community halls and pubs, and in accordance with his principles both amateurs and professionals went on tour together. He would later go on to develop his concept of 'total theatre', using theatre in the round, sound effects, multimedia and simultaneous actions to draw actors and audience together in a pan-aesthetic, participatory experience. It was a complete artistic experience, designed to be meaningful and gripping, and it kept its roots firmly in the superficiality and fragility of reality. In his manifesto on the Proletarian Theatre, Piscator wrote that all formal stagecraft must be subordinate to the intention of producing 'performances that can inhabit the psyche of the masses; trivial forms that are clear and comprehensible to every man'. Consequently Piscator did not often stage the classics; nor did he opt for modern dramas. Instead, inspiration was drawn from the harsh realities of life, including the abortion law, and from current events such as the tenth anniversary of the KPD (German Communist Party), or the Parliamentary elections of 1924, which defined daily life. They became the subjects of the revue-style sequences of scenes saturated in realism and upholding the class struggle.

'What we call "art" serves to put feeling back into life; to feel things once again; to feel that a

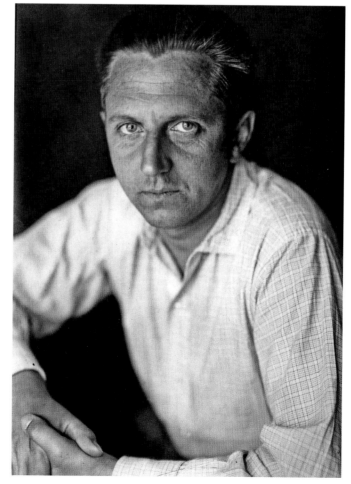

Below:
Erwin Piscator, c. 1920. Photograph.

Overleaf:
Erwin Piscator, Das politische Theater. *Cover design by László Moholy-Nagy. Berlin: Adalbert Schultz Verlag, 1929.*

ERWIN
PISCATOR
DAS
POLITISCH
THEATER

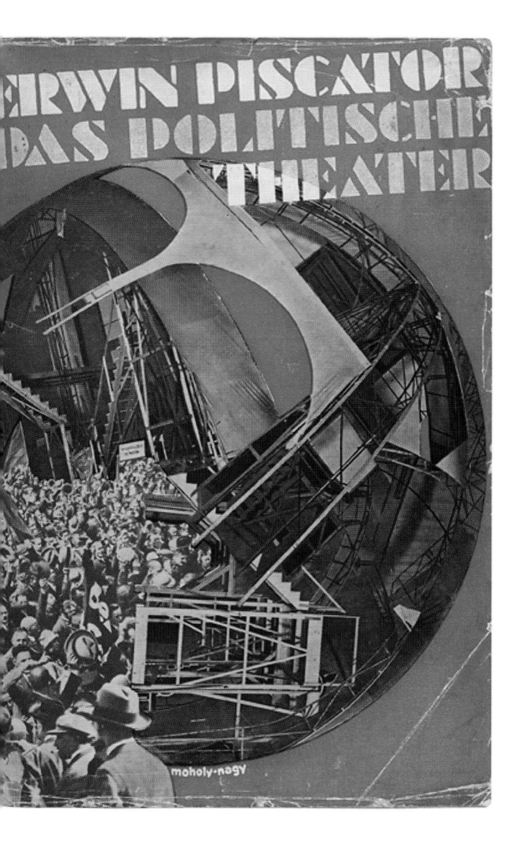

ERWIN PISCATOR
DAS POLITISCHE
THEATER

moholy-nagy

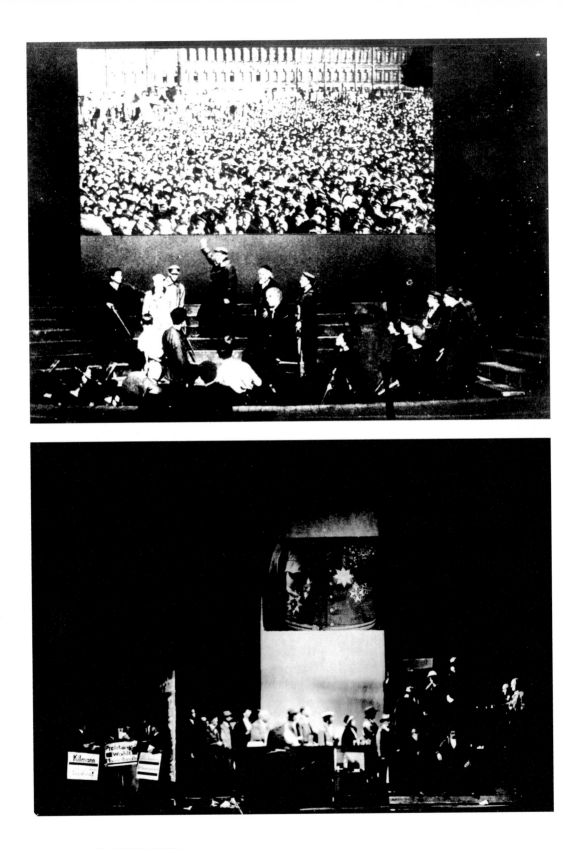

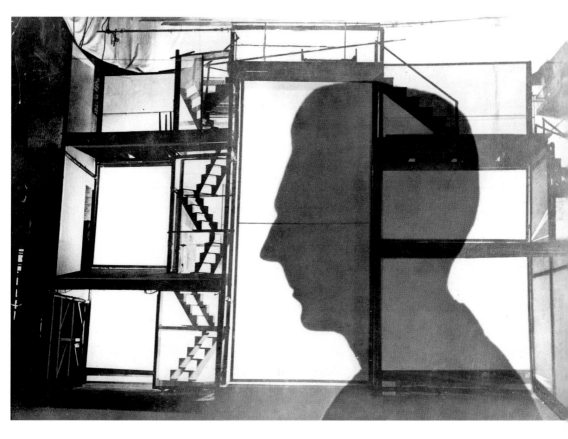

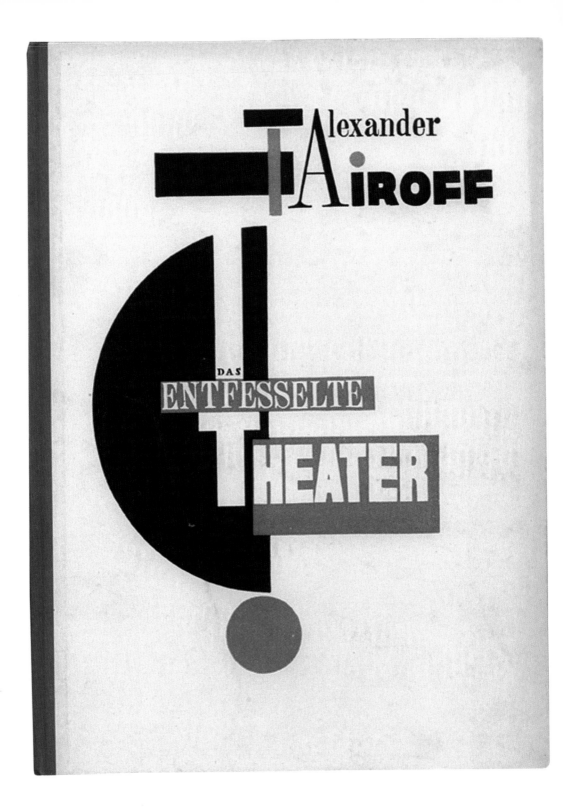

stone is stony. The aim of art is to awaken our sensitivity to things; to really see them and not merely to recognize them.' This quotation was written in 1917 by Viktor Shklovsky, the influential theorist of Russian Constructivism. In this text, *Art as Technique*, Shklovsky suggests how this heightened sensitivity can be achieved, this seeing rather than merely recognizing. He calls it 'defamiliarization', a technique that forces the audience to see familiar things in an unfamiliar light. Defamiliarization should involve a closer scrutiny of things, thereby robbing them of the familiarity with which they are usually viewed. It is a Verist technique because it aims to discover the truth behind routine and familiar forms.

In the book *Neue Sachlichkeit*, edited by Henri R. Paucker, it says: 'In order to defamiliarize an event or a character, all you need to do is to rob it of all familiarity, normality and revelation, and create instead amazement and curiosity.' This was the formula created by the man who is perhaps most readily associated with the 1920s theatre in Berlin: Bertolt Brecht. The extract comes from Brecht's 'Theory of Epic Theatre', which although not published until the Thirties, had formed the basis of his dramatic practice in the Twenties. His most successful play in Berlin was *The Threepenny Opera*, which he produced in 1928 in collaboration with the composer Kurt Weill. The piece was intended as 'an attempt at epic theatre'. With its use of alienation techniques, epic theatre is an offshoot of Verist theatre; it is a theatre of close scrutiny. Brecht continued: 'So what is achieved by all this? What is achieved is that the spectator does not see on the stage characters that are unalterable, insusceptible to influence and wedded to destiny. Instead, the

Opposite:
Alexander Tairoff, Das entfesselte Theater. *Cover design by El Lissitzky. Potsdam: Gustav Kiepenheuer Verlag, 1927.*

Below:
Bertolt Brecht in his Berlin apartment, 1927. Photograph.

Right:
Bertolt Brecht, In the Jungle of Cities,
a play about the struggle of two men in the
metropolis of Chicago. Cover design by Ernst
Aufseeser. Berlin: Propyläen Verlag, 1927.

Below:
Harald Paulsen in The Rise and Fall of
the City of Mahagonny *by Bertolt Brecht*
and Kurt Weill, staged at the Kurfürstendamm
Theatre, 1931. Photograph.

Opposite:
Bertolt Brecht, 1927. Photograph.

spectator sees that a character behaves as he does because of his circumstances, and that the circumstances are the way they are because of how the character is.'

Brecht's formula is entirely comprehensible on stage. Verism is the attempt to illustrate – visually, dramatically and through the spoken word – the relationship between a particular individual and the circumstances that surround him. Circumstances reveal the character, and vice versa. Such an art is primarily one of physiognomy. The drastic works of Verism may depict a rigid, inflexible and sinister world, but they also show the possibility of change, and in this way they are a form of propagandist art. This lies at the heart of their contemporary and disturbing appeal.

Above:
First performance of The Threepenny Opera *by Bertolt Brecht and Kurt Weill, staged at the Schiffbauerdamm Theatre, 1928. Photograph.*

Below:
Bertolt Brecht in his Berlin apartment, 1927. Photograph.

Opposite:
Scaffold scene with Harald Paulsen during the first performance of The Threepenny Opera *by Bertolt Brecht and Kurt Weill, Schiffbauerdamm Theatre, 1928. Photograph.*

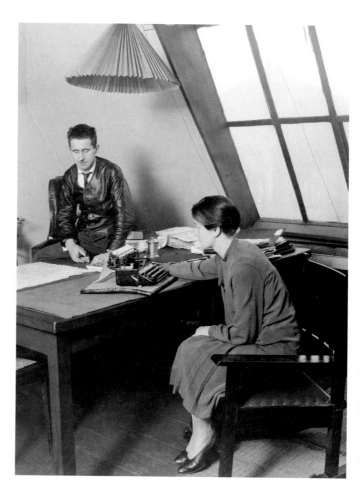

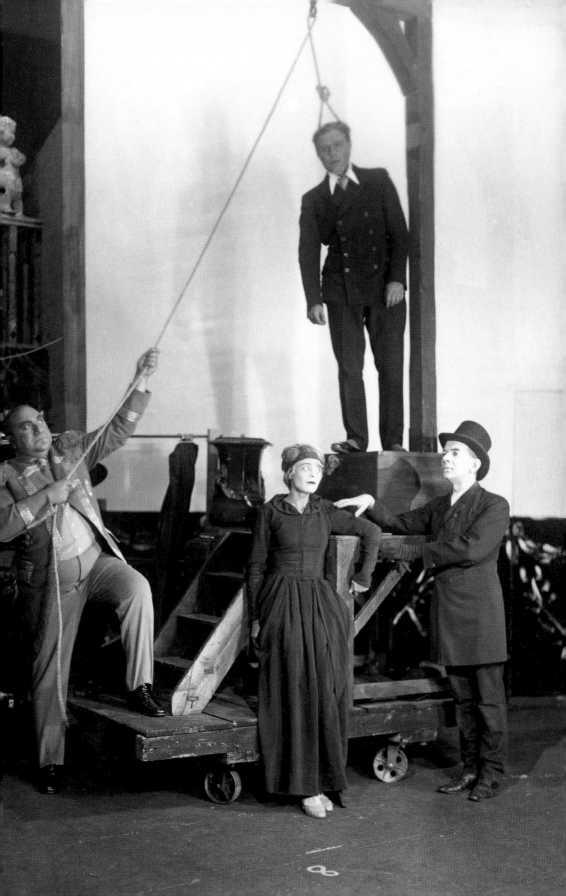

UNITY AND PURITY

CHAPTER 5
UNITY AND PURITY:
UTOPIAS, COLLECTIVES AND FUTURISMS

There were many different artistic endeavours in Berlin around 1923–24, pushing for revolution, stirring the spirit, warming the heart and making history, but if there is one text that encapsulates them, it is *Aufruf zur elementaren Kunst* ('Call to Elementary Art'). The text of the manifesto was written in the rousing language that embodied the irresistibility, the radicalism and the true spirit of the time. It was signed by Viennese-born Raoul Hausmann, Alsatian-born Hans Arp, Russian artist Ivan Puni and Hungarian painter and photographer László Moholy-Nagy. *Aufruf* therefore speaks volumes for the nature of the metropolis as a melting pot, and the role of the foreigner within this alloy. The manifesto was published in Berlin in 1921, but the foreword makes the breadth of its target readership quite clear: 'To the artists of the world!' It then continues in quintessential style: 'This manifesto is our call to action: we have been seized by the spirit of the times, and with our elementary art we proclaim our renewed vision, and our reawakened consciousness of the ever-bubbling sources of strength which define the spirit and the form of an epoch. They allow the art of the epoch to develop as something pure, something elemental in the individual, free from utility and free from beauty. We demand elemental art! We are against the reactionary in art!'

One of the characteristics of most manifestos written about the orthodox Modern is that one tends to be none the wiser by the end of them, and this is a particularly fine example. These days we feel inclined to agree with the passionate tirade, not only because the pathos and brilliance of these manifestos are quite palatable to us, but also because of the innate relevance of the concepts being upheld: action, movement, renewal, strength, sources, spirit, shape, purity, freedom, elements. We are not told what the action is to be, or the direction in which the movement is heading, or how this strength is to be harnessed.

It is reminiscent of Goethe's Faust, who right at the beginning of the Modern Times, is attempting to translate the Greek word *logos*, which appears in the New Testament, into German. He tries out one word after another – *Wort* ('word'), *Sinn* ('meaning'), *Kraft* ('power') and *Tat* ('action') – but remains dissatisfied with all of them. He has mislaid divine inspiration, and the concepts, which have been employed in order to explain the focus of all present hope and expectation, have become abstract. They go around in circles,

Opposite:
Fritz Kortner and Gerda Müller in
William Shakespeare's Macbeth,
Staatliches Schauspielhaus, 1922.
Photograph by Zander & Labisch.

waiting for someone to give them some logic. In the same way, the concepts in *Aufruf zur elementaren Kunst* are proudly displayed as empty shells, unoccupied spaces and unfinished formulas, which all signify one thing: that anyone who follows them will become filled with the dynamism that they exude. They do not point to a destination, but wherever the destination may be, it will be reached far more quickly with their assistance. That is the logic behind the orthodox Modern.

The signatures of the classical Modern style are unified under the banner of the 'elemental' in the *Aufruf* written by Hausmann and his colleagues. There is the impetus towards movement urged by the Futurists, the return to basic forms as proclaimed by the Purists, and the appeal for renewal, which is a constant theme amidst all the enthusiasm. Such a widespread mood of awakening can only be revolutionary, and so the final sentence of the *Aufruf* seems somewhat redundant. Indeed, the Modern considered itself to be revolutionary in its tireless efforts to move forwards. In the remarkable decade of the Twenties, that worked well. The Nazis then seized control of the relentless march forwards, organizing party conferences that were nothing more than parades masquerading as 'movements', and it was Nazism that perverted this vigour. The Nazis were to adopt the words of Richard Wagner: 'To be German means to do something for its own sake.' They were to cash in on the idea of self-definition, which the Isms had so taken to heart, as long as it remained an aesthetic idea. Once Isms migrate into politics, then suddenly revolutionaries become synonymous with reactionaries.

But things had not yet gone that far in 1920s Berlin, and despite the difficult realities of unstable, radical right-wing activity in society, and galloping inflation in the economy, there was still a naive belief that things would get better – if not for the whole world, then at least in the sphere for which art felt itself to be responsible. The image of a better world is evoked in the elementary, in purity and in all the arts working together. It is not surprising that this did not actually manifest itself in the real Berlin, but only somewhere in the Neverland, a non-place best described by the Greek word 'utopia'.

On 12 December 1919 the curtain went up on the premiere of Friedrich Schiller's *William Tell*. The stage was bare apart from a flight of green stairs. The stage set, designed by the artistic director Leopold Jessner, caused a scandal in the theatre world. Those who upheld truth, goodness and beauty thundered on about the denigration of a classic; the advocates of the New thought otherwise. In Jessner's interpretation, the story of a Swiss national hero, written by a German national hero, with the famous actor Albert Bassermann in the title role and Fritz Kortner as Gessler, under-

went something akin to a process of democratization. The sacro-sanct text was treated as canonical, and liberated from any cosy or chauvinistic elements. Jessner had instigated a rite of purification, and that also applied to the stage set. The abstract and immediate set, consisting of the famous green stairs in front of a mono-chrome, black background, served as the backdrop to every scene; it was scenery and props, the empty street and place of execution, the place for all action, both central and peripheral. It was nowhere and everywhere at the same time.

The flight of stairs, which became known as the 'Jessner Steps', and was repeated in many different variations on the stage, brought the idea of Purism right before the eye of the public; the Purism that had developed out of the avant-garde, and which affiliated itself organically with the political Left. The reactionaries had recognized this instinctively, giving equal importance to the political alignment of the stage direction and to the sparseness of the decor.

In addition to the theatre, there was another art form that could express the utopian Neverland, and that of course was architecture, which since time immemorial has been inextricably linked with the idea of place. Architecture produced the most eye-catching manifes-

Above:
The 'Jessner Steps', part of the set for Schiller's William Tell, *Staatliches Schauspielhaus, 1919. Photograph by Rudolf Hatzold.*

Opposite:
Albert Bassermann in the title role of William Tell, *Staatliches Schauspielhaus, 1919.*
Photograph.

Above:
The Rütli scene in William Tell, *Staatliches Schauspielhaus, 1919. Photograph by*
Zander & Labisch.

Above:
Stage set by Emil Pirchan for Franz Schreker's
Der Schatzgräber, *Berlin Staatsoper, 1922.*
Photograph.

Centre:
Scene from Gerhart Hauptmann's Der weisse
Heiland, *Großes Schauspielhaus, 1920.*
Photograph.

Below:
Stage set by Emil Pirchan for William
Shakespeare's Othello, *Großes Schauspielhaus,*
1921. Photograph.

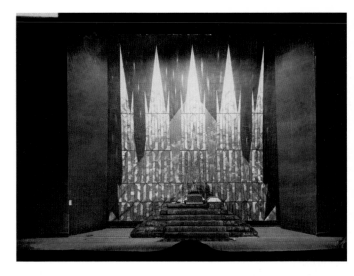

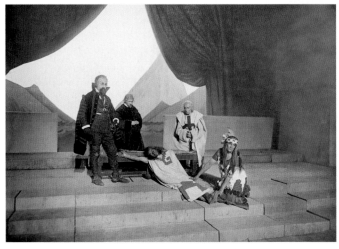

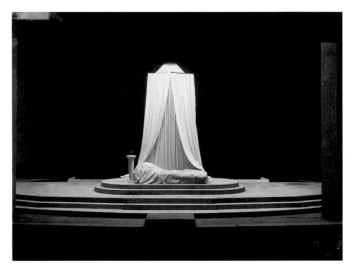

tations of an unshakeably idealistic optimism, brimming with audacity and unfeasibility. In the autumn of 1918, a parallel organization to the Novembergruppe had been formed by architects, known as the Arbeitsrat für Kunst ('Work Council for Art'), and it had been founded along the lines of the Soviet principle of trade institutions. The group published its own *Architekturprogramm*, declaring that there should be a collective work of art, and that it should be the result of the efforts of 'the people'. Bruno Taut was the spokesman for the Arbeitsrat für Kunst. The programme had been the brainchild of Paul Scheerbart, a self-styled 'poet of architecture', and a bizarre Expressionist who had died as early as 1915. Scheerbart had played a central role in the 1914 Werkbund Exposition in Cologne, at the time when Taut was realizing his magical dream of a 'house made of glass', and he published over a hundred theses on glass architecture. For Scheerbart, the solution seemed close at hand: 'Through as many

walls as possible, made entirely of glass – from coloured glass…then we would have paradise on earth, and would not have to look longingly up to heaven for it.'

So much for the redemption of the earthly – in the chaotic times of the Revolution, people were not going to take such simple solutions literally. But Taut and his fellow activists Walter Gropius, Erich Mendelsohn and Hermann Finsterlin liked the idea of creating a crystal world, of establishing the 'crown of the city' as Taut put it. 'First of all, this construction will require a spiritual revolution,' he predicts in the *Architekturprogramm*. It was intended as 'the first attempt to unify the people and the artists; the development of a new culture.' It was only to be expected that this interplay of ideas, fluctuating between the grotesque and the grandiose, would really cause a stir.

Soon the architects lapsed into a kind of network, in which they corresponded with each other by letter, sharing their ideas about ideal constructions, and humouring each other whilst remaining

Above:
Bruno Taut, c. 1925. *Photograph.*

Right:
Bruno Taut, Alpine Architecture, *sheet no. 10, 1919. Colour lithograph, 39.3 x 32 cm (15½ x 12⅝ in.).*

Opposite:
Workers' Council for Art: 'A Call to Building'. Cover design by Bruno Taut. Berlin: Ernst Wasmuth Verlag, 1920.

Opposite:
*Skyscraper design by Ludwig Mies van
der Rohe, at Friedrichstraße station, c. 1921.
Photomontage.*

locked in their ivory towers of autonomy. The group called itself Die Gläserne Kette ('The Glass Chain'), and continued to write architectural history until the day that 'Glass' (alias Taut), 'Mass' (alias Gropius) and 'Prometheus' (alias Finsterlin) managed to find their way out of the crystal prisons of their lofty aspirations. For the time being, they had created exalted visions of what a revolution could achieve, were it to take place somewhere over the rainbow. But the impracticability and seeming impossibility of these glass ideas were not to be the last words on the subject: these soaring aspirations in due course became reality, in four different respects.

Firstly, a time was to come when these bold conceptions of construction were actually built. Perhaps the best example is Ludwig Mies van der Rohe's design for an office block in Berlin's Friedrichstraße, which was conceived in 1921. Showing his inclination towards the simple solution, he combined the theory of glass architecture with the shape of the available plot of land in the centre of Berlin – a triangle. His solution was a prism constructed entirely of glass and steel: transparent, futuristic and highly practical in terms of material and attractiveness. His own design was to remain a model, but it formed the basis for future ideas, particularly in the United States after the war. It came with the price that by that stage it was no longer accompanied by a dream of a better world: the inexorable truth is that utopias disintegrate when they are implemented.

Secondly, the perfectionist idyll fulfilled its duty in that it was eventually transformed into an institution. In 1919 Walter Gropius, a member of the Arbeitsrat für Kunst, and correspondent of Die Gläserne Kette, became the founder member of the Bauhaus. This world-famous school was not directly linked with Berlin, but due to its pre-eminence and the involvement of its teachers in the life of the metropolis, it maintained strong connections with the city. The Bauhaus started off in Weimar, moved to Dessau in 1925 (where Gropius built its distinctive headquarters), and then in October 1932 moved to Berlin, albeit for the last few months of its existence. It was disbanded in 1933 on Nazi orders. The caesura that defined the Twenties is markedly present in the Bauhaus's concept and execution of design: up until 1923 the school remained sympathetic to the rapturous ideas of those who wanted to change the world; it was committed to handcrafts, and upheld the esoteric philosophy of the Swiss teacher Johannes Itten, who taught the preliminary course and initiated the novices in the harmony of colour and composition. In 1923 Itten was replaced by the thoroughly rational, bold Constructivist Moholy-Nagy, and from that moment on industry played a greater role in the work of the school. Models for an improved

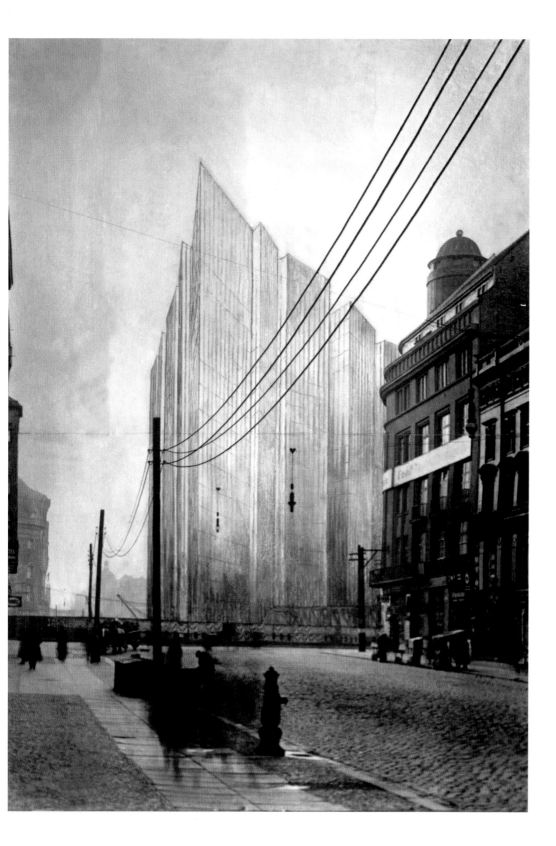

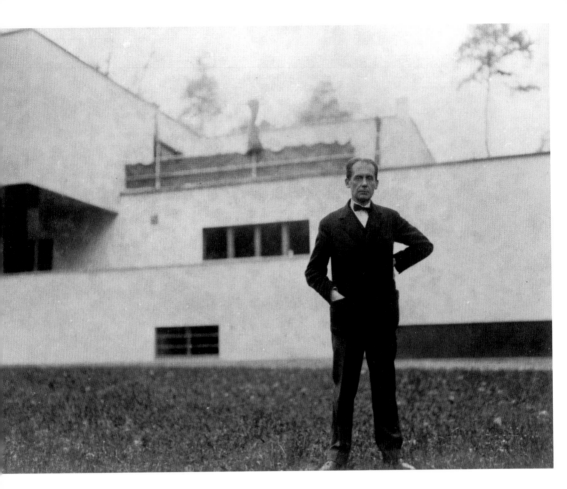

world were replaced by prototypes for machine manufacture; the Bauhaus developed its distinctive style, which became known all over the world.

An example of the changing climate during 1923 is to be found in Oskar Schlemmer's inadvertent faux-pas. He contributed a passage to the publicity brochure for the first Bauhaus exhibition, which was held between July and September in that year, using the ambitious, elevated language typical of the Expressionists: 'The Bauhaus movement, founded after the catastrophe of the war, in the chaos of revolution and the golden age of expressive, explosive art, is set to draw together all those who believe in the future, all those unshakeable idealists who want to build the cathedral of socialism.' The loyal metaphor of 'the cathedral of socialism' was no longer to the taste of those who were seeking a new concept. Gropius, who two years earlier had been in unconditional agreement with such ideas, immediately tried to have the brochures pulped, but some of these *corpora delicti* survived, thereby shifting the emphasis from what

Above:
Erwin Piscator's apartment, desk and bookshelves, 1928. Photograph by Lotte Jacobi.

Below:
Erwin Piscator's apartment, 1928. Photograph by Sasha Stone.

Overleaf:
Bauhaus design for a Berlin apartment, c. 1930. Photograph by Lotte Jacobi.

had been a simple work ethic to a definite expression of intent, declaring that the revolutionary formation of objects would need to go hand in hand with the revolutionary formation of society.

The third legacy of the utopian designs was that they now started to become part of mainstream society, without losing their distinctive quality of concern for the future of socialism. The spectacular, flowing and unconventional lines of utopian architecture still gave the visual thrill with which capitalism was so obsessed. When Erich Mendelsohn designed a building for the Mosse newspaper group, or Hans Poelzig conceived the new theatre for Max Reinhardt, they were carrying out commissions for people who already had a high profile in society. This is also true of the observatory that Mendelsohn built in 1921, which became known as the Einstein Tower. This cheerful concrete sculpture, a rampant, swelling expanse of curves and lines, like a living organism, was what later became known as a 'signature building' – a building whose architectural character combines both pride in a new style of building, the scientific institute, and a philosophical conviction of the importance of

progress. Albert Einstein, the world-famous genius of the century, had come to Berlin, and the tower that was dedicated to him was like an index finger pointing in acknowledgment.

Fourthly, the enthusiasm for 'the people', who would help to build the new world, led to a new concept of building that has remained central to architecture ever since: the apartment block. Its aim was to provide accommodation for the many people who had been mouldering away in cramped, damp, impersonal conditions, having had to share their living space with others, or for those who had no roof over their heads, having spent their last pennies on their children. Necessity was the mother of invention, and within a short time social constructions, social settlements and social districts sprang up, with the financial backing of Berlin's coffers, committed to the socialization of the aesthetic. Again it was Taut, Gropius and Mendelsohn who were at the forefront of this work.

Architecture is the art of compromise, building a reality out of hopes conceded. It is fitting that this chapter about great projects – or rather, the great ideas behind projects – which came from autonomous minds, freed from rules and accountability, should close with a mention of a particular project that once again involved all the different artistic registers. The peak of utopianism, collectivism and futurism in Berlin during the Twenties was represented by one film: *Metropolis*. This film, directed by Fritz Lang and produced

Opposite:
Hans Poelzig, 1927. Photograph by Alexander Binder.

Below:
Britz settlement in Berlin, at the intersection between Parchimer Allee and Dörchläuchingstraße, 1926–27. Designed by Bruno Taut for the private sector housing companies GEHAG and DEGEWO, 1927. Photograph.

Overleaf, left:
Erich Mendelsohn, 1931. Photograph.

Overleaf, right:
Rudolf Mosse on the corner of Jerusalemer Straße and Schützenstraße (enlarged and renovated by Erich Mendelsohn between 1921 and 1923), 1933. Photograph.

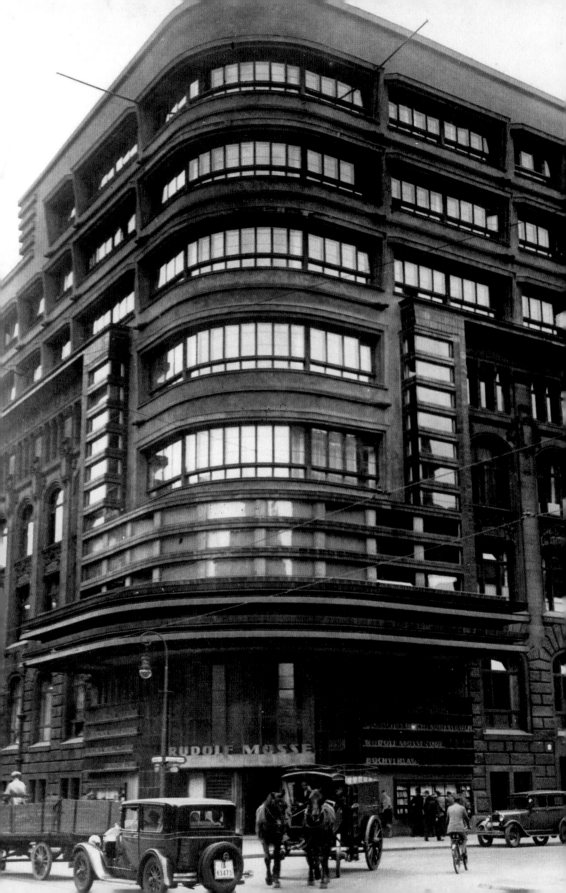

Opposite:
The Einstein Tower at Potsdam: Harald von Klüber at the telescope, 1928. Photograph by Sasha Stone.

Above:
Albert Einstein conducting a dictation in his Berlin loft apartment, c. 1930. Photograph.

Left:
The Einstein Tower: part of the coelostat, 1928. Photograph by Sasha Stone.

Overleaf:
Albert Einstein at the Einstein Tower in 1921, built to designs by Erich Mendelsohn, 1919–21. Photograph.

UNITY AND PURITY

Above:
Fritz Lang, c. 1925. Photograph.

Opposite:
Fritz Lang directing Metropolis, *1926.*
Photograph.

by Erich Kettelhut, was the brainchild of Thea von Harbou. With great hubris it seized the opportunity to portray a parallel world: a para-, meta-, hyper-reality in which the laws of civilization disintegrate in one hysterical moment, and madness and lust are unleashed in full force.

Metropolis is a pioneer of self-definition. It plunges the viewer into a world of mechanical rotation of machines, men and mutants; a world of silent, uniform, anonymous columns of slowly shuffling workers; and at the same time into the narcissistic world of the *jeunesse dorée*, amusing themselves with sport competitions. It is a relentless flow of motor functions, and yet each person is completely wrapped up in themselves. The film depicts the 'salaried masses', as Siegfried Kracauer described it in 1927, the year of the film's premiere: an obsession with pattern and rapport triggered by a fever of order.

Metropolis really came along two years too late, for it spoke the language of Expressionism: the overwrought plot, the exalted succession of scenes, always over-stressed regardless of pace, the at times unbearable sentimentality of relationships, whether male–female or father–son, and above all the eschatological mood in which no disaster or redemptive figure is omitted, and which calls for the rebirth of civilization in a classless harmony. *Metropolis* is not a film about the city of Berlin in the Twenties; rather, it is a film about ideas and ideals. It is Taut's glittering crown flirting with the apocalyptic; finally the utopias have run themselves into the ground. *Metropolis* shows a towering stone construction, stretching endlessly up and down, limitless expanses of busy streets and busy skies which cannot be captured in a picture: a self-defining colossus. The one constant throughout this megalomaniacal, inhospitable scenario is the hierarchy amongst the inhabitants. The workers remain below, and the bosses remain above; even the much-heralded marriage of a girl from Hades to a boy from Olympia cannot change this.

What remains of the spirit of world improvement, which was so close to the heart of Die Gläserne Kette, is the calculation of the dramatic; spectacle for the sake of spectacle. *Metropolis* reached that zenith considerably late in the day, for by 1927 an entirely different aesthetic was well under way.

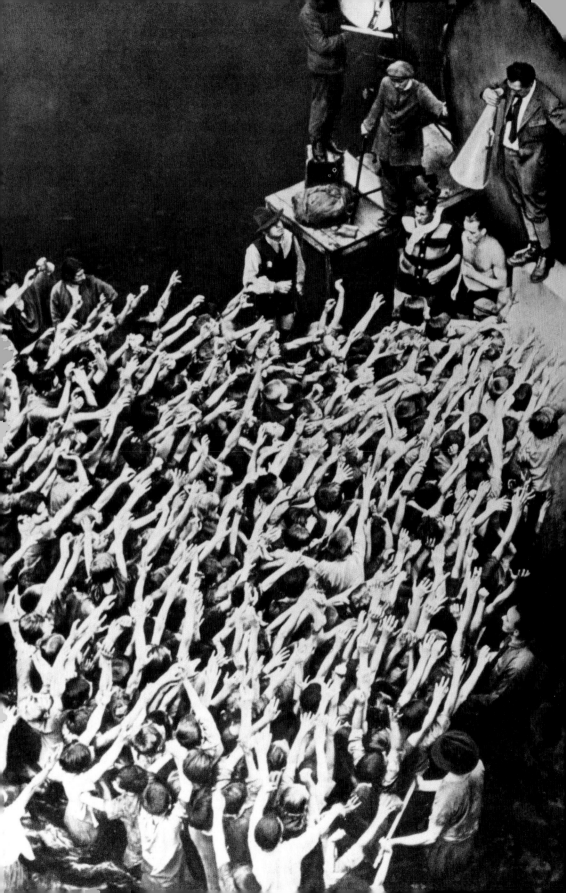

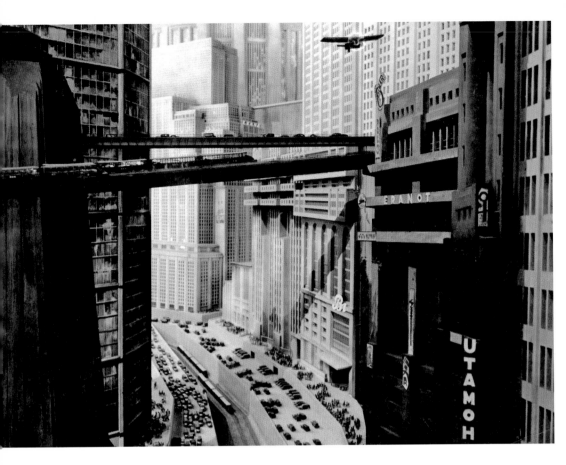

Above:
Scene from Metropolis, *'Futuristic Road'*,
1926. Photograph.

Below:
Brigitte Helm and Heinrich George in
Metropolis, *'Is the witch to be burnt?', 1926.*
Photograph.

Opposite:
Metropolis *special edition. Cover design by*
Werner Graul. Berlin: Ufa, 1927.

Below:
Brigitte Helm as Maria in Metropolis,
1926. Photograph.

Opposite:
Brigitte Helm in Metropolis, *1926.*
Photograph.

CHAPTER 6
METROPOLIS OF THE MODERN:
DETACHMENT AND INDIFFERENCE

The boorish poet: the man brought to life on the canvas has very little of the writer about him. His torso is bare, he is slightly over-weight, and he looks mistrustful. He is situated in an elevated position, but instead of riding on the wings of Pegasus, he seems to have been borne aloft by some kind of crane. He sits in the lofty heights, displaying his tattoos as proof of his many travels. The largest ones appear to be from East Asia, from America, and from the ships that have taken him around the world. The man is indeed a writer, but from his appearance it is clear that he is not one with a penchant for lyricism. His tattoos speak volumes, for he is a reporter, which in the Twenties was not incompatible with being a belletristic writer. He is the quintessential reporter, *The Raging Reporter* – the title he chose for his collection of works published in 1924, which along with *Hetzjagd durch die Zeit* ('Race through Time') made him famous. He is Egon Erwin Kisch, who was born in Prague in 1885, lived in Berlin from 1921, was a member of the German Communist Party and a figurehead for the metropolitan view of the world, which encompassed elements of both high culture and subculture. Kisch tended to see the world from the bottom rather than the top, and so his elevated position in the portrait seems inappropriate.

However, the painter of this portrait, Christian Schad, was in the habit of adding his backgrounds later, and it is not as if Kisch looks like some young whippersnapper from the higher echelons. Instead, he resembles a builder constructing a new reality of tower blocks and steel architecture. Schad was born in 1894 in Miesbach, Bavaria, and had been living in Vienna until he too felt the magnetic pull of Berlin in 1928, the year he painted Kisch's portrait. That same year Max Schmeling took on Franz Diener in the German heavyweight boxing championship in the Palace of Sport. The programme for the championship contained an essay by Kisch, along with contributions by the director Leopold Jessner, the composer Friedrich Hollaender, who was later to compose a song for Marlene Dietrich, 'Ich bin von Kopf bis Fuss auf Liebe eingestellt' (which became 'Falling in Love Again' in its English version), Kurt Pinthus, editor of *Menschheitsdämmerung*, Carl Zuckmayer, and Herbert Ihering who, along with Alfred Kerr, was the fiercest theatre critic of the Weimar period. All these literary heroes were writing for a sports event: nothing perhaps typifies the intermingling of elite reflections and the excitement of the masses in Berlin better than this strange coin-

Opposite:
Christian Schad, Egon Erwin Kisch, 1928. Oil on canvas, 90 x 61 cm (35⅜ x 24 in.). Kunsthalle, Hamburg.

Above:
Egon Erwin Kisch, The Raging Reporter. Anonymous cover designer. Berlin: Erich Reiss Verlag, 1924.

Right:
Max Schmeling with his manager Arthur Bülow, after defeating Franz Diener at the German boxing championships in Berlin, 4 April 1928. Photograph.

Opposite:
Max Schmeling, c. 1930. Photograph.

cidence. It was like an early or premature form of what would later become known as Pop Art – the concept of mass popular urban culture as the vernacular culture shared by all, irrespective of professional skills – and it was Berlin's very individual contribution to the cultural history of the world.

Schad has tried to keep his portrait free from turbulence and from hubris. Kisch has been depicted completely relaxed and still, like a tree, and this gives an overall sense of nonchalance and calm. The frenzy that was in vogue in Expressionism has been eradicated, along with the exaggeration that tended towards caricature, which was so beloved of Grosz and Dix. In their portraits of the literary critic and occasional poet Max Herrmann-Neiße, both artists portray his physical deformity in a grotesque style. Christian Schad's portrait of Egon Erwin Kisch is a perfect example of the style that, in 1925, became known as the New Objectivity, which blazed a new aesthetic trail. It began in 1924, coinciding with a greater calm in the economic and social situation following the introduction of the *Rentenmark* (an intermediate currency) to avoid

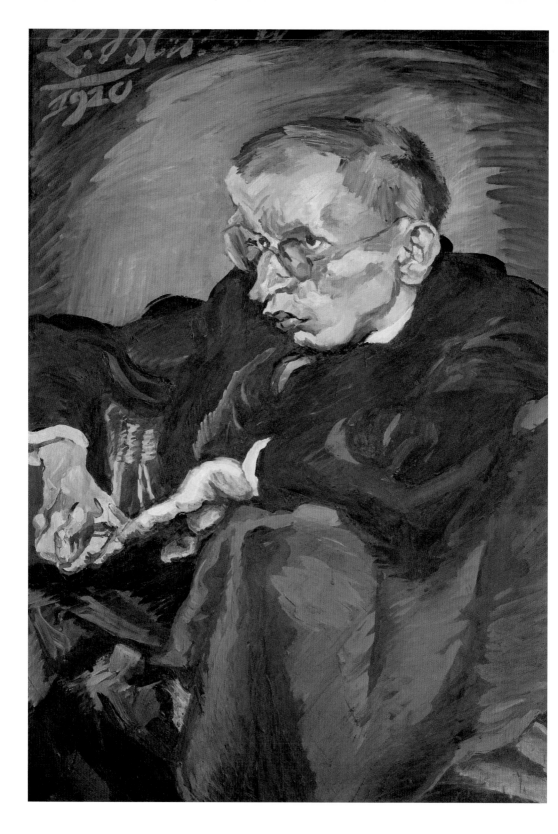

Opposite:
Ludwig Meidner, Portrait of the Writer
Max Herrmann-Neiße, *1920. Oil on
card, 101 x 72 cm (39¾ x 28⅜ in.).
Städtische Kunstsammlung, Darmstadt.*

Above:
George Grosz, Portrait of the Writer Max
Herrmann-Neiße, *1925. Oil on canvas,
100 x 101 cm (39⅜ x 39¾ in.). Kunsthalle,
Mannheim.*

inflation, along with the financial aid provided by the American Dawes-Plan and the authoritative actions of the key figure in politics, Gustav Stresemann. It was the beginning of the 'Golden Twenties', a period that was glittering enough in its own right but, when compared to what went before it and what came afterwards, took on an almost mythical aura. As times became calmer, so mentalities became cooler, and this clearly was not solely because of foreign and domestic policy. The change reflected the nature of the capital city, which was urban, smart and metropolitan. Berlin's culture was now at an international level.

In 1925 the art critic Franz Roh mounted an exhibition that marked the transition from Expressionism, which had been dominant until then, to post-Expressionism, which seemed to be the new direction. 'Ecstatic objects' had become 'sober objects', and so the list of comparisons continued: 'rhythmic' to 'representative', 'exciting' to 'deeply moving', 'dissolute' to 'strict, puritanical', 'dynamic' to 'static', 'monumental' to 'miniature', 'roughening' to 'smoothing', 'unhewn rock' to 'polished metal', 'expressive deformation' to 'harmonious cleansing', and lastly, 'elemental' to 'cultivated'. Roh's comparisons were made with reference to painting, but the polarity between 'elemental' and 'cultivated' particularly characterizes the entire world of art and culture in Berlin.

During the post-war years in Berlin, the gazes of all dance-lovers were firmly fixed upon the movements, the poise and the energy of Mary Wigman. Born in Hanover, she had been christened Marie Wiegmann, and her Expressionist dancing had earned her the status of a star. She was used by Max Reinhardt, and in her 'expression dance' she brought elemental passions and existential feelings onto the stage. Sometimes she renounced music altogether, using an occasional percussion instrument, because she was able to rely on her instinctive, profound body language alone to find an outward expression for inner emotions. Every muscle fibre communicated what she wanted to say.

In the mid-Twenties, Wigman's deeply expressive level of physical language met its match in a widespread taste for the superficial. The fashionable dances such as the Charleston, the shimmy and the foxtrot became hugely popular. There was a strong desire to lose oneself in the rhythm, and to let one's body react to the syncopation and feelings engendered by the beat. Internal prompting had given way to an exuberance that was a combination of circumstance and coincidence. This newly unleashed power was personified by the dancer Valeska Gert, who was six years younger than Mary Wigman; she brought reality onto the stage by portraying women of the

S'Ora
BENDA

street, whom no one would ever have bothered to ask about the state of their inner being.

The shift in emphasis can be described by means of a simple concept: world war versus world city. At one time the focus had been on the domestic qualities of people pulling together at home and camaraderie in battle; on authenticity and simplicity, on a sense of place and belonging to a clan. They had been replaced by the qualities of the urban lifestyle: a blasé attitude, a sense of being driven, and of being absorbed in a thousand different impressions. The spectacular had become sought-after, at the expense of authenticity; pathos, emphasis and tension had given way to an indifferent coolness towards everything. The wartime culture was a rebellion against

Preceding pages:
Scene from the ballet mime Der Weg *by Mary Wigman, c. 1930. Photograph.*

Above:
Dancer and actress Valeska Gert, 1930. Photograph by Lotte Jacobi.

Right:
Valeska Gert in mime, c. 1925. Photograph.

Opposite:
Poster for a cabaret-dance production with Valeska Gert, in the auditorium of the College of Music, Berlin.

Overleaf, left:
Ballroom dancing, 1926. Photograph.

Overleaf, right:
Käthe Rathaus and Riccardo de Lucca dancing the Charleston, 1926. Photograph by Alexander Binder.

Binder

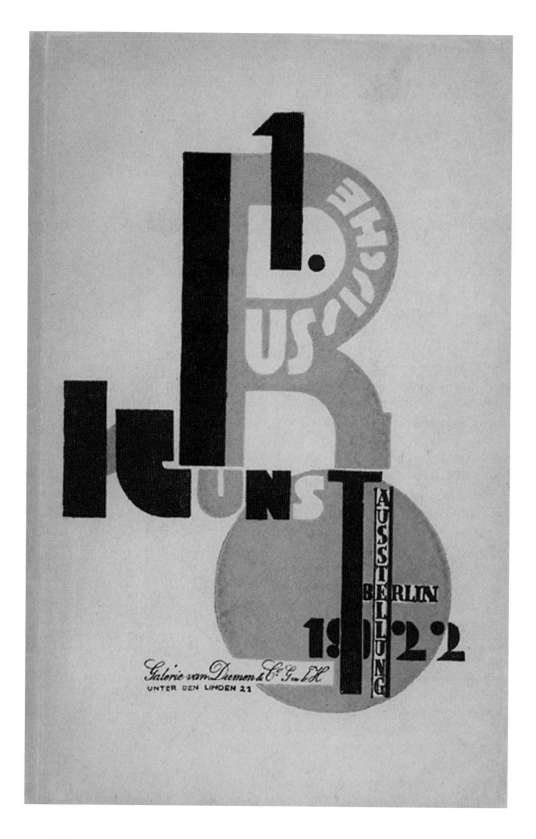

two of many. Without the many people who moved to Berlin out of choice or out of necessity (fleeing Bolshevism, for example), Berlin would have been robbed of some of its diversity. Berlin was first and foremost a whirlpool, a centrifugal force that was capable of attracting people and objects and spinning them until their own originality was wrung out of them.

The Russians Kasimir Malevich, Marc Chagall, Naum Gabo and Antoine Pevsner and the Hungarians Moholy-Nagy and László Péri raised the standard of the plastic arts to a world-class level. Lissitzky and Ilya Ehrenburg published a magazine in three different languages, *Vesc* in Russian, *Objet* in French and *Gegenstand* in German (all meaning 'Object'). Dutch painter Theo van Doesburg swore his allegiance to primary colours.

A new chapter opened on the music scene. No other city at the time had three opera houses, and the Vienna school of Neutoner (avant-garde composition) was active in Berlin: Arnold Schönberg taught composition at the Academy of Music from 1924, Alban Berg celebrated his greatest success with the premiere of *Wozzeck* towards the end of 1925, and Hanns Eisler had a road-to-Damascus experience there, and changed his style from esoteric twelve-tone compositions to popular works for the mainstream stage.

One distinguishing feature of a metropolis is that not only does each artistic discipline have its own enterprises, experts and institutions, but there are many such institutions. There is a competitive climate in which a sensorium is created for every nuance of artistic expression, and the smallest supply of a particular cultural sensation finds the requisite amount of demand for it.

On 2 October 1930 Count Harry Kessler was invited by the Prussian government to a banquet in Berlin Castle. The baroque exuberance of the Hohenzollern castle sat uneasily with him, for he was clearly proud of the achievements of his era. In his diary entry for that day, he sings the praises of Modernity: 'We have, and it is almost a miracle, in the dozen years since the revolution produced a new sort of beauty, including a younger generation better built and looking than that of pre-war days. But this new world must not be brought into contact with the old baroque one, else an intolerable clash occurs. Never before have I had it so vividly impressed on me that the former epoch is dead and done with.' This note of praise sounds too good to be true, and indeed it was not long before it became clear that the changes were not irrevocable. The modern outlook had not kept pace with the mindset of Modernity. Many contemporaries wanted to return to the nirvana of simple solutions. The 'Golden Twenties' were an application.

Opposite:
Galerie van Diemen & Co, 'First Russian Art Exhibition'. Cover design by El Lissitzky. Berlin: Verlag Internationale Arbeiterhilfe, 1922.

Below:
Arnold Schönberg, c. 1930. Photograph.

Overleaf, left:
The composer Hanns Eisler (standing, left), Bertolt Brecht (seated) and director Slatan Dudow discussing the direction of the film To Whom Does the World Belong?, *1932. Photograph.*

Overleaf, right: From left to right, Erich Kleiber, Alban Berg and Leo Schützendorfer before the premiere of Berg's Wozzeck *at the Staatsoper in Berlin, 1925. Photograph.*

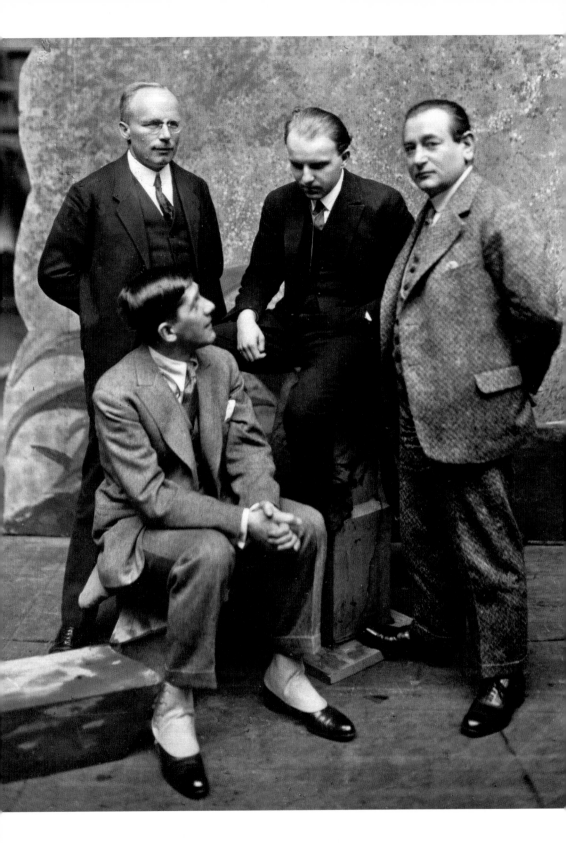

The following chapters chart the Modernity of Berlin during its finest years, in three different sections. The first will look at the importance of the superficial: in paintings and novels, amongst dancers in ballrooms, on stage in the revues, in the brightness of the illuminated streets, in the milieu of the courtyards, on the big screen, and in glittering gowns and slicked-back hairstyles. The second will address the attempt that was made to illustrate the truth beneath the surface, and how central this was to the desire – so typical of Berlin – to find memorable moments amid the amnesia, although these traces were shortly to be erased by the events that followed. The third will look at the lasting value of all that was achieved in Berlin in the second half of the Twenties, at that blissful moment of reconciliation between the culture of the elite and the culture of the masses. In other words, Berlin at its zenith.

Opposite:
Ernst Krenek (centre) with chorus master Ernst Zulauf, director Paul Bekker and librettist Oskar Kokoschka (seated), at a rehearsal for Krenek's opera Orpheus and Eurydice, *1926. Photograph.*

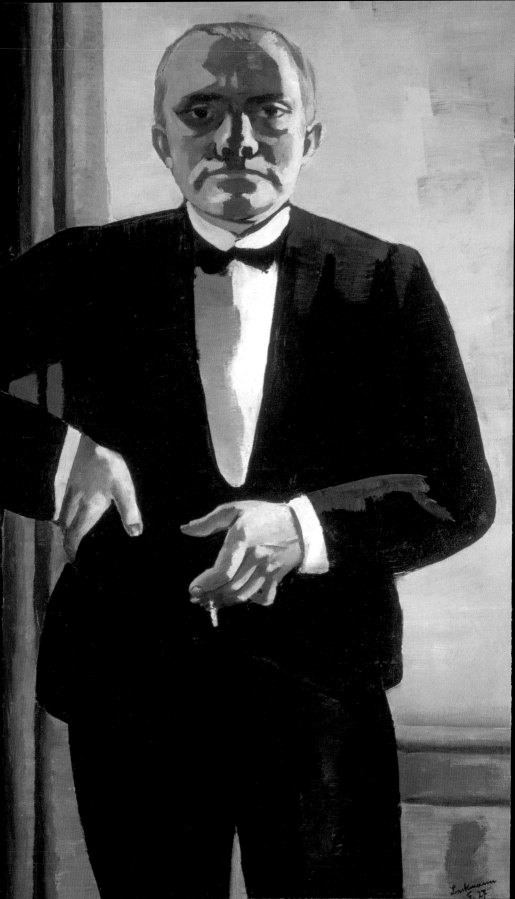

CHAPTER 7
CULT AND CULTURE OF THE SUPERFICIAL: THE NEW OBJECTIVITY

In July 1929, Alfred Barr Jr, the first director of the newly founded Museum of Modern Art, received a letter from Germany. The New York enterprise had set itself the task of documenting the development of the modern aesthetic – of observing painting, graphics, sculpture, design, architecture, film, photography, and anything else at the cutting edge of art. It was inevitable that Gustav Friedrich Hartlaub, the director of the Kunsthalle in Mannheim, would become involved at some stage. Hartlaub wrote: 'The expression "New Objectivity" was in fact coined by me in the year 1924. A year later the Mannheim exhibition was held, which bore the same title…. It was related to…the widespread mood in Germany at that time, which was one of resignation and cynicism after a period of exuberant hopes (which had found an outlet in Expressionism). Cynicism and resignation are the negative side of the New Objectivity; the positive side expresses itself in the enthusiasm for the immediate reality, as a result of a desire to take things entirely objectively on a material basis, without immediately investing them with immaterial meanings.'

With his exhibition, Hartlaub was able to help establish this new preference for reality, or 'healthy disillusionment', as he also referred to it in his writings; he was able to raise its public profile and create an institution for it. His exhibition in the Kunsthalle in Mannheim, which ran from June to September 1925, was mainly composed of paintings, making the distinction between the left-wing 'Verist' works, and the more right-wing 'Classical' ones. Whatever the political leanings of the artists, they were largely grouped in coalitions rather than opposing forces, with Dix, Grosz, Rudolf Schlichter and Georg Scholz on the one side, and Schad, Beckmann and Karl Hubbuch on the other. In 1927 Otto Dix wrote: 'For me, the object remains the priority, and the form only takes shape through the object. The challenge facing me is to make the object as lifelike as possible, as the "What" is more important than the "How", and the "How" can only develop out of the "What".' Two years previously all of these artists had been behind him in his plea for the importance of the objective over the subjective.

'The little window is open, and shows me the familiar view of the street with the church spire looming up at the end. There are a few flowers on the table. Pens, pencils, a shell for a paperweight, the inkwell – nothing here has changed.' These well-known lines are

Opposite:
Max Beckmann, Self-portrait in Dinner Jacket, 1927. Oil on canvas, 141 x 96 cm (55½ x 37¾ in.). Harvard Museum, Cambridge.

Above:
Max Beckmann, Self-portrait with Saxophone, 1930. Oil on canvas, 140 x 69.5 cm (55⅛ x 27⅜ in.). Kunsthalle, Bremen.

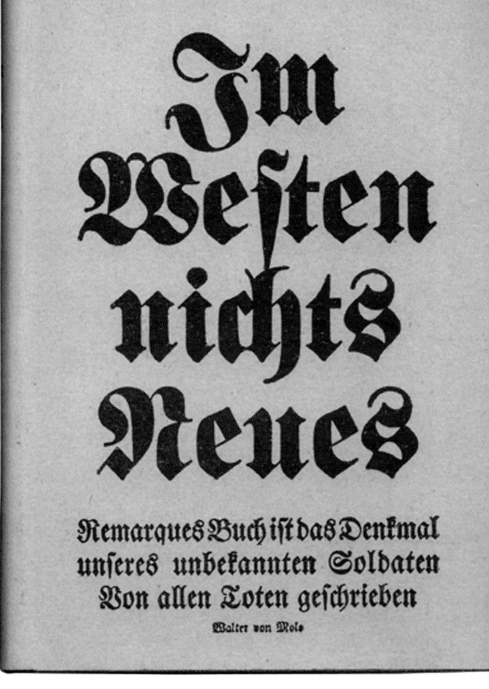

Above: Erich Maria Remarque, All Quiet on the Western Front. *Cover design by Werner Beucke. Berlin: Propyläen-Verlag, 1929.*

180 CULT AND CULTURE OF THE SUPERFICIAL

Left:
Erich Maria Remarque, 1929. Photograph.

Below:
Ernst Jünger (ed.), Krieg und Krieger.
Cover design by Rudolf Schlichter. Berlin: Junker
& Dünnhaupt Verlag, 1930.

from the novel *All Quiet on the Western Front* by Erich Maria Remarque, perhaps the most important literary work of the New Objectivity. Language is used to describe objects in succession – the lines read like a type of inventory, on which each item present is listed, almost counted out. But the humble surroundings presented here leave a bitter taste in the mouth; an escapist longing for another reality, for the catastrophe that is always imminent in the idyllic minutiae.

Remarque's war novel was the sensation of the decade. Four months after its publication, at the end of January 1929, it had sold more than a million copies in Germany alone, and had been translated into twenty-three different languages. Remarque had tapped the pulse of a generation with the memory of a terrible experience and the feeling for life in the present. 'And so we live out a closed, hard existence of extreme superficiality' was his conclusion.

Johannes R. Becher chose to say it differently, as did the entire Expressionist brotherhood. Closed, hard and superficial: these

words could well be used to describe characters such as Count St Genois d'Anneaucourt, whose portrait by Christian Schad exemplifies the New Objectivity style on canvas. They seem to be an accurate description of Schad's pictorial method: the clear contours and the row of figures, calm in the knowledge that even the architecture around them is a mere façade. Like the Count, all the personalities of the New Objectivity, whether they come from the salons or off the streets, or even from the Front, have a strong awareness of the superficial in pictures and words. Remarque sums this up admirably in a scene that is really about something very different, a miserable death in a military hospital. He describes his dying comrade: 'His lips are pallid, his mouth has got bigger and his teeth look very prominent, as if they were made of chalk. His flesh is melting away, his forehead is higher, his cheekbones more pronounced. The skeleton is working its way to the surface.'

Even, or precisely at the moment of death, the presence of the superficial is celebrated. What is happening existentially is described soberly and coolly: 'The skeleton is working its way to the surface.' This would appear to be the process at work in the figures painted by Grosz, the fanatical advocate of a better society: what is going on in the hearts and minds of his figures seems to push through their strange skulls, rendering the inner content visible on the surface.

Enthusiasm for the immediate reality, as Hartlaub put it, an emphasis on what is actually happening, the pathos of *sic* in its purest form: this was the substance of the new, international language of Objectivity. It was concerned with taking the world literally, but that was not all. This idiom would not have been modern had it only been a reflection of reality, which would have been no more than compliance with the old, natural model. What set it apart was its accountability for its own function. The realism of the New Objectivity had another dimension, in that it reflected itself. It searched out all possible ways to express reality, and investigated all the possibilities of material and medium to which it might be subject, whether they would force its hand or block its path. This was modern realism – in a word, modernist.

Modernism is an aesthetic concept that came from America, from the Museum of Modern Art. Modernism implies the process of making cultural reference to one's own capabilities, and a realistic approach to the natural laws governing a particular mode of expression. It involves self-reference, self-proposition and self-reflection, which clearly subject the principle of Objectivity to close scrutiny. Pictures, for example, are able to capture the three-dimensionality of the world in their own two-dimensional existence. Writing can

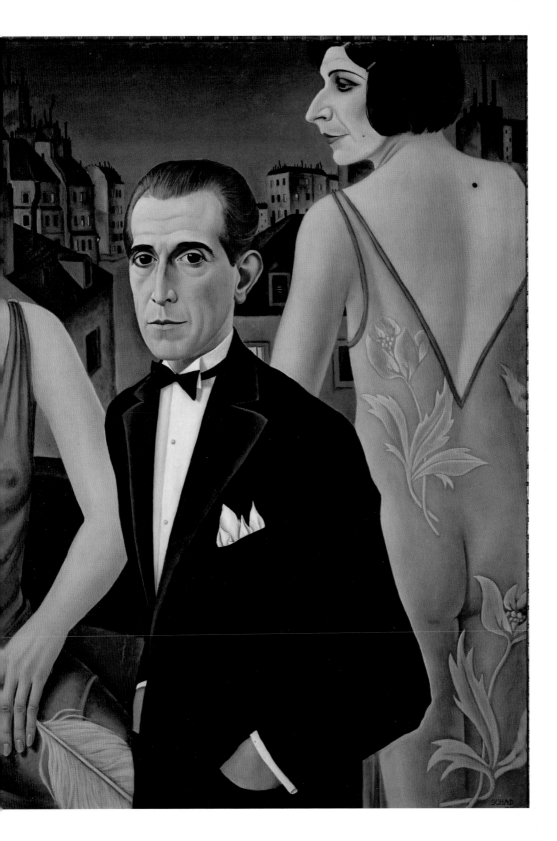

provide a reconstruction of the world through a succession of words and sentences. We will now take a closer look at these qualities and opportunities, but also at the inevitable limitations. What was happening in Berlin in the Twenties was modern because it was urban and metropolitan. It was also modern because it was modernistic and aware of its own potential. Examples of this can be found in photography, film and architecture.

Photography: New Objectivity became the label for certain types of photography. In the first category, photographers chose to shoot familiar objects from unusual perspectives, resulting in tumbling lines and bold diagonals, right-angled shapes distorting into strange curves, a method that was used by 'camera-artists' such as Moholy-Nagy and the Bauhaus photographers. They claimed that the photographs were still abstract even when the shot contained a concrete object.

The second category consisted of the use of a series of photographs showing people at work, in their own milieu and profession; photographs that turned anonymous contemporaries into particular types, endowing the physiognomy of their faces with qualities suggestive of a world far beyond their immediate circumstances. Perhaps the best-known example of this is August Sander's *Antlitz der Zeit* ('Face of our Time') of 1929.

Thirdly, there was the genre of reportage and forensic photography, the daily documentation of daily life. This type of photography featured prominently in magazines, which were steadily gaining in popularity. Erich Salomon was an exemplary figure in this field. He worked for the Berlin newspaper giant Ullstein, and in 1931 published a book; its title, *Berühmte Zeitgenossen in unbewachten Augenblicken* ('Famous Contemporaries in Unobserved Moments'), described a particular approach to photography which has come to be associated with the paparazzi.

Lastly, Berlin became a centre of portrait photography. Lotte Jacobi is the finest example of the many women who excelled in this field. New technology had liberated women from the limitations imposed by a male-dominated system of education in the arts and crafts, and they had become important figures in the world of culture in their own right. Previously they had been merely decorative; in reaching for the camera, they had altered their role as companions to become key players themselves.

One quote from Renger-Patzsch reads like a parody of an obsessive lack of aesthetic criteria: 'To use photography as a means to create photographs that can exist through their own photographic qualities.'

Opposite:
Young couple dancing, 1932. Photograph by Yva.

Above:
László Moholy-Nagy, c. 1925. Photograph.

Overleaf, above left:
August Sander, Painters: Husband and Wife (Martha and Otto Dix), *1925–26. Photograph.*

Overleaf, below left:
August Sander, Architects: Husband and Wife (Dora and Hans Heinz Lüttgen), *1926. Photograph.*

Overleaf, right:
August Sander, The Dadaist Raoul Hausmann (with Hedwig Mankiewitz and Vera Broido), *1929. Photograph.*

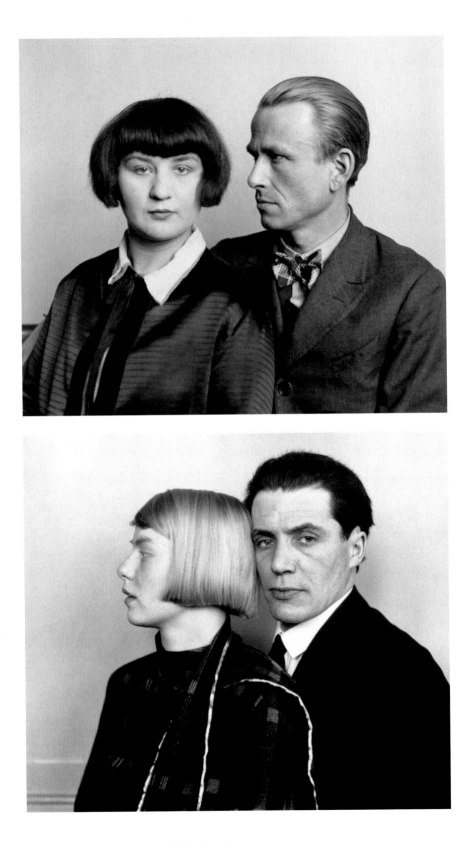

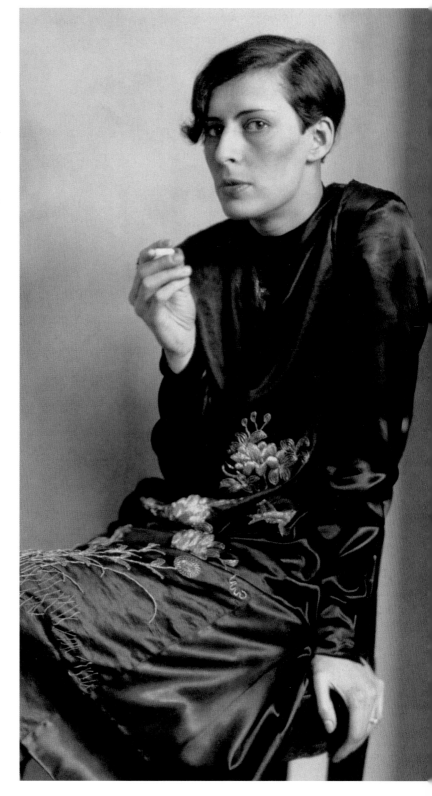

Opposite:
August Sander, Wife of a
Painter (Helene Abelen),
c. *1926. Photograph.*

Right:
August Sander, Secretary with
the Westdeutscher
Rundfunk in Cologne, *1931.*
Photograph.

Overleaf:
Werner Gräff, Es kommt der
neue Fotograf! *Cover design by*
Fritz Adolphy. Berlin: Hermann
Reckendorf Verlag, 1929.

WERNER GRÄFF

VERLAG HERMANN RECKENDORF GMBH

Carl Zeiss. Jena Nr. 238532

F = 5,0 cm DRP

Tessar 1:3,5

ES KOMMT DER NEUE FOTOGRAF!

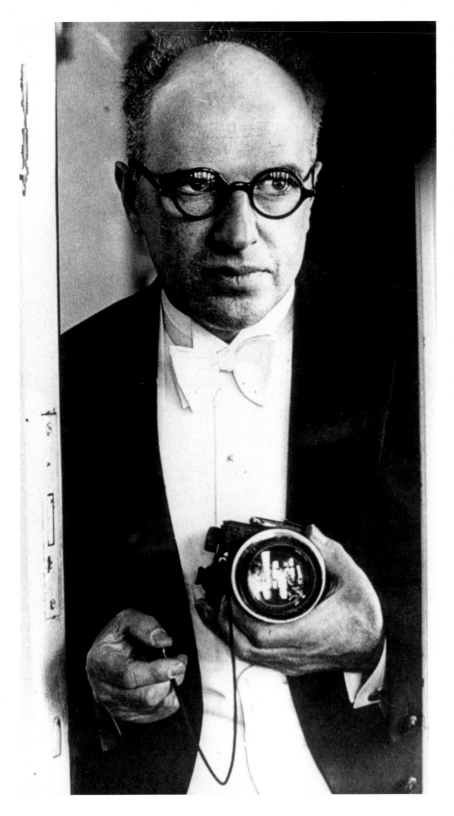

Left:
Erich Salomon, 1928.
Photograph by Lore
Feininger.

Opposite:
Lotte Jacobi, self-
portrait, c. 1930.
Photograph.

Overleaf:
Meeting of the
department of poetry at
the Prussian Academy
of Art, Berlin, 1929.
Seated, from left to
right: Alfred Mombert,
Eduard Stucken,
Wilhelm von Scholz,
Oskar Loerke, Walter
von Molo, Ludwig
Fulda and Heinrich
Mann. Standing, from
left to right: Bernhard
Kellermann, Alfred
Döblin, Thomas Mann
and Max Halbe.
Photograph by Erich
Salomon.

medium and different visual opportunities. Ruttmann's film requires no set; his actors are the people on the street, and the action takes place across Berlin. It was shot on the spot, from dawn till dusk, and the footage assembled to form a full-length film without different scenes. From the outset, a film is the product of pasting and assembling at the cutting table, and this familiar method of working with material is somehow reminiscent of a city existence: life in a metropolis is itself a patchwork of impressions, routines and reactions, cut and pasted together.

There are two further films that follow a similar pattern: *People on Sunday* (1930), directed by Robert Siodmak with a screenplay by Billy Wilder; and *To Whom Does the World Belong?* (1932), produced by Brecht and the director Slatan Dudow, which was a swansong to the proletarian aesthetic. Both films are largely composed of documentary material and are bold attempts at bringing the city to the fore.

Opposite:
Max Pallenberg, c. 1925. Photograph.

Below:
Ernst Lubitsch, c. 1930. Photograph.

Overleaf, left:
Scene from the film Berlin: Symphony of a Great City *by Walter Ruttmann, 1927. Photograph.*

Overleaf, right:
Poster for Berlin: Symphony of a Great City, *1927. Colour lithograph.*

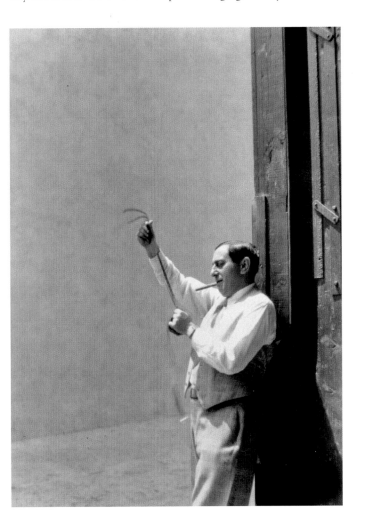

BERLIN

DIE
SINFONIE
DER
GROSSTADT

FOX

EIN FILM VON
WALTHER RUTTMANN
SINFONISCHE BEGLEITMUSIK: EDMUND MEISEL

Today, the term 'found footage' is used to describe the concept that began then, at the cutting edge of cinema.

The most significant theory of early cinema, *Film as Art*, was written and published in Berlin in 1932. The author was Rudolf Arnheim, who was born in Berlin in 1904, and although he later moved away from film, as many others did, he is still regarded as the psychologist of visual art. His early book was a masterpiece, as were the film reviews that he was writing for various magazines before the age of twenty-five: full of wit, originality and a superior knowledge of the mechanisms of the genre and the business of the cinema. In the foreword to his book, he states that he wanted 'to take seriously the words often spoken so lightly: that the laws governing an art form can be perceived through the properties of the materials used.' This sentence contains the theory of Modernism in a condensed form. Arnheim took this completely to heart, consequently becoming a devotee of the silent film because here the moving image was in its element. He thought that there was a need 'to acknowledge that words are not necessary to convey deep, spiritual meaning, but that pictures and sounds are capable of doing it alone.' The cinematic revolution alluded to here came in 1930, when cinema was no longer accompanied by music from the orchestra pit, but was transformed by sounds that emanated from the opaque world within and beyond the screen. For a Modernist like Arnheim, the degeneration was clear: after the triumph of self-knowledge and self-reliance, cinema had finally wandered off its determined course, and what followed was merely filmed theatre.

Architecture: Between 13 and 16 October 1928, inner-city Berlin between the Kurfürstendamm and Alexanderplatz was bathed in a sea of bright colours. It was the 'Berlin Festival of Light', and each night from seven in the evening until one in the morning there was a 'public festival of illumination in the city', as the brochure put it. 'Berlin has become the city of the beautiful illuminated advertisement,' it continued with pride, and indeed there had been a good deal of PR work associated with raising the profile of the metropolis. It is a matter of conjecture as to whether the illuminated advertisements served the purpose of promoting products, for naturally many of these eye-catching displays highlighted certain brands, or of promoting the streets, façades and billboards, a showcase for the boulevards and avenues of the city.

It is possible that the cult and culture of the superficial, so popular in 1920s Berlin, reached its climax in the remarkable application of the plastic art of architecture in this showy, two-dimensional form.

RUSSISCHE
FILMKUNST

Opposite:
Rudolf Arnheim, Film as Art. *Cover design by György Kepes. Berlin: Ernst Rowohlt Verlag, 1932.*

Above:
Alfred Kerr, Russische Filmkunst. *Cover shot taken from a silent film. Berlin: Ernst Pollack Verlag, 1927.*

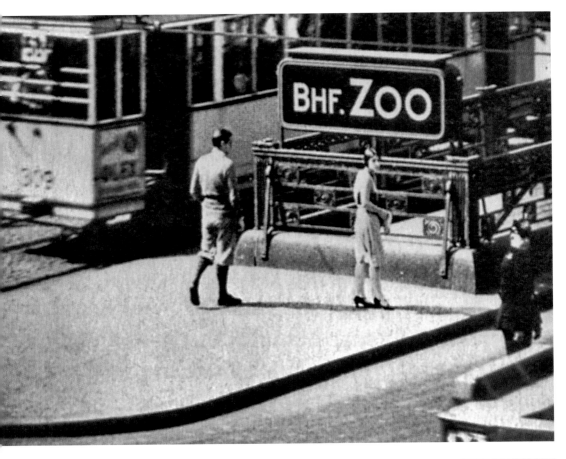

Above and below:
Scenes from the film People on Sunday *by Robert Siodmak (screenplay by Billy Wilder), 1929. Photographs.*

Above:
Scene from the film To Whom Does the
World Belong? *by Slatan Dudow (screenplay
by Bertolt Brecht), 1932. Photograph.*

Overleaf, left:
Poster advertising Fritz Lang's film M
*('Murderers among Us'), 1931. Colour
lithograph.*

Overleaf, right:
Peter Lorre in M, *1931. Photograph.*

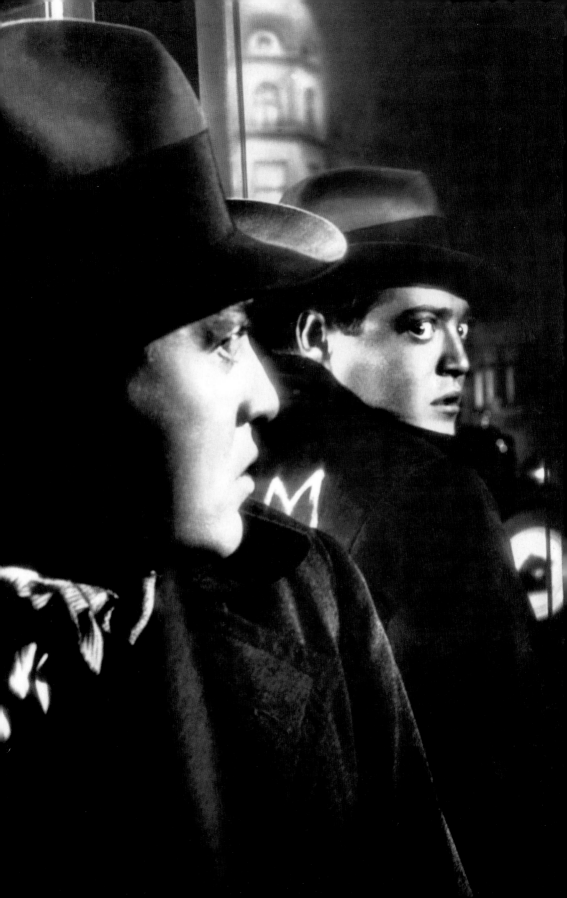

EXPRESSIONISMUS
UND FILM

VON

RUDOLF KURTZ

Den Einband zeichnete
PAUL LENI

Mit 73 ein- und mehr-
farbigen Abbildungen

Ganzleinen Preis 16 M.

VERLAG DER LICHTBILDBÜHN
BERLIN SW48 / FRIEDRICHSTRASSE
TELEPHON: HASENHEIDE 3201, 3202, 3

6–6

Preceding pages:
Hans Richter (ed.), G, *magazine for elementary art and design, issue 5/6 (last): 'Film'. Cover design by Werner Gräff. Berlin: Eigenverlag, 1926.*

Left:
The first weekly newsreel cinema in Berlin, September 1931. Photograph.

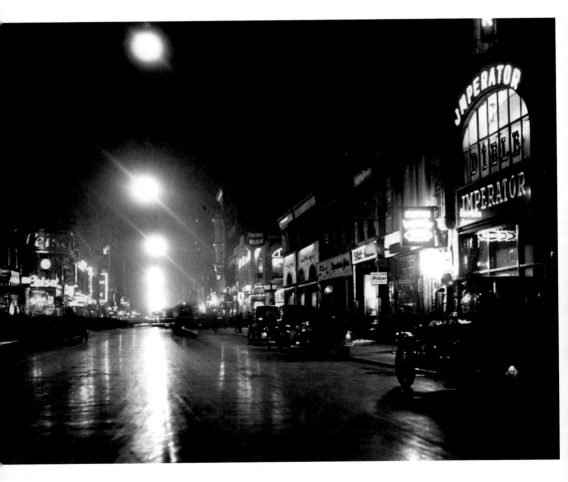

Yet this strange and superficial approach to buildings was the result of architecture's own search for self-definition. The new constructions of the Twenties had renounced decorated façades and ornamentation in favour of a bright, friendly and neutral façade which could serve as a medium for the commodities in the building behind it – perhaps it could be said that the architectural skeleton was 'working its way to the surface' – and this of course provided the perfect surface for a colourful, sensational, riveting application.

The city reclaimed its houses, leaving its own distinctive mark on them. In previous times, the historical, exuberant façades were evidence of a retro style, freely chosen in accordance with the taste of the architect or the function of the building. An event such as the 'Festival of Light', on the other hand, showed the metropolis that there was no longer a place for such self-satisfied ostentation. Houses were part of an ensemble, a conglomeration, an area; the individuality of a single house was subjugated to the ego of the city.

The festival brochure echoed this sentiment: 'The current night-time view of Berlin may be composed of a multitude of different illuminations, but they all unite into one complete sphere of light.'

The cult and culture of the superficial. These were the years of undisguised androgyny; of redefining the roles of men and women; and of constantly changing sexual preferences; the true sexual identity remained hidden, but the sexual identity of choice was paraded in a desire to shock and entice. These were the years of the great revue shows, when entertainment took on huge and opulent proportions with the sheer number of performers. These were the years of the great impresarios such as Erik Charell, James Klein and Hermann Haller, whose shows promised '150 girls' or '400 performers'; or even the Christmas revue in 1926, an 'incredible sensation' with '60 different acts'.

These were the years of perhaps the most banal, kitschy and superficial of all the performing arts: operetta. Operetta – a relic of the *fin de siècle* with its sweet world-weariness – celebrated a magnificent comeback.

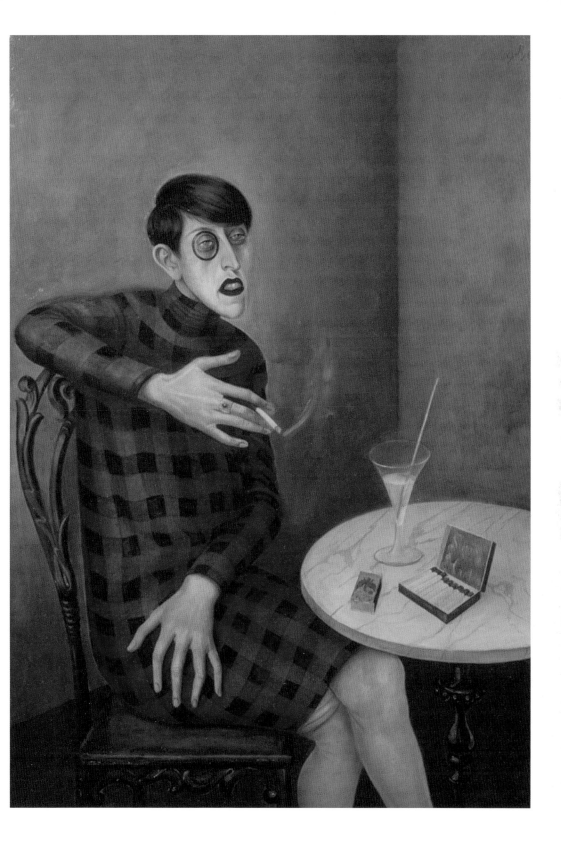

Opposite: Hans Albers with a Woman, *1924. Photograph by Alexander Binder.*

Above: Woman with Monocle (Roma Bahn), *1925. Photograph by Becker & Maass.*

Above:
Alexa von Poremski, 1928. Photograph by Alexander Binder.

Opposite:
The Katz twins at a polo game in Frohnau, Berlin, 1928.
Photograph by Zander & Labisch.

Opposite:
The writer Ruth Landshoff, Countess York von Wartenburg, c. 1930.
Photograph by Elli Marcus.

Above:
Annemarie Schwarzenbach, 1933.
Photograph by Alexander Binder.

Above:
Film star Lil Dagover with her dog in a car, 1928. Photograph by Lotte Jacobi.

Opposite:
Sculptress Renée Sintenis in her Studebaker, 1928. Photograph by Baruch.

Overleaf:
Actress Fritzi Massary with her dogs, in front of her limousine, 1926.
Photograph by Zander & Labisch.

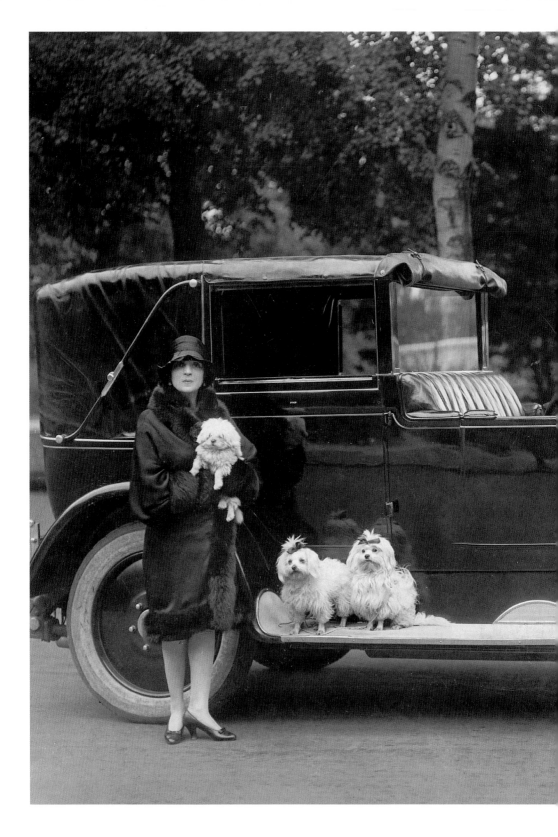

Above:
A weekend outing to a lake near Berlin, 1927. A woman digs her Cabriolet out of the sand. Photograph by Alexander Binder.

Above:
Fashionable glasses for women, 1931.
Photograph by Hans Robertson.

Below:
Ladies' wear: Andrée Doussin in a motoring
outfit, 1924. Photograph by Alexander Binder.

Above:
Poster for the Tabarin dance club, Berlin, c. 1925. Colour lithograph by Ernst Deutsch-Dryden.

Opposite:
Poster for a nude dance show by Erna Offeney at the Palais der Friedrichstadt, 1919–20. Colour lithograph.

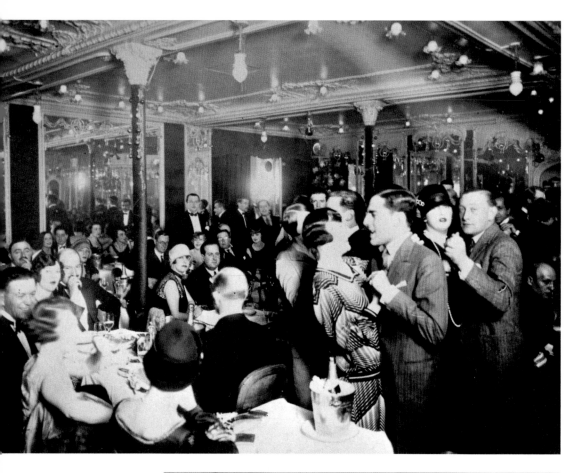

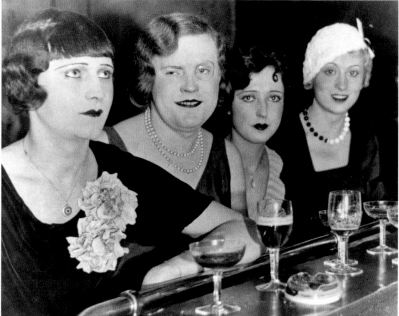

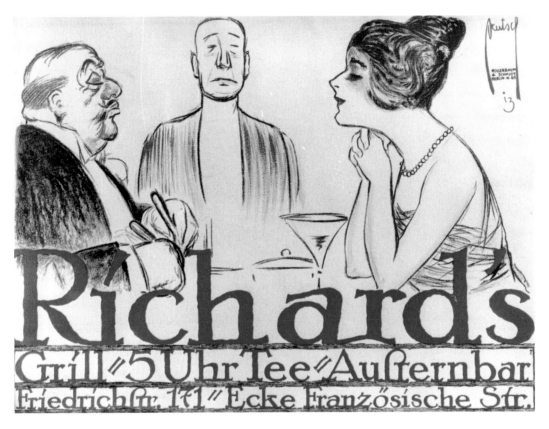

Opposite, above:
Berlin dance hall, c. 1930. Photograph.

Opposite, below:
Transvestites in the El Dorado bar, a well-known gay hang-out, Motzstraße, Berlin-Schöneberg, 1929. Photograph.

Above:
Poster for Richard's bar, Berlin, c. 1925. Colour lithograph by Ernst Deutsch-Dryden.

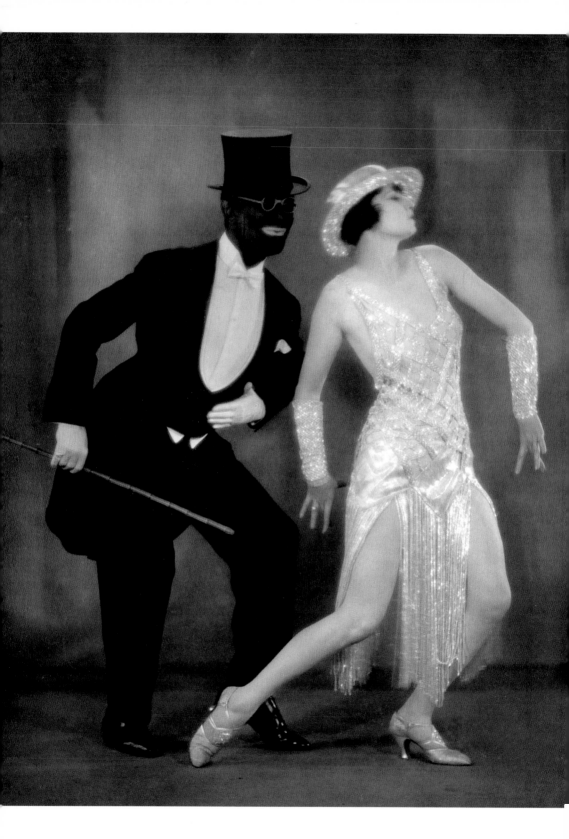

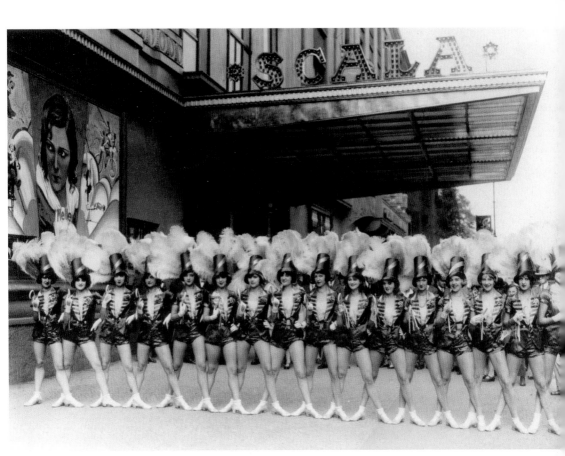

Opposite:
Variety: Erik Charell in rehearsal with revue girls, 1925.
Photograph by Zander & Labisch.

Above:
Variety: The Jerry Girls at the entrance to the Scala Theatre, Berlin, c. 1925. Photograph.

Right:
Ilse May, the first and best-known 'number girl' of the Scala, 1928.
Photograph by Hans Robertson.

Overleaf:
Dancers rehearsing for the revue Für Dich, *1925. Photograph by Zander & Labisch.*

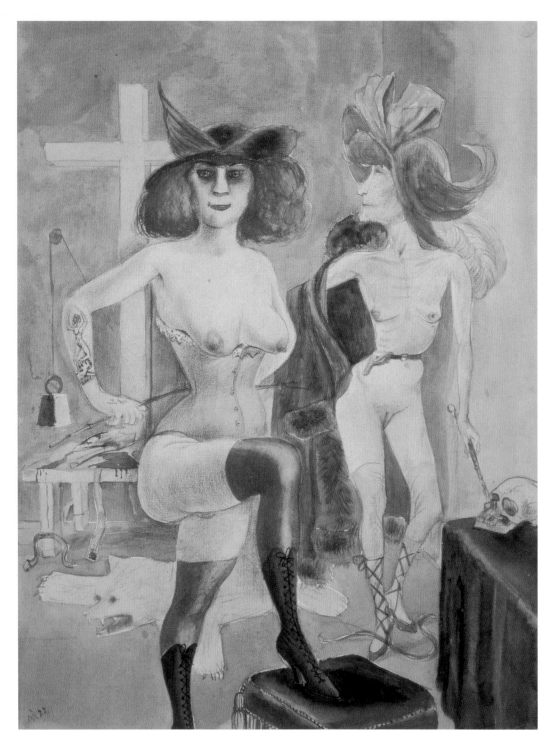

Above: Otto Dix, Sadists, 1922. Watercolour, 39 x 27 cm (15⅜ x 10⅝ in.). Private collection.

Opposite: Dressing room at the Großes Schauspielhaus, 1925. Photograph by Zander & Labisch.

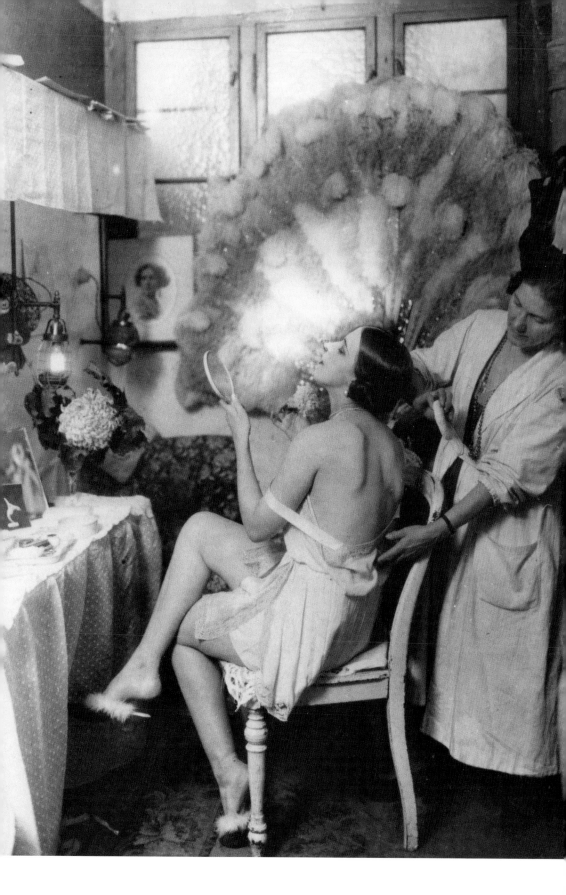

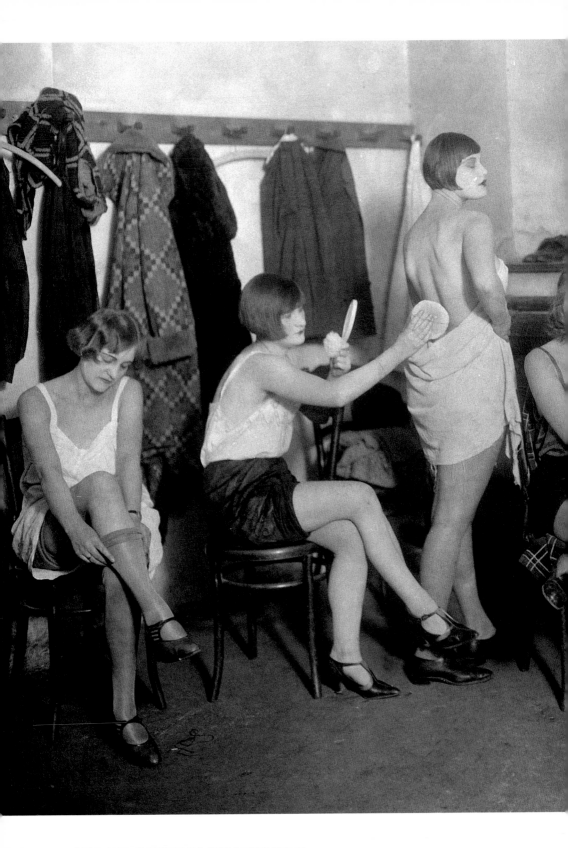

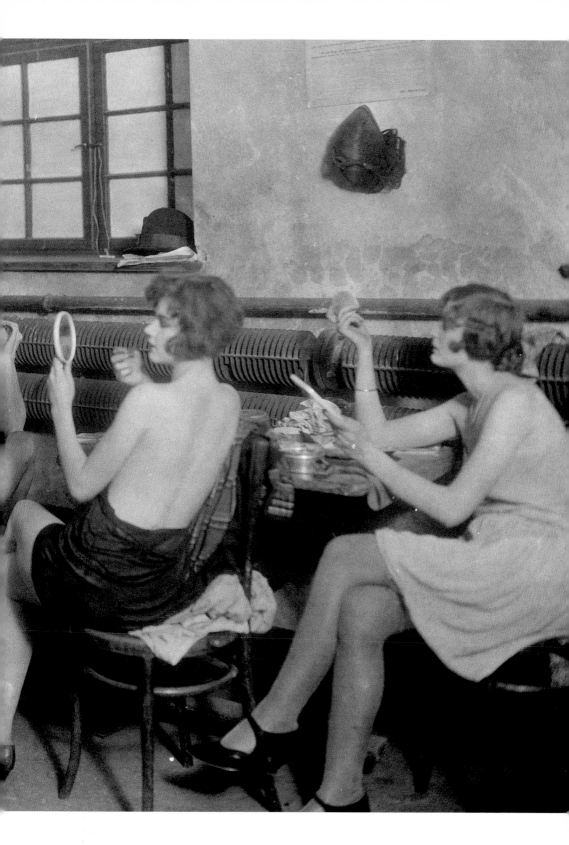

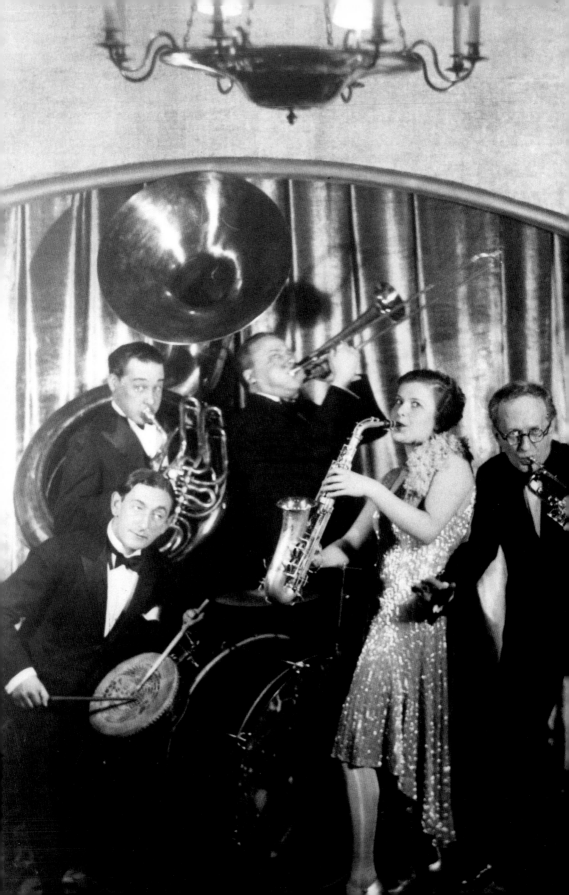

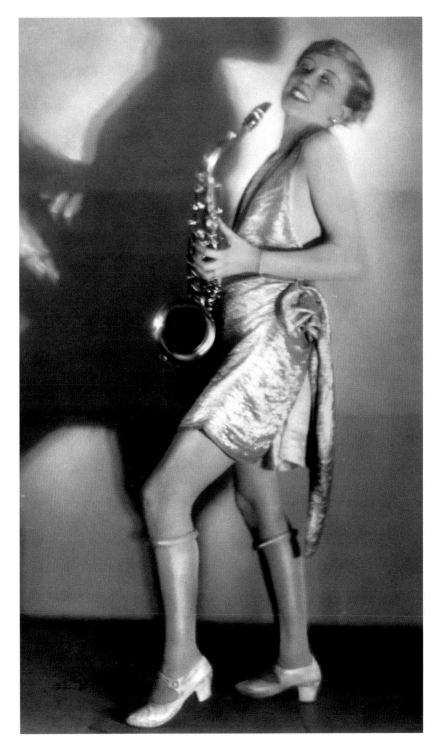

Preceding pages:
Dancers' dressing room at
the Großes Schauspielhaus,
1925. Photograph by
Zander & Labisch.

Opposite:
Renate Müller, Paul
Graetz, Paul Morgan,
Max Hansen and Max
Adalbert in a jazz band,
1929. Photograph by
Wolff Freiherr von
Gudenberg.

Right:
Actress Hertha Schroeter
with a saxophone, at a
fancy-dress party, 1928.
Photograph by Yva.

Overleaf:
Variety: Members of Jack
Shea's American jazz band
after a performance in
Berlin, c. 1925.
Photograph.

Composers such as Paul Lincke and Ralph Benatzky, and artists like Fritzi Massary, universally admired and worshipped by the critics, brought about an astonishing renaissance. At its peak, Brecht summed it up in a few words: 'Opera seems to me to be far more stupid and more unreal than operetta, and altogether inferior to it.' For once, the bittersweet taste of champagne was superior to the melancholy truths of the loftier style.

These were also the years when Josephine Baker was one of the top acts on the nightclub scene. She was exotic with her black skin, primitive in her banana skirt, feminine in her nakedness, boyish with her short haircut, and artificial with all her wigs. She was one of the top acts in the culture of the superficial. A hair gloss, 'Bakerfix', was named after her, and she seemed immortal, however mortal she was. It was rumoured that German women used to rub themselves with walnut oil in an attempt to gleam as she did, and hopefully to luxuriate in the same feelings. For that was the alluring charm of the

Below:
Group shot of the White Horse Inn *cast, Großes Schauspielhaus, 1930. Photograph by Wolff Freiherr von Gudenberg.*

Above:
Set for the first performance of Ralph Benatzky's operetta White Horse Inn *in the Großes Schauspielhaus, 1930. Photograph.*

Opposite:
Fritzi Massary in the title role in Michael Krauß's operetta Eine Frau von Format, *Theater des Westens, 1927. Photograph by Wolff Freiherr von Gudenberg.*

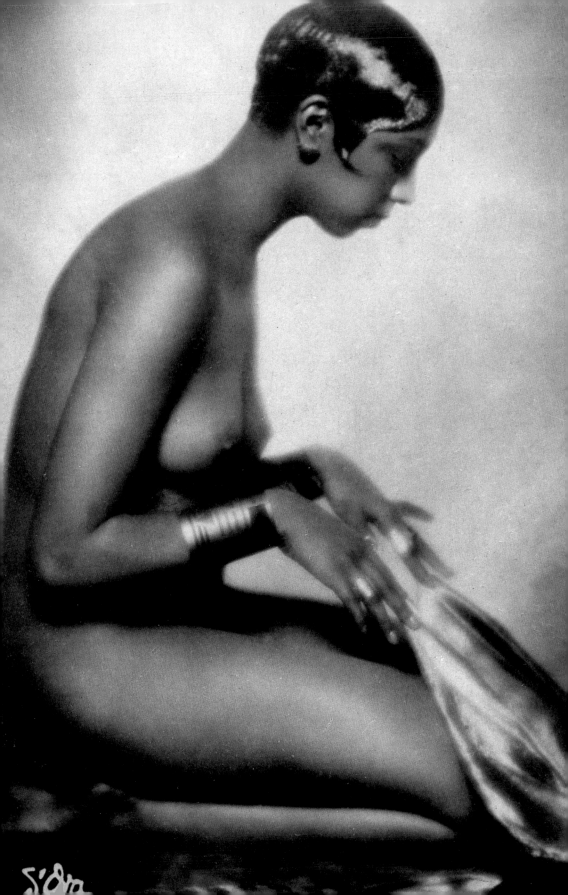

superficial: a belief that there really was something underneath the surface display.

Once more, Count Harry Kessler offers a wry insight. After a gathering on the evening of 8 December 1929, he wrote: 'Dinner at Baby Goldschmidt-Rothschild's on the Pariser Platz. Eight to ten people, intimate party, extreme luxury. Four priceless masterpieces by Manet, Cézanne, van Gogh, and Monet respectively on the walls. After the meal thirty van Gogh letters, in an excessively ornate, ugly binding, were handed round with cigarettes and coffee. Poor van Gogh! I saw red and would gladly have instituted a *pogrom*. Not out of jealousy, but disgust at the falsification and degradation of intellectual and artistic values to mere baubles, "luxurious" possessions.' Kessler objected violently to the 'trivialization' of values into a cult of the utterly superficial.

Kessler himself admitted to 'murderous thoughts' towards someone like Rothschild, who 'would have to be killed' on account of his superficiality. Soon the Nazis would implement what the cultured Kessler had only hinted at, under the masquerade of returning to the profound. Berlin had thoroughly mastered the art of keeping up appearances: the fact that it openly embraced such a concept was partly why it had become so prominent. It was no more than the flipside of the new, world-shaking Modernity; the highly reflective, acutely conscious Modernism that was taking shape.

CHAPTER 8
ETERNITY IN TRANSIENCE:
BERLIN AND THE 'OTHER MODERNITY'

In 1929 Café Moka Efti on Friedrichstraße reopened after refurbishment. It was an ordinary establishment, not a meeting place for artists like the Romanisches Café or the Schwannecke. Unlike Vienna, where people frequented coffee houses in order to be alone, yet not quite alone, in the hectic lifestyle of Berlin no one had the time to sit and peer into a cup. Café Moka Efti thought of a solution and created an extra room where men of the world could continue to work away at their business without feeling restrained. A desk was added to each table, and those who could afford it could even order a typist along with their cake, to take dictations. Bosses, and any others able to pay for the service, were made welcome. In reality, there seemed to be a slightly contrived sense of activity.

Opposite:
Terrace of the Romanisches Café, c. 1925.
Photograph.

Below:
Romanisches Café, 1926. Photograph by Sasha
Stone.

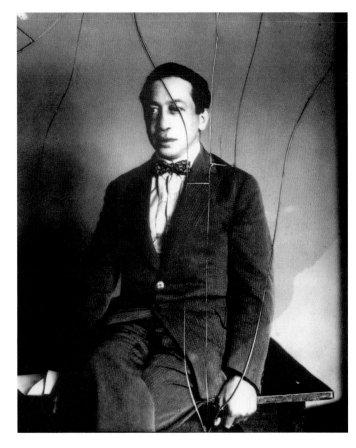

Siegfried Kracauer's comments on the subject sum up the mentality of his time: 'The mystery of *die neue Sachlichkeit* could not be more conclusively exposed than here…. Just one step down and you are lapped in the most luxuriant sentimentality. But this is what characterizes *die neue Sachlichkeit* in general, that it is a façade concealing nothing; that it does not derive from profundity, but simulates it.'

This reiterates what has already been discussed in the previous chapter. According to Kracauer, the New Objectivity had nothing to offer but a layer of superficiality. He also perceived that a new clique was forming, and gaining in size with extraordinary speed. In 1930 he published a book entitled *The Salaried Masses: Duty and Distraction in Weimar Germany* (from which the above quote is taken), in which he discussed the development of a new social type, which is completely familiar to us in this day and age. He saw the world as becoming increasingly dull, faceless and joyless through this new type of employee; through the splendid Nine-to-Five people, who work for others, but do not need to get their hands dirty in the process; they are names on the payroll, submerged in neutrality and anonymity. Saturated in the data and archives that constitute reality, they would

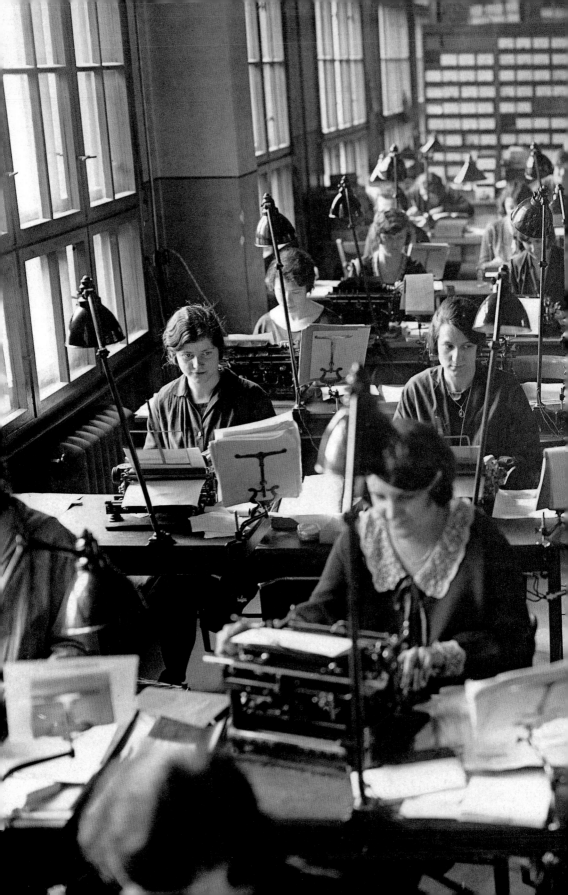

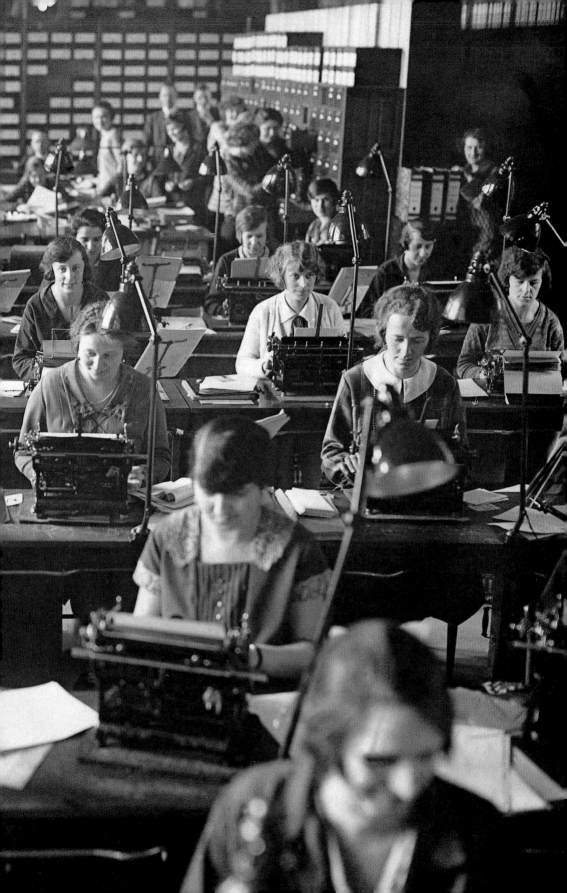

Opposite:
A waiter brings a cup of coffee to a secretary at work, 1931. Photograph.

Above:
Office worker with a telephone / telex machine by Siemens & Halske, 1932. Photograph.

Left:
Demonstration of office machines at an exhibition of office technology, 1929. Photograph.

Overleaf:
Pupils at a school of gymnastics demonstrate the order of letters on the keys of a typewriter, c. 1930. Photograph.

Above:
Librarian (Charlotte von Hessel), 1925.
Photograph by Becker & Maass.

Opposite:
A registrar sorting through shelves of Leitz files, 1925. Photograph by Becker & Maass.

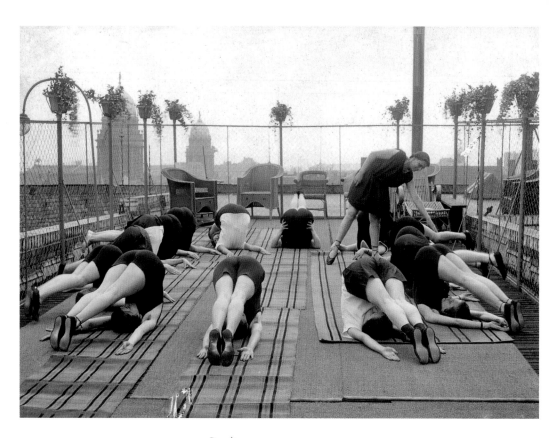

Preceding pages:
Exhibition hall of the 'International Office Show' on the Kaiserdamm, c. 1930.
Photograph.

Above:
Female employees of the silk manufacturer Nichels doing gymnastics on the roof before work,
1926–27. Photograph.

Opposite:
A young office employee performs a balance exercise to strengthen the muscles in the back,
c. 1925. Photograph.

Above:
American dancer Nina Payne, c. 1925.
Photograph by the Binder Studio.

Opposite:
Jeanne Mammen, Revue Girls, 1928–29.
Oil on card, 64 x 47 cm (25¼ x 18½ in.).
Berlinische Galerie, Berlin.

lose their memory. However, a new kind of culture was soon to ensure that they had plenty of resources for the evening, for in the Twenties a different quality of life was emerging, and not just for the working classes.

Thanks to new technology, and in particular to new methods of organization in the workplace, there was a widespread premonition of prosperity, although this was not the case for everyone of course: the statistics for the number of unemployed tell a very different story. Yet the well-known rationalism of Taylorism, the breaking-down of the manufacturing process into small steps, the advent of the conveyor belt, and the precision work required in particular tasks all suggested that employees would now be able to get a larger slice of the cake. Increased alienation would be the price they would have to pay, but it was still a reward well worth having.

It is significant how quickly Berlin's free spirits and free thinkers picked up on the prevailing liberality, which was the result of people having money in their pockets. In 1921, under the pseudonym of Peter Panter, Tucholsky wrote an anthology entitled *Jazz und Shimmy: Brevier der neuesten Tänzen* ('Jazz and Shimmy: Guide to the Latest Dances'). In an attempt to amuse the exemplary secretary, Miss Piesewang, he peers into the orchestra pit and observes that 'the music clacks to the same beat as the typewriters that the audience left behind two hours ago; the songs are the boss shouting in rhythm, and the dancing is performed as if around the Golden Calf. The jazz band is merely a continuation of business, but using other tools.'

According to Tucholsky, entertainment and work obey the same internal rhythms. The conveyor belt moves like a dance routine. Kracauer sees it very differently in *The Salaried Masses* scarcely a decade later: 'The more monotony holds sway over the working day, the further away you must be transported once work ends.... The true counterstroke against the office machine, however, is the world vibrant with colour. The world not as it is, but as it appears in popular hits. A world every last corner of which is cleansed, as though with a vacuum cleaner, of the dust of everyday existence.' Entertainment and work are arch-enemies, he continues, one holding out the promise of enjoyment, and the other creating frustration. His words perfectly embody the theory that culture is a form of compensation. Whichever one of them was right, by 1920 Tucholsky had established himself as representative of the New Objectivity, and Kracauer as a left-wing thinker and critic of the mechanism of distraction that was later to become known as the 'entertainment industry'.

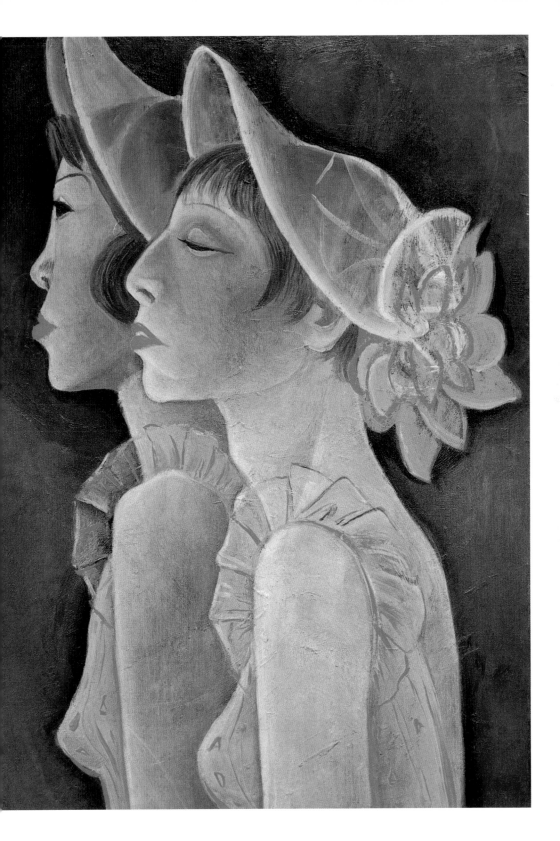

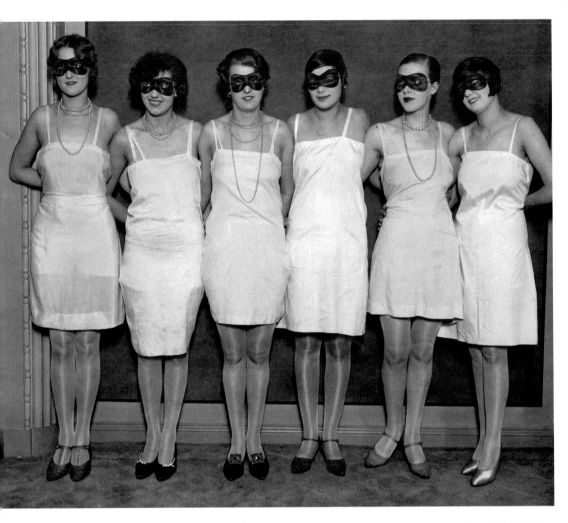

Above:
Girls in negligees and eye-masks, c. 1925.
Photograph.

Right:
Spectators in eye-masks during a nude dance
at a nightclub, c. 1925. Photograph.

Opposite:
Miss Germany, Irma Hofer, c. 1928.
Photograph.

Overleaf:
Training for the first revue circus in Berlin,
1925. Photograph.

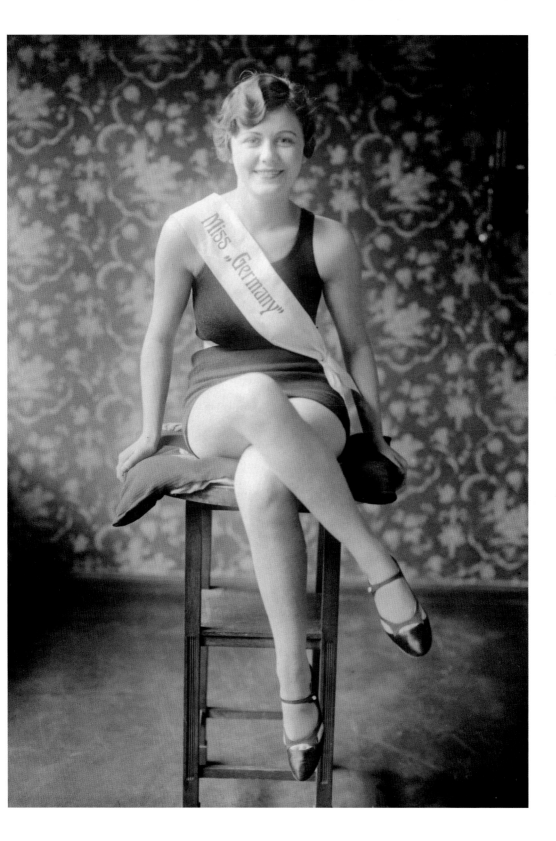

Above:
Otto Dix, Salon I. *Oil on canvas, 86 x 120.5 cm (33⅞ x 47½ in.). Galerie der Stadt Stuttgart.*

Below:
Fashion models assemble in the Lindenstraße, c. 1930. Photograph.

Opposite:
Otto Dix, The Ill-matched Lovers, 1925. *Tempera/wood, 180 x 100 cm (70⅞ x 39⅜ in.).*
Galerie der Stadt Stuttgart.

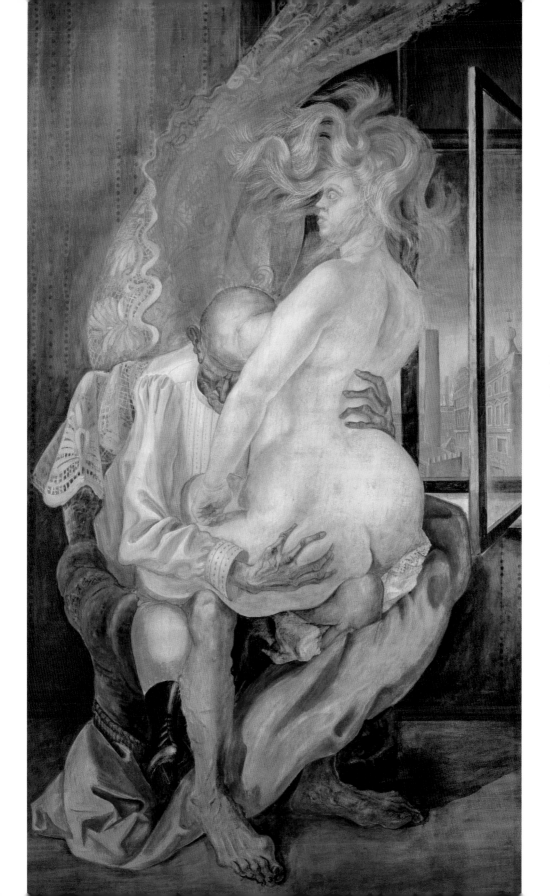

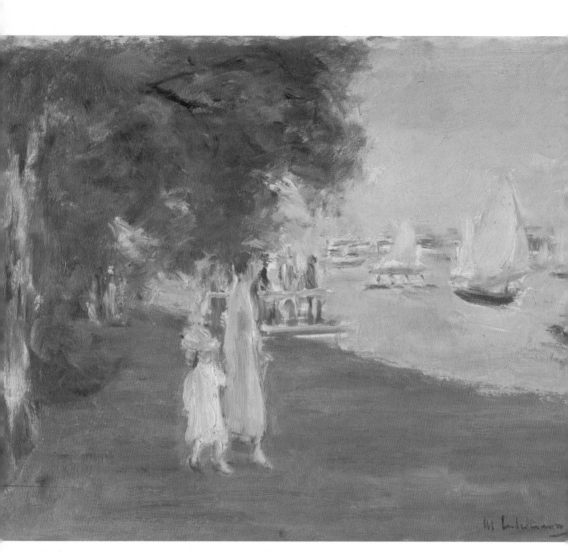

Preceding pages:
*Floating ice-cream parlour on the Wannsee,
1925. Photograph.*

Above:
Max Liebermann, Wannsee Landscape,
*c. 1910. Oil on wood, 31.5 x 39.6 cm
(12½ x 15⅝ in.). Private collection.*

Opposite, above:
On the beach on the Wannsee, 1929. Photograph by Martin Munkácsi.

Opposite, below:
Relaxing on the shores of the Wannsee, c. 1930. Photograph.

Overleaf:
Weekend outing to the Wannsee, c. 1930. Photograph.

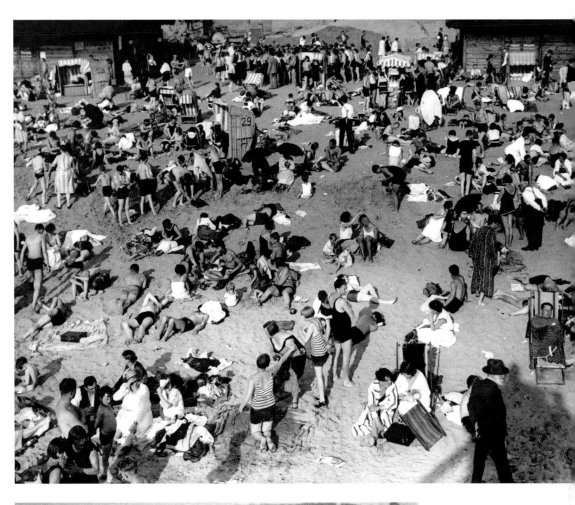

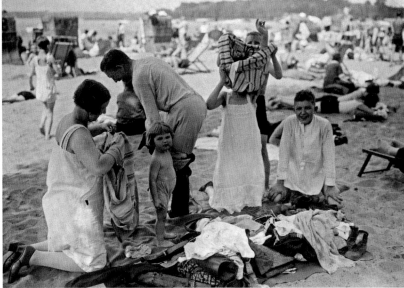

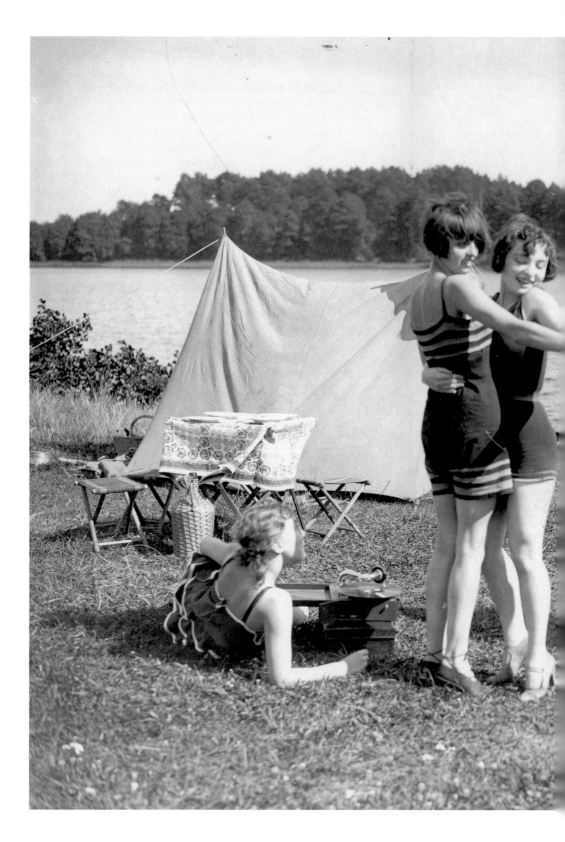

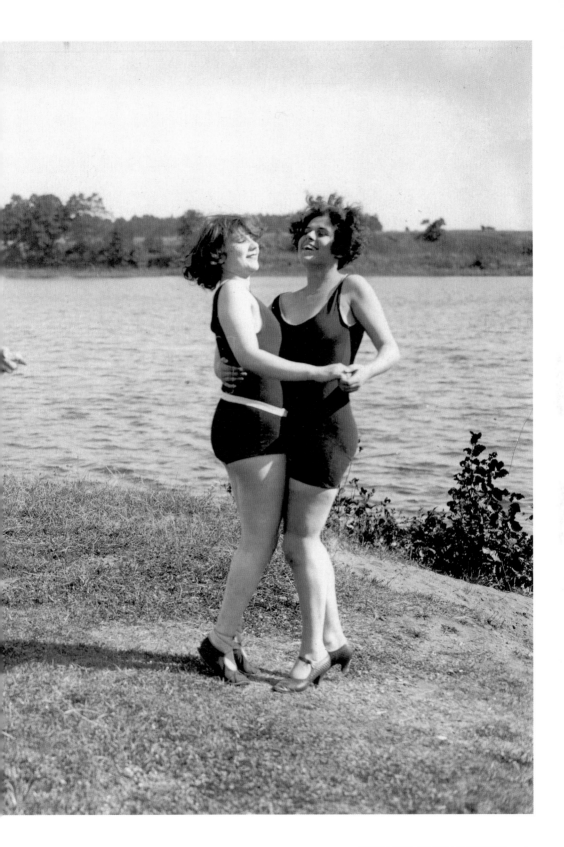

ETERNITY IN TRANSIENCE 281

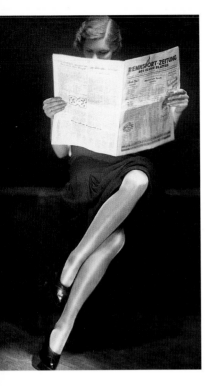

Above:
Fashion shot, c. 1930. Photograph by Yva.

Whether it was a means of reflection or compensation, either way the people who flocked to the dance halls, revues, cinemas and stage spectaculars were engrossed in the present. Once again people began to question whether this really was all that there was to existence, whether perhaps culture could go further than just supplying immediate, short-term gratification, which would inevitably be replaced by something different the next day. It would not have been the culture of 1920s Berlin had not the pendulum swung in the opposite direction again, with a push to rediscover the traditional purpose of art. In 1929, the critic Max Osborn wrote a book of observations entitled *Berlin 1870–1929: Der Aufstieg zur Weltstadt* ('Berlin 1870–1929: The Rise to International Status'), in which he levels an accusation at his metropolis: 'The people of Berlin will have to ask themselves in all seriousness whether they did not show the tendency to embrace a distorted and exaggerated form of Modernity, which was all too quick to pursue new impressions and sensations.'

According to Osborn, Modernity meant something breathless and exaggerated to most Berliners. He did not mention the other interpretation of Modernity – one that doubtless did not enjoy the same degree of popularity in Berlin at that time, compared with the raging and self-obsessed Modernity, totally absorbed in the present. This second interpretation existed nonetheless, and it was the Berliner Walter Benjamin who contributed its story to the history of culture. The concept itself came from the 'capital of the nineteenth century', to quote Benjamin – from Paris and one of its most famous chroniclers, Charles Baudelaire.

The poet and critic had written an essay in 1861 which was dedicated to a painter named Constantin Guys, who by and large remains little known to this day. Baudelaire described Guys as a 'peintre de la vie moderne', a painter of modern life, continuing with the statement that Guys 'searches for a certain something, which we like to call Modernity, for there is no better expression for the ideas which are currently being discussed. His intention is to liberate whatever aspects are poetical and historical from all the ideas in fashion; in other words, in order to draw the eternal out of the transitory.' Modernity is that quality of the eternal in the transient, and Baudelaire knew where that quality could be found: in 'L'art mnémonique', the art of the memory.

Memory is capable of adding another dimension to our immediate reality and bringing it out of the short-term; recollection keeps it from being completely transient and ephemeral. Modernity embodies the concept of unifying these two seemingly opposite spheres; it sounds out the interference zones where the fashionable

connects with the timeless. In Berlin there was indeed a complex concept of Modernity, which went beyond a depiction of the bustle of the metropolis. Otto Dix and Alfred Döblin provide some of the best examples of works that reflect the culture of the city.

Otto Dix's triptych *City*, which he painted between 1927 and 1928, shows three scenes that are typical of Berlin in the Twenties.

Below:
Metropolen machen Mode, *1924.*
Colour lithograph by the fashion artist Kenay for the Berlin fashion magazine Elite.

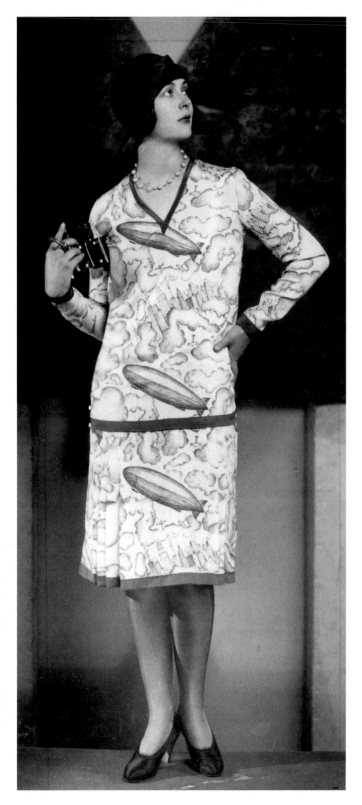

Left:
Dress with Zeppelin design, c. 1930.
Photograph.

Above:
Ladies' fashion in Berlin, 1925. Photograph
by the Binder Studio.

Opposite:
Millinery fashion in Berlin, 1932. Photograph
by Elli Marcus.

Overleaf, left:
Travelling and sailing attire, c. 1930.
Photograph by Yva.

Overleaf, right:
Millinery fashion in Berlin, c. 1932.
Photograph by Yva.

The left panel is dominated by a disabled figure, reminiscent of the Verist style and straight from the horrors of war. Still dressed in his uniform, the ex-soldier has been hobbling along on his crutch until suddenly stopped in his tracks. A man is lying on the uneven cobbles; maybe he is drunk; maybe he has been beaten up, but either way it is of no consequence to the rabble around him. There are prostitutes, brutal faces, the whole menagerie of the city's under-belly – Dix has made sure that none has been missed out. The central panel shows a scene somewhat more refined in character: a jazz band is playing, of the sort Tucholsky would have listened to, and people are dancing. The leg movements of the woman with backcombed hair and a backless dress are suggestive of the Charleston, and the jewels around the women's necks are glinting in time to the music. Most likely there are employees amusing them-selves amongst the crowd, perhaps secretaries; certainly there will be bosses throwing their weight around. In the right panel, the hellish cast from the first scene reappears: the disabled soldier has aban-doned his prosthetic legs and lies in the corner, and the prostitutes are in the foreground, pictured in their flagrant nakedness, or with the even more blatant motif of a fur boa draped over the red swathes of a silk dress, which Dix has clearly designed to represent an over-sized vagina.

Judging by this glaring onslaught of images from the arsenal of psychoanalysis, it is clear that Dix was not just casting an idle glance around the nightlife in the city; he was a master of the transparent, the profound and the emotionally charged. Doubtless he was inter-ested in the drastic status quo, but what he has really produced amounts to an ambitious set for a kind of world-theatre: the trip-tych acts as a high altar, awaiting the culmination of all things. He did not use canvases but instead chose wooden tablets, like an old master. He created a striking juxtaposition between the brightness of the dance hall and the darkness of the streets, which is reminis-cent of the ultimate choice awaiting mankind on doomsday: the stark division between heaven and hell. The work is imbued with the symbolism of the memento mori, and the vanity of all earthly pleas-ures, so that any political and proletarian gestures that evoke the label of Verism are superseded by the sense that this is an initiation into the depths of the human soul. Here Dix is paying tribute to his Expressionist background. He clearly had a specific moral purpose here, but, equally, endowed these passing impressions with a univer-sal relevance, incorporating an aesthetic purpose. He was acting in accordance with Baudelaire's principle of Modernity by securing a glimpse of eternity in transience.

Right:
Otto Dix, City, *1927–28. Triptych: central panel. Tempera/wood, 181 x 201 cm (71¼ x 79⅛ in.). Galerie der Stadt Stuttgart.*

Overleaf:
Otto Dix, City, *1927–28. Triptych: left panel (left) and right panel (right). Tempera/wood, 181 x 101 cm (71¼ x 39¾ in.) each. Galerie der Stadt Stuttgart.*

Below:
Typing, 1929. Photograph by Lotte Jacobi.

Opposite:
Alfred Döblin, 1930. Photograph by Lotte Jacobi.

Overleaf:
Alfred Döblin, Alexander-Platz, Berlin: The Story of Franz Biberkopf. Cover design by Georg Salter. Berlin: S. Fischer, 1931.

An even more explicit – and perhaps artistically more successful – example of this 'other Modernity' came in the form of a novel by Alexander Döblin. Published in 1929, *Alexander-Platz, Berlin* brings a completely ordinary person into the spotlight, and turns him into an internationally recognized figure. The nature of his daily existence does not change, but his life changes dramatically. He has no more money at the end of the book than at the beginning, and his surroundings are exactly the same, but the hero of the book, Franz Biberkopf, has undergone a 'drastic treatment', as it is described in the foreword. This is the process of taking control of a life that has been passively evaporating away, and Döblin's novel captures this idea masterfully. Whereas Dix employed the pathetic formula of the triptych to arouse compassion in the onlooker, Döblin uses the

formula of the *Bildungsroman*, the novel of character development, like Goethe's *Wilhelm Meister's Apprenticeship*.

The circumstances that need to be overcome, the moments of reformation, and the crucial decisions to be made – all of these events are played out within a few paces of the Alexanderplatz. Franz Biberkopf resembles Leopold Bloom, the hero of James Joyce's *Ulysses*, written seven years previously, in which a city-dweller becomes a figure of mythical proportions. It is in keeping with the detached style of the New Objectivity that Döblin manages to avoid any resemblance to Homer's *Odyssey*, and any parallels with the ancient sagas in terms of names, characters or groups of figures. It was clearly Döblin who 'raised the status of the nature of a real life, lived within the common life of our beloved city, within the life of humanity, to the universal status of the ancient epic, or of the even more ancient myth', according to the perceptive observations of Kurt Pinthus in his review of the book.

In its excessive use of the montage technique, its documentary style and its virtuoso employment of fragmentation, *Alexander-Platz, Berlin* resembles Ruttmann's film of two years earlier, *Berlin: Symphony of a Great City*. Döblin employs a particularly cinematic style, which begs the question of how this may benefit a novel that functions

Alfred Döblin

BERLIN ALEXANDER-PLATZ

DIE GESCHICHTE VOM FRANZ BIBERKOPF

S. Fischer Verlag

Von einem einfachen MANN wird hier erzählt, der in BERLIN am ALEXANDERPLATZ als Straßenhändler steht. Der MANN hat vor anständig zu sein, da stellt ihm das Leben hinterlistig ein Bein. Er wird betrogen, er wird in Verbrechen reingezogen, BRAUT rohe Weise zuletzt wird ihm seine genommen und auf umgebracht. Ganz aus ist es mit dem MANN FRANZ BIBERKOPF. Am Schluss aber erhält er eine sehr klare Belehrung: MAN FÄNGT NICHT SEIN LEBEN MIT GUTEN WORTEN UND VORSÄTZEN AN, MIT ERKENNEN UND VERSTEHEN FÄNGT MAN ES AN UND MIT DEM RICHTIGEN NEBENMANN.

Ramponiert steht er ALEXANDERPLATZ, hat ihn mächtig zuletzt wieder an das Leben angefasst.

G. SALTER

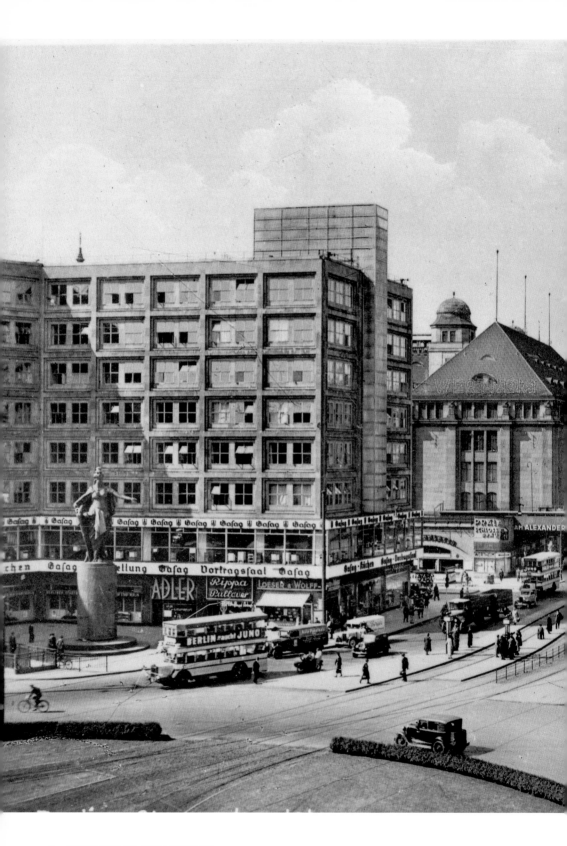

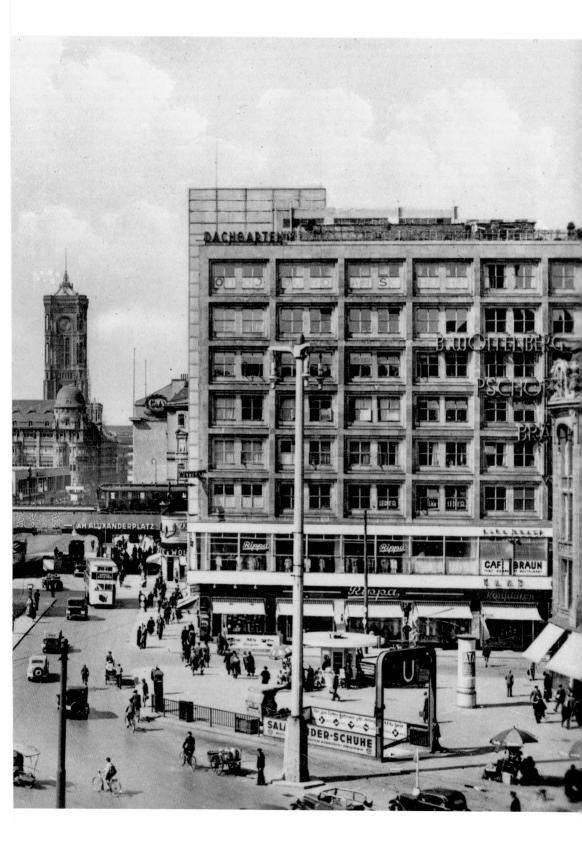

devastating destructive forces that the world has ever known. Benjamin's book about the chimeras and charades of his childhood was not allowed to be published until 1950. He committed suicide in 1940 trying to escape his Nazi persecutors. History, however, has proven him right, for Benjamin remains the most influential figure of 1920s Berlin.

MARLENE DIETRICH
EMIL JANNINGS

Der blaue ENGEL

SUPER film

MIT:
HANS ALBERS · KURT GERRON · ROSA VALETTI · EDUARD v. WINTERST
Frei nach dem Roman "PROFESSOR UNRAT" von HEINRICH MANN · PRODUKTION: ERICH POMMER · REGIE: JOSEF von STERNBE

CHAPTER 9
THE ARGUMENT OF THE MASSES:
FOUR MILLION PEOPLE CANNOT BE IGNORED!

If the mountain will not come to the prophet, then the prophet must go to the mountain. In accordance with this saying, Heinrich Mann, the eldest of the famous literary family and brother of the Nobel Prize winner Thomas, took a trip to the department store Karstadt. The author of *Man of Straw* (the key novel of 'Wilhelmism') and *Professor Unrat* (which was liberally adapted into the ground-breaking film *The Blue Angel*) did not want to purchase anything, nor did he want to advertise anything. He wanted to read — to read out loud, and recite from his own texts, from belletristic pieces that were generally destined to spend their lives on book-shelves. So in 1930 Heinrich Mann gave a recital at Karstadt, in Hermannplatz, Neukölln, the newly opened and, of course, largest of the department stores, which had become one of the hallmarks of the metropolis, not only in Berlin but elsewhere too. He described his recital as a review 'of overflowing proportions', and

Opposite:
Poster for the film The Blue Angel, *directed by Josef von Sternberg, 1930. Colour lithograph.*

Below:
Heinrich Mann, 1927. Photograph.

Overleaf, left:
Karstadt department store in Hermannplatz, Neukölln, 1929. Photograph by Szigethy.

Overleaf, right:
Karstadt at night, 1931. Photograph.

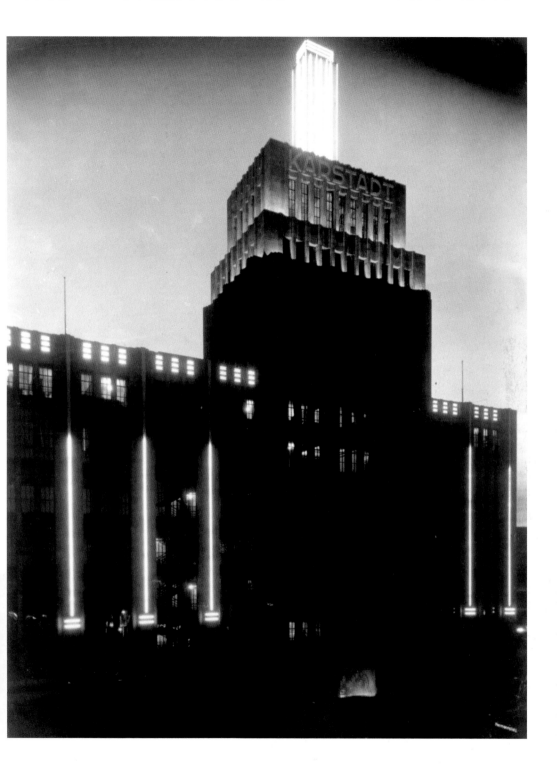

Above:
Marlene Dietrich in her Berlin apartment, preparing for her role in The Blue Angel, *1929. Photograph.*

Right:
Josef von Sternberg and Marlene Dietrich, c. 1930. Photograph.

Opposite:
Marlene Dietrich with feather boa and telephone in the film I Kiss Your Hand, Madame, *1928. Photograph.*

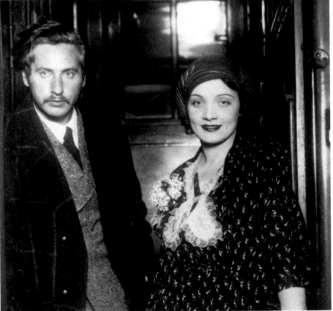

Above:
Willy Fritsch, Max Schmeling and Fritz Lang during the filming of Woman in the Moon *at the Ufa Studios in Babelsberg, 1929. Photograph.*

Below:
World champion boxer Max Schmeling receives a hero's welcome in Berlin on his return from his American tour, 1930. Photograph.

Opposite:
Spanish boxer Paolino Uzcudun training for the match against Max Schmeling in the Paradise Gardens, c. 1930. Photograph.

an occasion that provided him with his 'purest memory of public life during the Republic'.

Looking back, it could be said that the writer gave a performance worthy of a popular name in literature. For that is what it was: in the Berlin of the Twenties, forces of change and transformation were at work which also affected the canonical manifestations of culture. It is not so remarkable that Alban Berg's *Wozzeck* was running at the same time as a revue by Erik Charell with some 5,000 performers. What is remarkable is that Berg was a pupil of Schönberg, as was Eisler, who composed proletarian songs. And it is not remarkable that Leopold Jessner was building his 'Jessner Steps' while athletes were training for a six-day race in the Palace of Sport, but it is remarkable that he wrote an essay for the programme of Max Schmeling's boxing championship. Berlin in the Twenties forced new departures in culture – not just new aesthetic phenomena, but the definition of new aesthetic criteria. The distinctions evident within the still life, the embarrassing divorce between, on the one hand, the complicated, scrupulous and artificial and, on the other, the violent, thundering and simple, were simply cancelled out. High-brow and low-brow merged into one. Forty years later this would be given the label Pop Art.

A reaction to Berlin and its goings-on was naturally coming into play. The true foundations of the city were to be found in its inces-

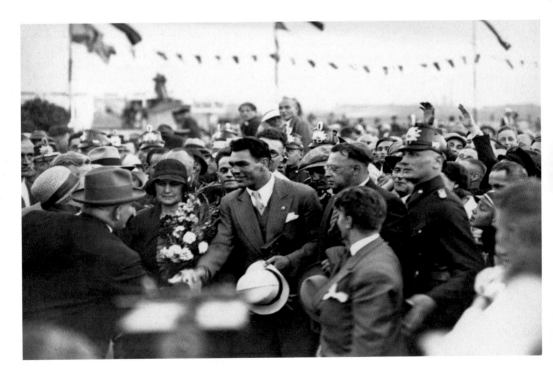

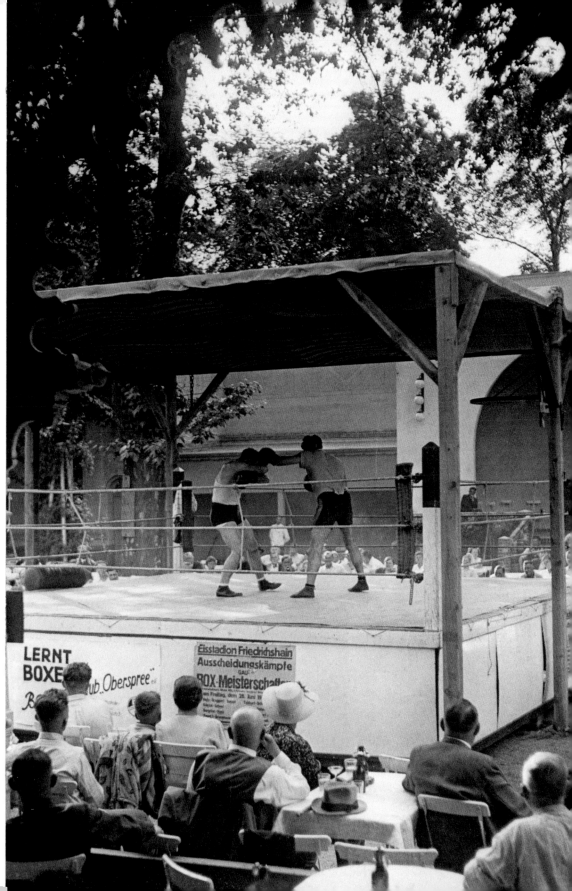

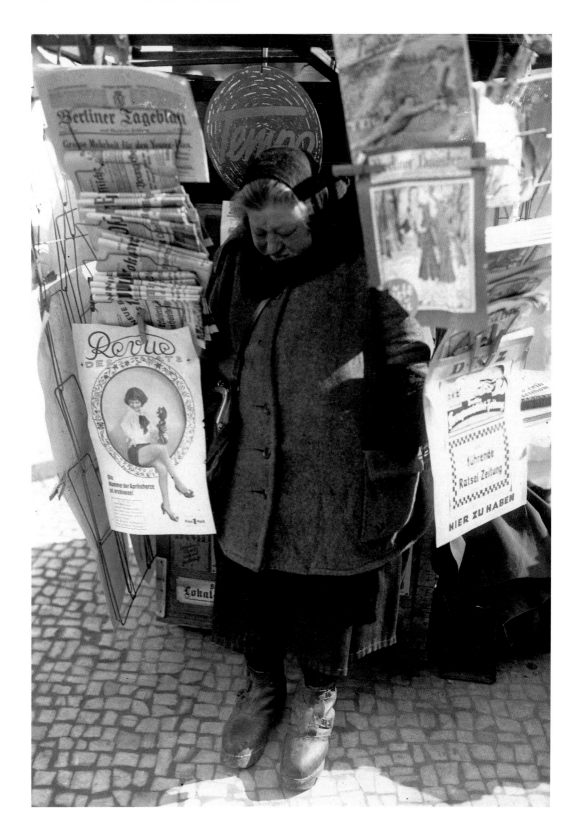

precarious freedom of thought and freedom of action really were in those days. With what was to follow, the political set itself against the aesthetic, the totalitarian against the libertarian. The Pop Art of the Sixties differed from the proto-Pop Art of the Twenties in one fundamental and historical way: forty years on, it was able to take root in a culture of democracy which had long since been taken for granted; it was a long-established and almost universal conviction.

Heinrich Mann called his performance at the department store a memory of public life during the Republic. Although this may be a form of heroic homage to the public, it certainly does not make any concessions to its mentality. The piece of prose that he recited the best would have been performed no differently had he chosen to do it in the style of his brother – that is, at an exclusive soirée, in front of a spell-bound audience of cognoscenti and enthusiasts. With his department store experience, Heinrich Mann showed his acceptance of the different forms of cultural distribution, although he did not acknowledge that this would therefore involve new forms of cultural production as well. His performance was a presentation of elite culture under conditions of mass culture.

It is of even greater interest to look into the cultural phenomena that emerged in this environment, as elite and mass culture became synthesized in order to produce a hybrid culture. There are four main avenues to explore: the mass media, propaganda through pictures, radio and architecture.

Mass media: It has been calculated that in Berlin in 1929 there were 2,633 magazines and newspapers, of which at least 147 were daily

Opposite:
Newsvendor in Friedrich-Wilhelm-Platz,
c. 1930. Photograph.

Above:
Newsvendor Pauline Fröhlich, 1931.
Photograph.

Left:
Mobile newspaper stand with Nazi publications,
1930. Photograph.

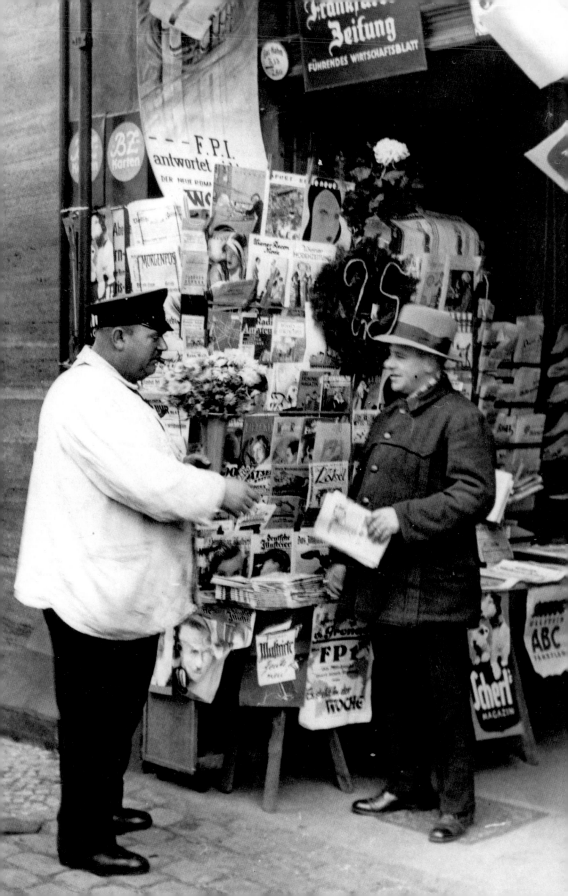

newspapers. Three companies divided the lion's share between them: Ullstein, with the flagship papers *Vossische Zeitung* and *Berliner Morgenpost*, Mosse with the *Berliner Tageblatt*, and Scherl with *Berlin am Morgen* and *Berliner Nachtausgabe*. In addition, there were the political publications such as the Communist paper *Der Rote Fahne* and the Socialist Paper *Vorwärts*. A new genre of photo-journalism was developing, led in particular by the *Berliner Illustrierte Zeitung* published by Ullstein, its proletarian counterpart *Arbeiter Illustrierte Zeitung*, which was published by the agitprop multinational Willi Münzenberg, cultural magazines like Ossietzky's *Die Weltbühne* and, finally, numerous regional newspapers from the provinces, especially Kracauer's *Frankfurter Zeitung*.

All of this meant that there was an immense demand for articles, and naturally a corresponding output, shaping one of the particular characteristics of Berlin in the Twenties: the most important texts to

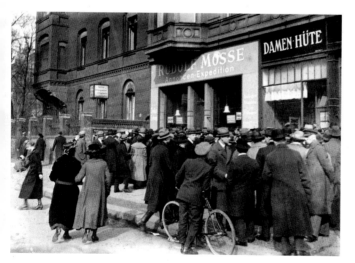

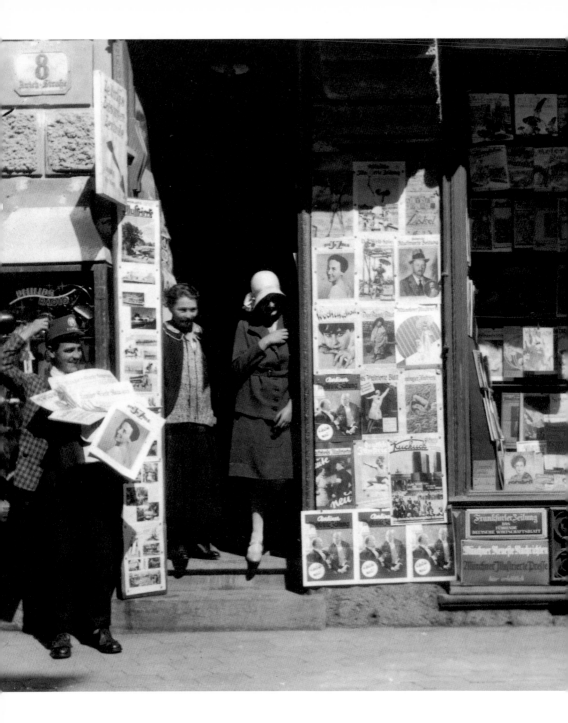

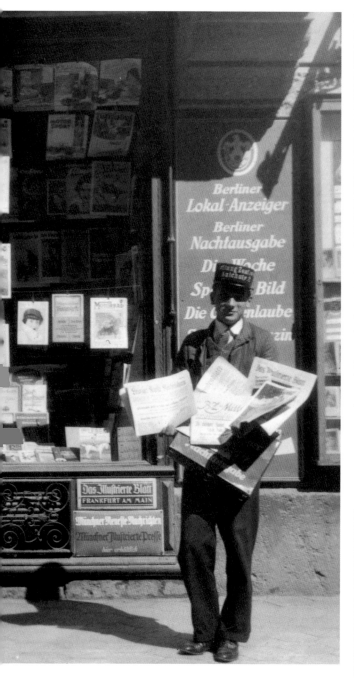

Left:
A Berlin newsagent, c. 1930. Photograph.

Above:
Rudolf Ullstein, c. 1925. Photograph.

Below:
Die Weltbühne, 29th year of publication, issue no. 9 (the very last, published on 28 February, 1933).

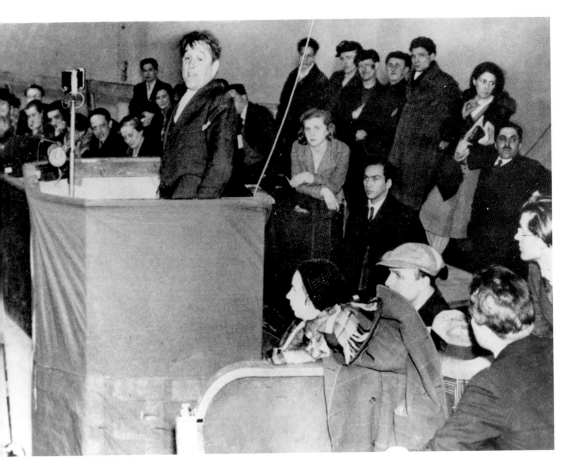

Above:
Willi Münzenberg, editor of Arbeiter Illustrierte Zeitung, *and member of the German Communist Party, at a press conference of the Internationale Arbeiterhilfe ('International Assistance for Workers') in the Palace of Sport, Berlin, 3 March, 1932. Photograph.*

Opposite, above:
Secessionist Ball in Berlin: the publisher Ernst Rowohlt (far right) with (from left to right) Clärenore Stinnes, Heinrich Heuser, Olga Chekhova and the architect Leyser, 1926. Photograph by Zander & Labisch.

Opposite, below:
Box at the Press Ball in Berlin. From left to right: Marlene Dietrich, Maria Paudler, Luigi Pirandello, Liane Haid, Max Hansen, Anita Davis, Anni Ahlers and Theodor Däubler, 1929. Photograph.

Berlin
und
Paris
im

Mai 1931
: M 1,50

QUERSCHNITT

...yläen - Verlag, Berlin

Above: Der Querschnitt, *founded by Alfred Flechtheim, 11th year of publication, issue no. 5. Yellow card with cover drawing by Chas-Laborde. Berlin: Propyläen-Verlag, 1931.*

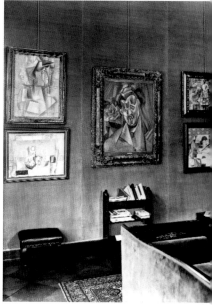

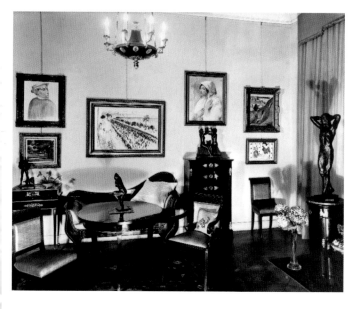

Left:
Alfred Flechtheim, c. 1928. Photograph.

Above and below:
Home of the artist Alfred Flechtheim: gallery wall with Cubist paintings and drawing room, 1929. Photograph by Zander & Labisch.

Above:
John Heartfield, c. 1928. Photograph.

Below:
Propaganda poster for the Nazi Party on the building of the Angriff publishing house on Wilhelmstraße, November 1932. Photograph.

Opposite:
John Heartfield, The Meaning of the Hitler Salute. *Cover of* Arbeiter Illustrierte Zeitung, *issue no. 42, October 1932.*

course—only last week my father sprained his ankle in the synagogue." He says he might have known it by my curly hair. Actually it is waved and by nature as smooth as oil.'

Propaganda through pictures: This refers both to the advertisements covering the streets and squares, and to the methods of production of the various forms of propaganda, including photomontage and typography, which flourished in Berlin during the Twenties. From an anti-class point of view, the Weimar Republic was of course capitalist, and advertising was its chosen medium. What was distinctive about the propaganda was its political nature. The era of party propaganda had begun: there were constant elections, whether to elect a new Reichstag or to choose a new president of Germany, and frequently the people had to vote a second or even a third time because the result had been inconclusive. Unlike today, when the slogans and key words hardly seem to vary, in the realms of totalitarian regimes they encompassed the whole of social and, within a short space of time, individual existence, and the copious numbers of posters on display needed to communicate that. Hence the precision work demonstrated in the second half of the decade by John Heartfield, a descendant of Expressionism and one-time Dadaist, who devoted all his energies to the art of photomontage. He devised posters for the Communist Party, likewise produced covers for the *Arbeiter Illustrierte Zeitung*, and developed the medium as a highly appropriate vehicle for agitprop, as evidenced by the productions of amateur theatre groups, and by various theses by Piscator on the subject.

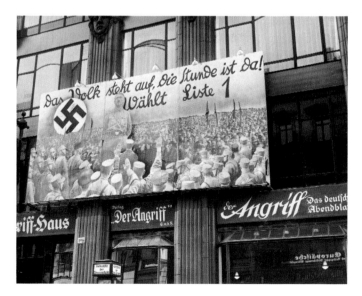

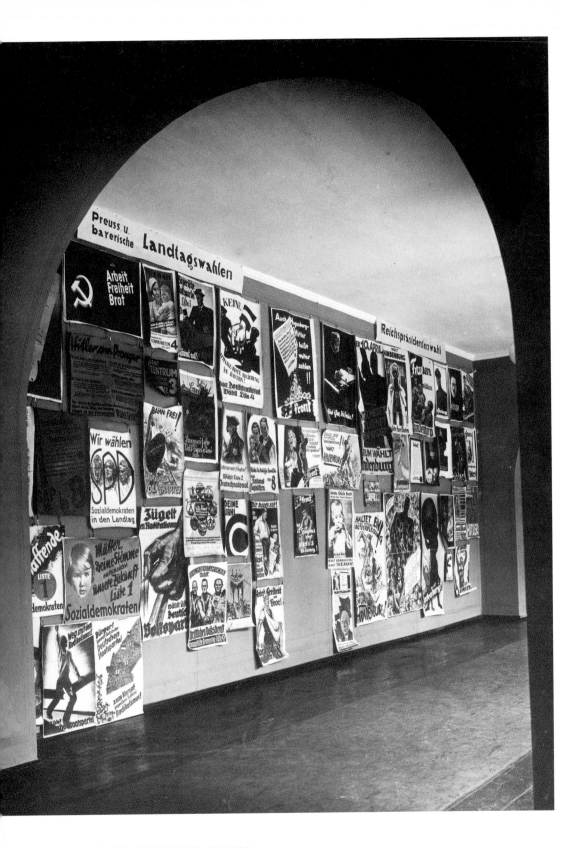

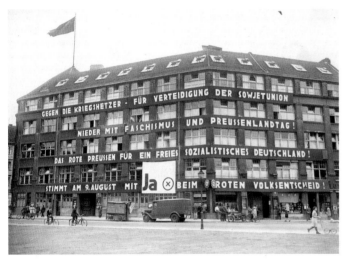

Opposite:
Exhibition of posters at the Berlin School of Politics, July 1932. Photograph.

Left:
Election party campaigners with placards, outside a polling station during the Reichstag elections, 6 November 1932. Photograph.

Centre:
Karl-Liebknecht House in Bülowplatz, the central headquarters of the German Communist Party, advising people to vote red in the referendum after the dissolution of the Prussian state parliament, 1932. Photograph.

Below:
Minister of the Interior Carl Severing leaving the polling station on Französische Straße, 10 April 1932. Photograph.

Overleaf, left:
Poster for the 'Advertising Show', 1929. Colour lithograph by Lucian Bernhard and Fritz Rosen.

Overleaf, right:
'The polyglot mannequin who is able to write' at the Berlin 'Advertising Show', 1929. Photograph.

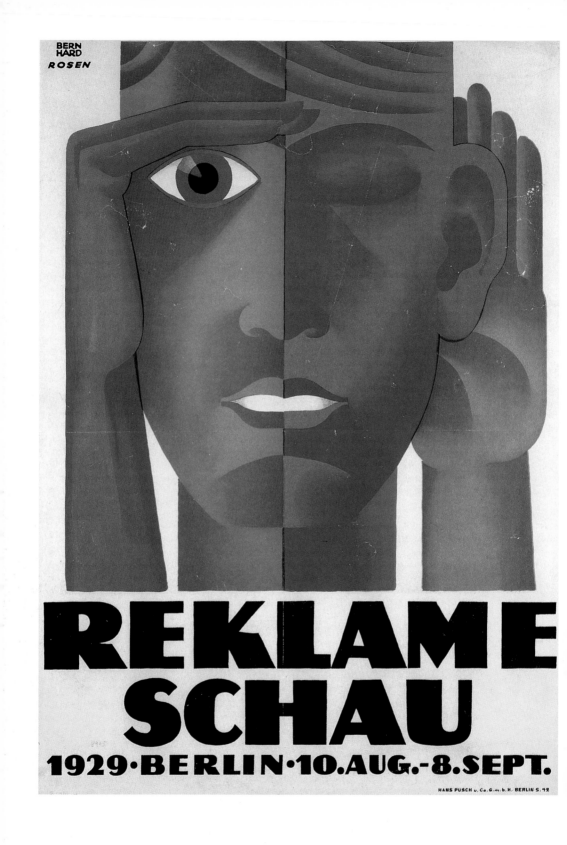

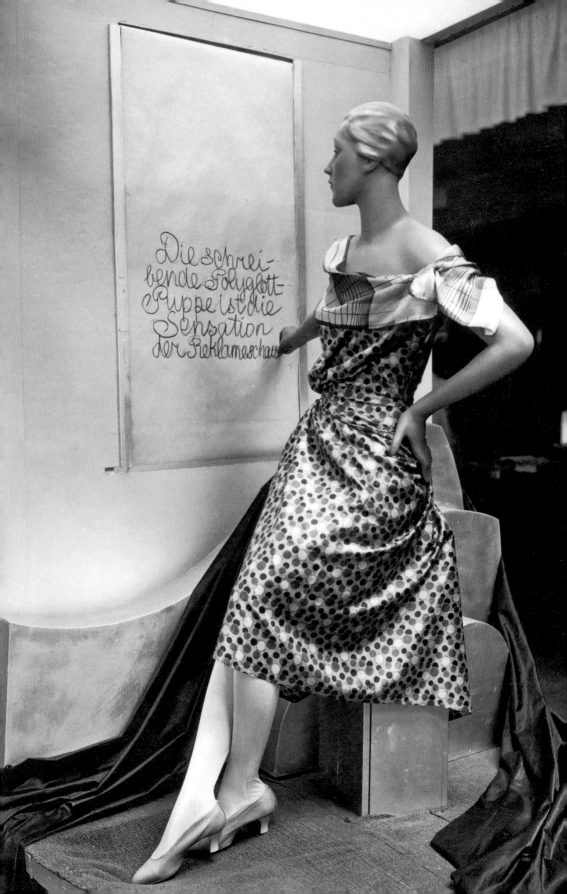

Die schrei-
bende Polyglott-
Puppe ist die
Sensation
der Reklameschau

Opposite:
Advertisement in a window of the Schocken department store, c. 1930. Photograph.

Above:
Advertisement for a Berlin motor showroom, c. 1930. Photograph.

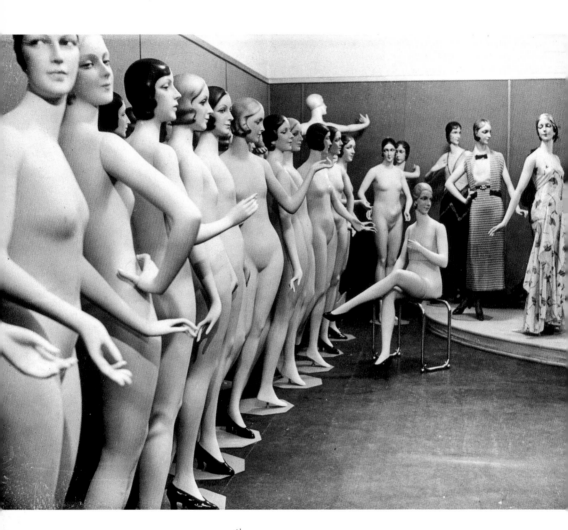

Above:
Modern mannequins produced by the Haefner & Schön factory, 1929. Photograph.

Opposite:
Pupils at the Berlin School of Ballet copying the pose of a mannequin, c. 1930. Photograph.

Overleaf, left:
Dressing the leg of a mannequin, c. 1925. Photograph.

Overleaf, right:
The 'Pixavon Queen' Jaggy Grasmann, c. 1925. Photograph by Anton Sahm.

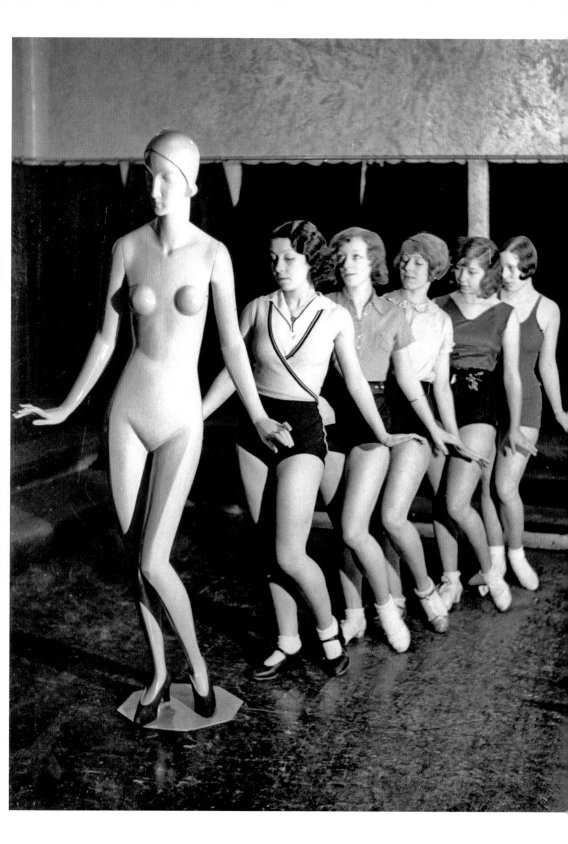

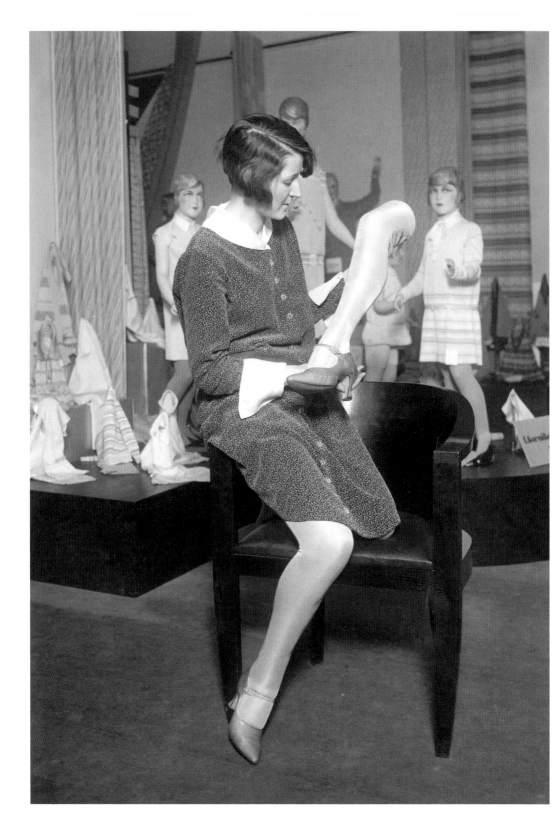

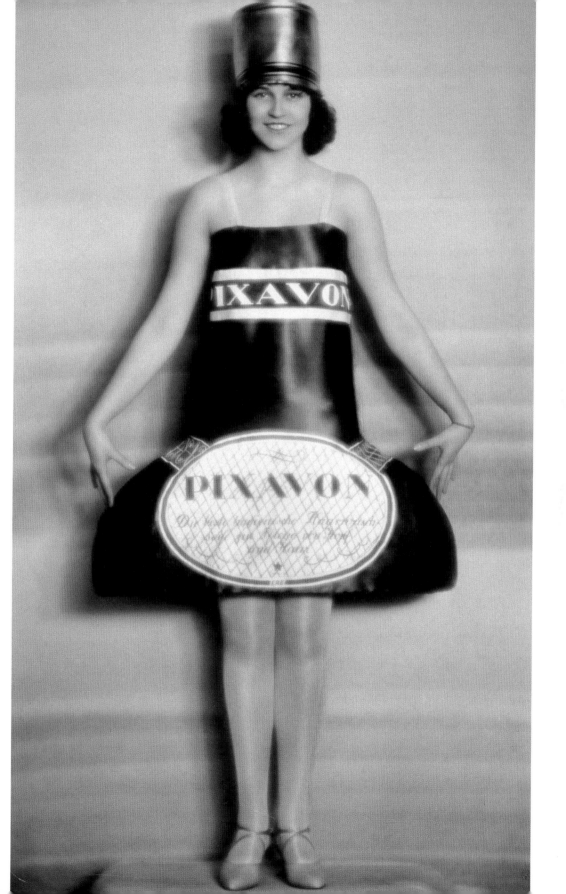

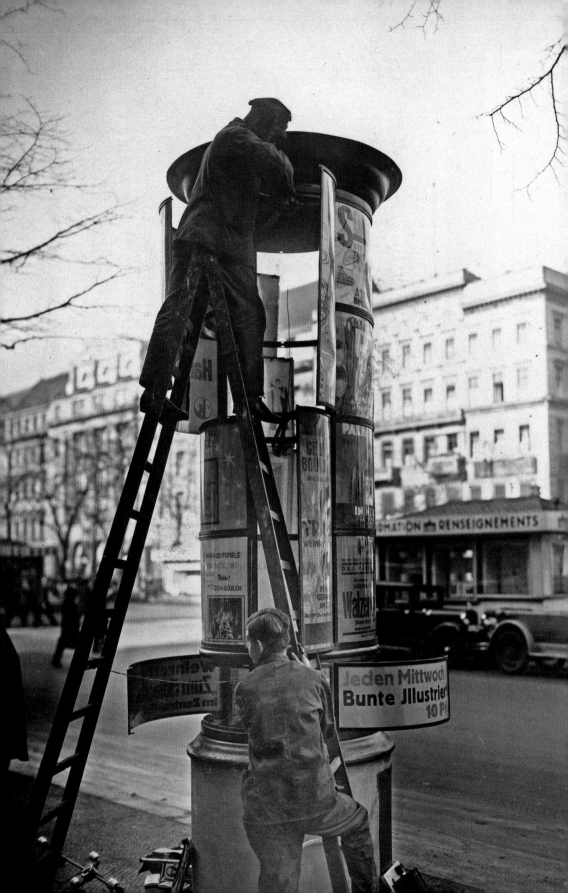

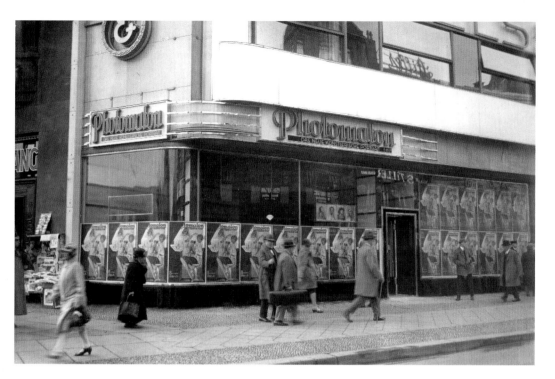

Opposite:
Installation of the first illuminated advertising
column on the corner of Friedrichstraße and
Unter den Linden, October 1930. Photograph.

Above:
New, automatic photo-machines for self-
portraits in Potsdamer Platz, c. 1930.
Photograph.

Below:
Flower vendors in Potsdamer Platz, with the
Columbus Building in the background, c. 1930.
Photograph.

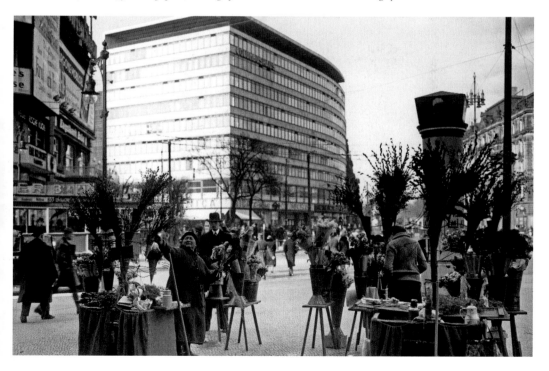

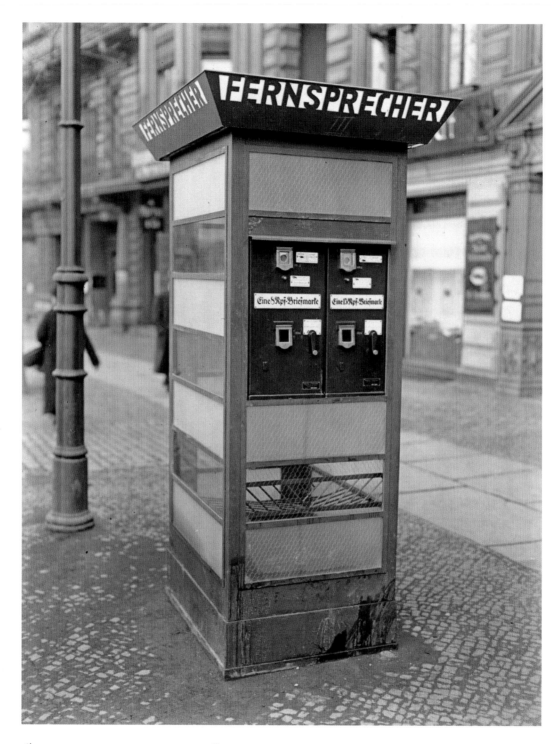

Above:
Telephone box with stamp machine at Hallesches Tor, c. 1920. Photograph.

Opposite:
Königgrätzer Straße in Berlin-Kreuzberg, renamed after Gustav Stresemann, March 1930. Photograph.

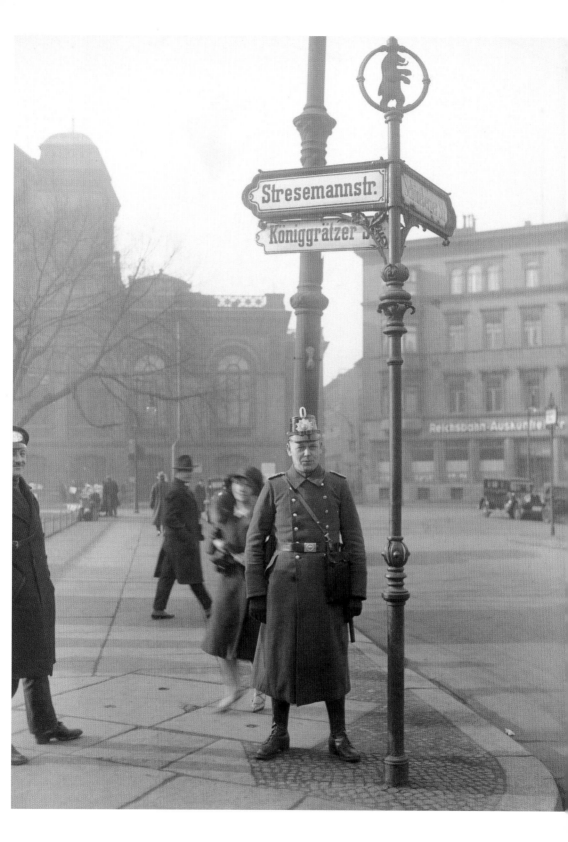

Hitler was the figure par excellence to be on the receiving end of Heartfield's despairing malice. One of his collages has the title *The Meaning of the Hitler Salute*. The Nazi chief is portrayed not with the raised right-arm salute stretching forward, but stretching backwards, palm facing upwards in precisely the right pose to receive the bank notes casually being placed into it by the figure of an old traditionalist, an industrialist through and through. The motto runs 'Millions stand behind me'. The collage was made in 1932; it was Heartfield's last attempt to stop the unstoppable, for the millions referred to in the desperate reality of the motto were not only flowing from capitalist coffers, but from the masses too. If there was a corresponding culture to this in the visual sphere, then it was Heartfield who invented it. For their own part, the Nazi poster designers were quick to poach his ideas when the time came.

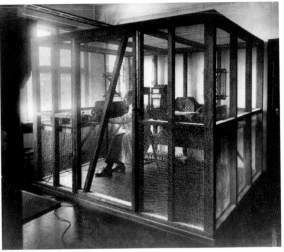

Radio: On the evening of 29 October 1923, when inflation was
running at an all-time high, a new phenomenon flowed out of the
so-called Vox-House in Potsdamer Straße and overwhelmed the city
of Berlin. Perhaps 'overwhelmed' is an exaggeration: there were just
200 listeners who were able to follow the first radio transmission as
there were no more radios available. Nonetheless, a further dam had
been burst by the flow of mass communication.

More and more people began to tune into the airwaves: according
to one statistic, in 1931, 48 out of every 100 households possessed
a radio. To begin with, the transmissions were mainly all live; a
mixture of news, lectures and music, mostly classical, dance and
'entertainment' – light *muzak* performed by a string orchestra. Soon
radio plays were added; some were especially written for radio, but
others were dramatizations of existing prose, such as an adaptation
of Alfred Döblin's *Alexander-Platz, Berlin*. Radio had succeeded in
creating a new aesthetic, and, above all, it proved to be a catalyst in

Above:
A family listens to its home transistor radio,
c. 1933. Photograph.

Below:
Britz, the horseshoe-shaped housing estate in
Neukölln, built between 1925 and 1933
to a design by Bruno Taut. Photograph.

be a far cry from the misery of the rented blocks, which stood in rows five deep; as the quality of light diminished with each successive row, the rent decreased and the level of dilapidation grew worse. The architectural publicist Werner Hegemann published a book in 1930, in which he proclaimed his adamant opposition to this 'stony-faced Berlin'; this wilderness, which had been created by the mentality of bureaucracy and the financial greed that had been so prevalent during the years of the population explosion. According to Benjamin, Hegemann was seething with righteous indignation, 'a Jacobin of our times', as he put it. The causes for such indignation would presumably have melted away once the city had come under the aegis of its new architectural director, Martin Wagner. Architects sought to reconcile city living with a greener way of life: Bruno Taut and his horseshoe-shaped housing estate in Britz, Neukölln, Walter Gropius with his Siemensstadt complex, Erich Mendelsohn with his Woga project, and Hans Poelzig with his accommodation units in Zehlendorf. Almost as a by-product, they also succeeded in reconciling their utopianism with a contemporary pragmatism.

One final insight, and totally in keeping with the spirit of Berlin, is afforded by the Republic's contribution to the World's Fair of

1929. Mies van der Rohe, then a member of the Bauhaus and soon to be its director from 1930, when he supervised the institute's final move into the capital, designed his Barcelona Pavilion for the universal exhibition. Such exhibits also represented the state of mind of the nation, and in designing the pavilion he chose to show the Germany of the 'Golden Twenties', full of optimism and open to the world. The Barcelona Pavilion demonstrated a democratically legitimate aesthetic; it was the sovereign idea of a high culture available to all.

The culture of the masses in Berlin was indeed something of which people were proud, as expressed by Count Harry Kessler in 1930. At the time, he was hosting the French sculptor Aristide Maillol, and he appears to be giving an explanation of the new style of relationships, as reflected by all the young bodies exercising in the swimming pool: 'I explained to him that this is indicative of only a part of a new vitality, a fresh outlook on life, which since the war has successfully come to the fore. People want really to *live* in the sense of enjoying light, the sun, happiness, and the health of their bodies. It is not restricted to a small and exclusive circle, but is a mass movement which has stirred all of German youth. Another expression of this new feeling for life is the new architecture and the new domestic way of living.'

Kessler's optimism in the face of a 'mass movement', which expressed itself freely both in nude bathing and new building, was in all honesty the flipside of the principle of the masses, a principle that the German youth had already grasped. The Nazis were to pervert this into a tool for their backlash: to implement the restitution of base instincts and selfishness, and to render life devoid of meaning. It is hard to imagine all of this being embraced by a nation like Germany. The most glorious culture was to be transformed into the most inglorious subculture. The final chapter will explore how the successes of the golden age of Berlin were perhaps to some degree complicit in the degeneration into the utmost vulgarity. Although there were other influential cultures, it was primarily the culture of Berlin that had taught the masses a lesson, which they had taken on board beyond all expectation. The lesson was simply the art of being important. The torchlight procession in January 1933 proved that Siegfried Kracauer was correct in what he had observed: the fact that the millions of Berliners were, indeed, not to be ignored.

Above:
Ludwig Mies van der Rohe, design model for a tower block made from glass and steel, c. 1925. Photograph.

Overleaf:
View of the Weiße Stadt, in the Reinickendorf area of Berlin, c. 1930. This residential area for workers was built in 1929–30 to plans by Otto Rudolf Salvisberg. Photograph.

Pages 354–55
Torchlight procession through the Brandenburg Gate along Unter den Linden, to mark the fourth anniversary of Adolf Hitler's election as Chancellor of Germany, 30 January 1937. Photograph.

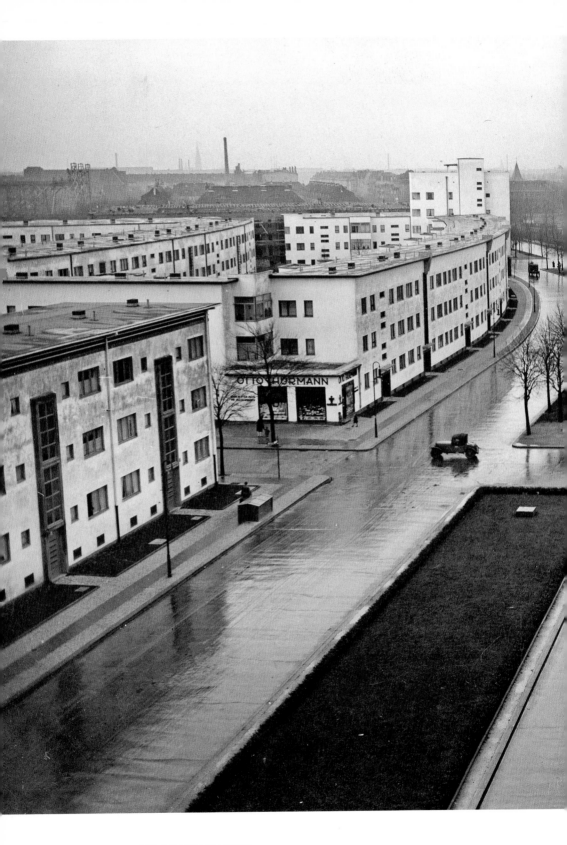

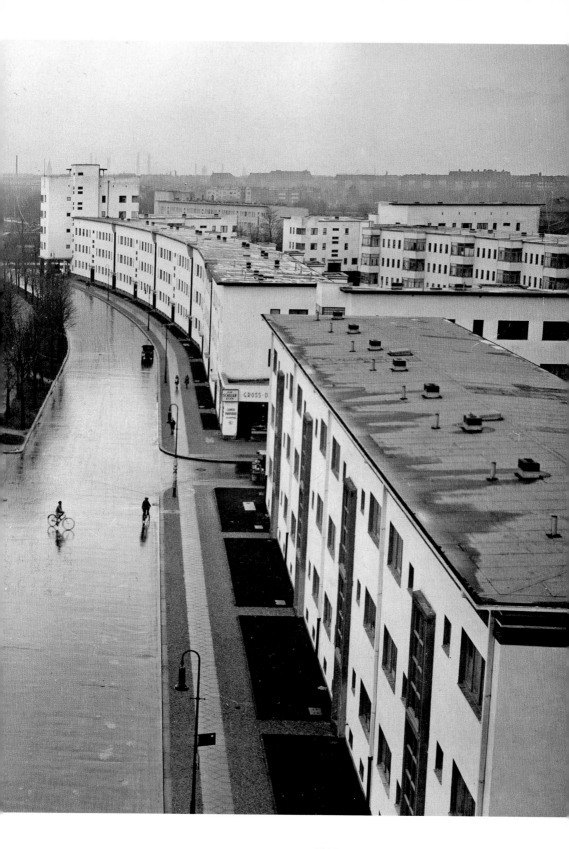

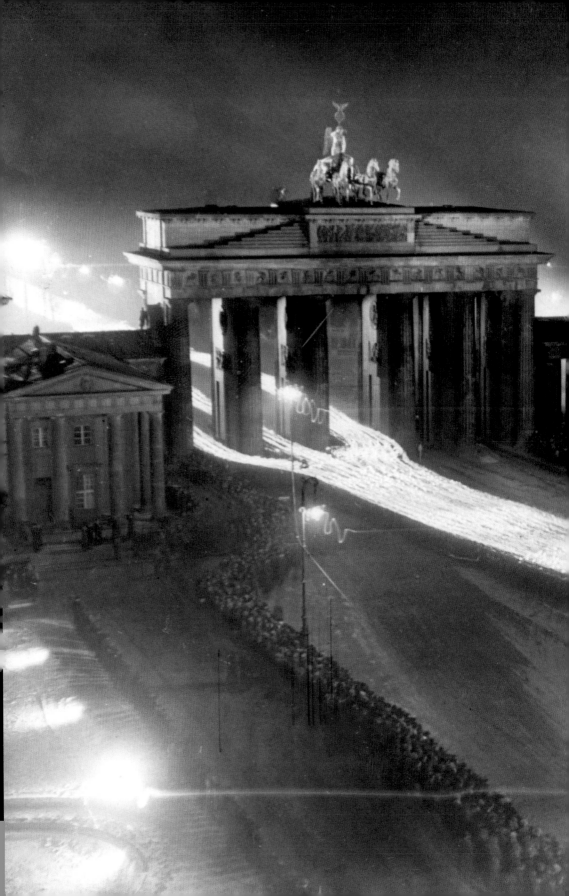

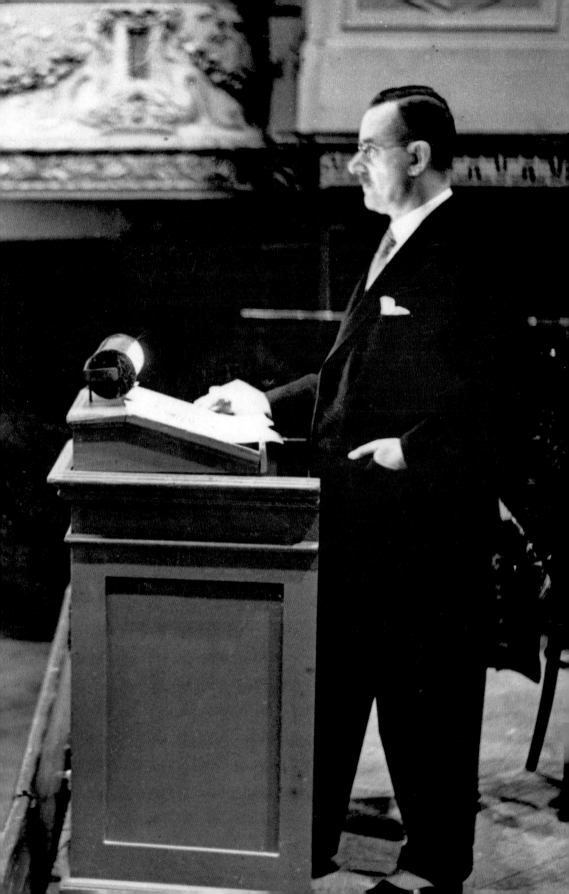

Above:
Beginning of the Six-Day Race in the Palace of Sport, 1929. Photograph.

Below:
Beginning of the 50 lap competition in the Palace of Sport, c. 1930. Photograph.

insistent and pernicious than the unworldliness of those political romantics who took us into the war. Nurtured on such spiritual and pseudo-spiritual fodder, the movement has become part of the huge wave of eccentric barbarity and primitive mass democracy which has all the coarse vulgarity of a fun fair about it. This wave is engulfing the world; it is the product of the wild, confused, exhilarating and intoxicating impressions that have been flooding into people's lives. Adventurous developments in technology, with their corresponding triumphs and disasters; the wildly over-estimated, wildly over-paid, and wildly crowd-pulling superstars; boxing championships hosting reams of honoured guests and attracting crowds of thousands: these and other such examples provide us with a picture of our times, together with the disintegration and loss of those wholesome and disciplined concepts such as culture, spirit, art and ideas.'

This crude plea for a return to the authority of the old, canonical system reveals that Mann has clearly not yet come to terms with the reality of his contemporary society. The key components in this

graphic factor: the baby boomers from the years between 1900 and 1914 were the generation who had learned about the reality of the war from inside their own homes, and they were excited by the war games staged by the Nazis. Finally, the intellectuals to whom Thomas Mann had addressed his famous speech turned their desks into dictatorships of despair, and prepared themselves for *The Decline of the West*, as outlined in Oswald Spengler's infamous book which was published in 1920. In addition to all of these factors, there is no denying that the Nazis were skilful, particularly their propaganda minister Joseph Goebbels, who had come to Berlin in 1926 to be a gauleiter. Full of evil intentions, the Nazis cashed in on all that the Republic had achieved, from its motorways, and its Olympic Games in 1936, down to the last technical innovation within the media.

Epochs in history have tended to announce themselves in some shape or form. However terrible the Nazi era was, we cannot but accept that it displayed a certain unity and, in its own way, summed

Opposite:
Joseph Goebbels making a speech in the Palace of Sport, during the Reichstag elections in 1932; a group of SS-guards is in the foreground. Photograph.

Below:
A racing championship on the new motorway at Frankfurt am Main between Rudolf Caracciola in a Daimler-Benz, the fastest German racing car, and a Heinkel 70 'D-UJET', the fastest German aircraft, November 1936. Photograph.

Above:
Adolf Hitler presiding at the opening ceremony of the Olympic Games, 1936. Photograph.

Opposite:
Closing ceremony of the Olympic Games, 16 August 1936. Photograph.

up the nature of the times. The bitterness of the Thirties would appear to be the fulfilment of prophecies that emanated from the glorious Twenties. The first half of the 1920s, the era of late Expressionism, which had been interrupted by the First World War, was characterized by the deep desire for purity, by an all-encompassing pathos, and by the firm conviction that the world must be made into a better place. The works of art from this era speak volumes: they involve genuine explorations of what it is to feel deeply rooted, to go back to one's origins and to the creation of all things, to feel a connection with the earth and with the under-world. These criteria were typical of the time, but in their tendency towards the ideological, they were then to find a different kind of expression within Hitler's ideology: purity became 'racial purity', pathos accompanied every appearance of Hitler's henchmen, and the chthonic element manifested itself in blood and earth. The late Twenties seem to have been characterized by forces directly

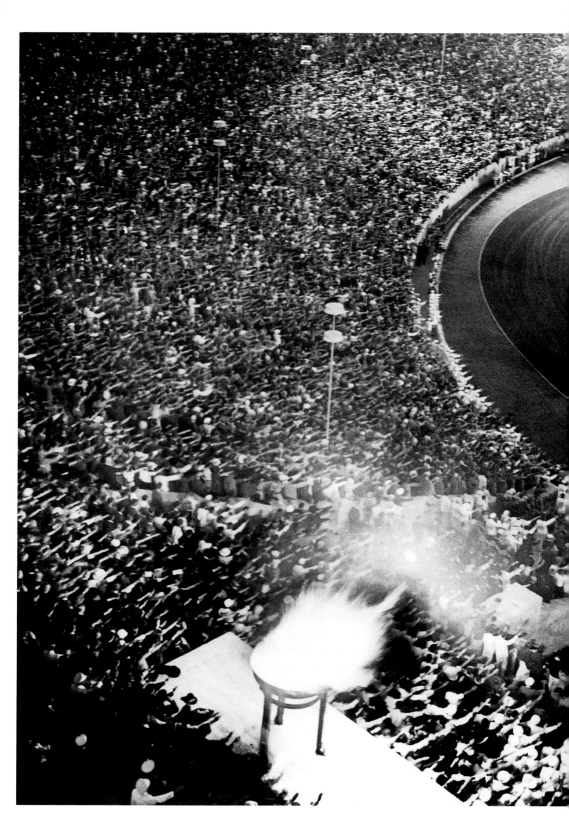

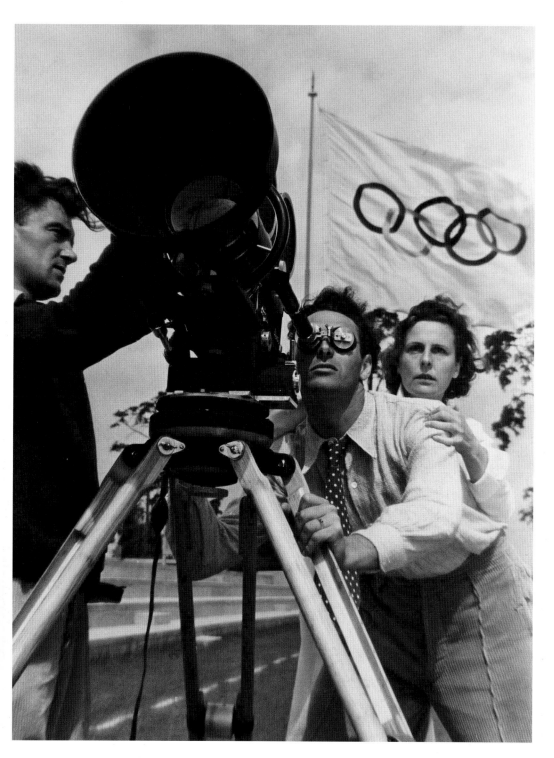

Opposite:
Leni Riefenstahl, 1930. Photograph by Lotte Jacobi.

Above:
Leni Riefenstahl directing the filming of the Olympics, 1936. Photograph by Lothar Rübelt.

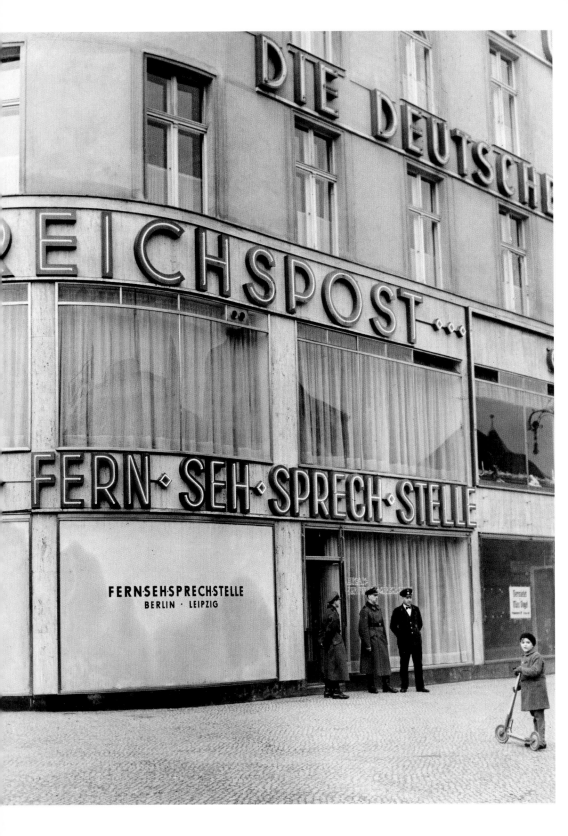

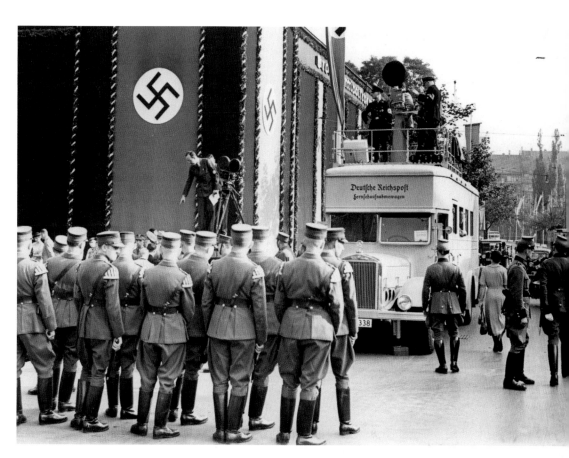

Opposite:
The first Fern-Seh-Sprech-Stelle ('Tele-Visual-Speaking-Point') in Berlin, for telecommunication with Leipzig, 1936. Photograph by Paul Mai.

Above:
A television broadcasting van belonging to the Reichspost ('Post Office'), during the first broadcast of a party conference in Nuremberg, 1937. Photograph.

Left:
The first attempt at a live broadcast of the summer Olympics, August 1936. Photograph.

opposed to those of the early Twenties, and again this is manifested in the most important works of art of that time. A certain reserve and coolness came into play, along with an element of distance towards feeling, and there was an unashamed desire for diversion, for losing oneself in entertainment, and for the sensation of plunging into a kind of wild free-flow with everyone else. This was the

Left:
Members of the Reich on their way to the Garnison Church. At the front, Adolf Hitler, Reich Chancellor; next to him on the right, Hermann Göring, President of the Reichstag, followed by Vice-Chancellor Franz von Papen, Joseph Goebbels and Paul Eltz von Rübenach, Minister for Transport, 21 March 1933. Photograph.

Below:
Adolf Hitler with the Reich President Paul von Hindenburg, 1 May 1933. Photograph.

Opposite:
Adolf Hitler (left) with Hermann and Emmy Göring and their baby at an evening function, c. 1937. Photograph by Rosemarie Clausen.

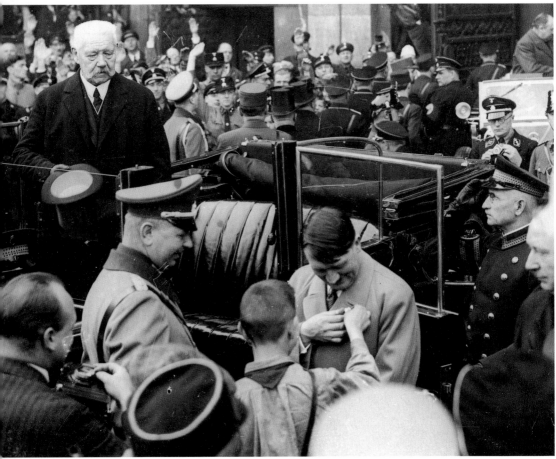

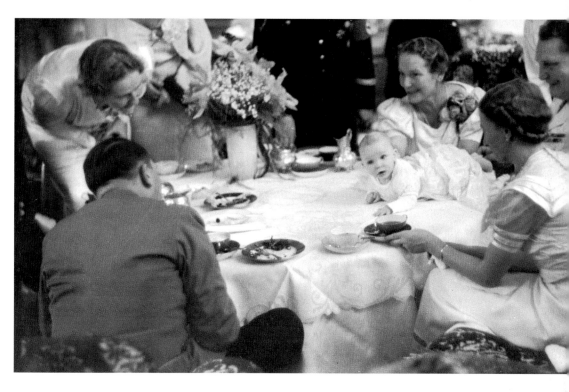

culture of the masses, and each person abandoned himself to the joy of unity with the crowd. Again, these tendencies towards the ideological found their parallels in the mentality of the Nazi period: distance became arrogance, reserve was transformed into the belief in selection and superiority, and the free-flow of amusement translated into participation in the parades and dressing up in the uniform of the movement. Finally, the culture of the masses, which had brought together rich and poor in a new hybrid form, became the folklore of the Nazi national comrades. The culture of variety became an obsession with homogeneity, which could only result in either compulsive enjoyment or fatal exclusion.

The formula outlined above may appear to be a forced attempt to unite elements that are incompatible and categorically different. There is however a big difference, which encapsulates the whole essence of the matter: the cultural achievements of the Twenties were essentially and predominantly self-defining. 'Movement' means a dance, not a political party, and 'purity' refers to the aesthetic qualities of purism and not to a biological view of racial selection. The Nazis adopted these concepts and gave them a different, political focus, distorting and adapting them to use in the promotion of their own perverse ideas. As aesthetic manifestations, these concepts and phenomena do not exclude anyone; on the contrary, they intend to

Below:
Three children presenting Adolf Hitler with a bouquet of flowers on a mountain farm, c. 1935. Photograph.

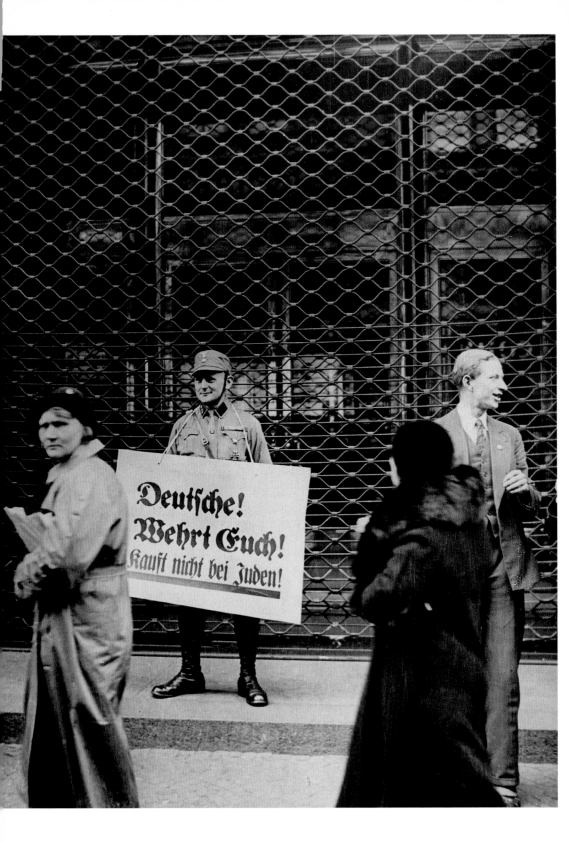

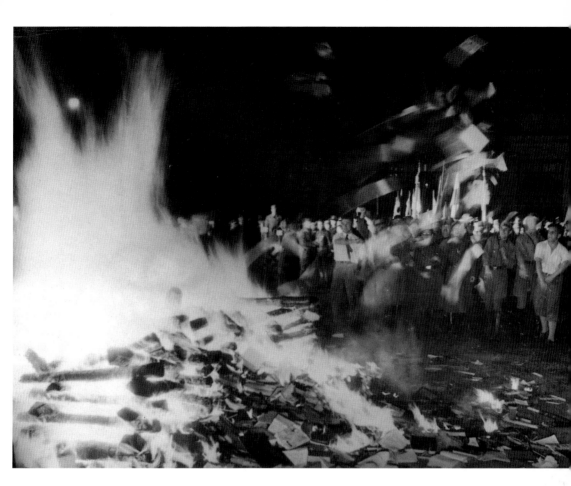

Opposite:
Nazi boycott of Jewish shops in Germany: a member of the SA stands guard in front
of the entrance to the Tietz store in Berlin, which had been forcibly closed, with the placard
'Germans! Defend Yourselves! Do not buy from Jews!', 1933. Photograph.

Above:
The bonfire of books organized by the Nazis in
Opernplatz, Berlin. Joseph Goebbels is addressing
members of the German students' union during
the campaign 'Wider den undeutschen Geist',
10 May 1933. Photograph.

Below:
'Beach for non-Aryans': German bathing
regulations being enforced at a beach on the
Ostsee, following the introduction of the
Nuremberg racial laws, c. 1937. Photograph.

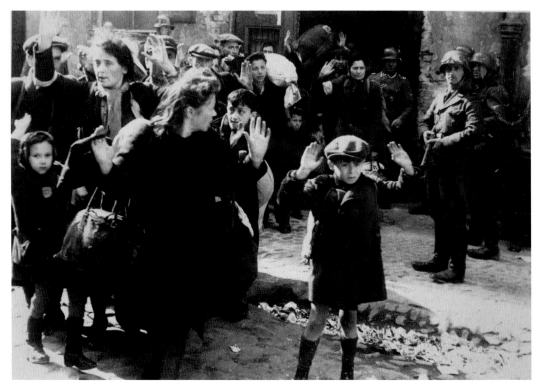

Above:
Warsaw ghetto uprising, April/May 1943:
a small boy puts his hands above his head as
women and children flee from a house that has
been stormed by Nazi troops. From the photograph
album belonging to SS group leader and police
superintendent Jürgen Stroop. Photograph.

be relevant to all. As political manifestations, they are fully intent on exclusion, and their aim is total homogenization. The difference is abundantly clear, as are the similarities.

In August 1914, a wave of euphoria swept through Germany, which it was hoped would sweep away all social, economical and ethnic differences. There was a passion for war and the promise of a classless society in an eternal moment of triumph. It soon became clear that the frenzy of egotism was fruitless, and frustration took hold. Maybe the euphoria had been greater than in other countries; the sense of dejection certainly was, and so was the wave of reaction that followed. The cult of distraction was the product of a mass psychology, in which total dejection was followed by total diversion. The spectacular 'art for all', which set Berlin apart in a uniquely alluring world, breaking down all barriers of high and low culture, was in reality a form of surrogate euphoria. The aesthetic world could provide in a lasting – or at least renewable – form what had only been a short-lived sensation in the political world. The political version may have been a more intense sensation than that afforded by a revue or a trip to the cinema, but it was a one-off, unrepeatable experience that ended ignominiously. Berlin's culture of the spectacular was none other than the promise of a mass euphoria that could be enjoyed in the long term.

When someone came along offering a more far-reaching promise of a mass euphoria that would once again be based in the political world, in a palpable reality, he needed only to catch the direction of the prevailing wind. He found people ready to follow him unconditionally, not only those who benefited from the soup kitchens, or those who were in receipt of unemployment benefits. He found his revolutionaries in the dance halls, in the cinemas, in the revue bars. He found them, as it were, thronging the entrances to the establishment, and being turned away by the bouncer for being too aggressive; he showed them in via a side entrance, with the promise that this second door was the gateway to paradise. The mentality that there was indeed such a thing as paradise, and that there might be a second door leading to it, was already embedded in people. It was a product of the golden years of Berlin in the Twenties.

Below:
Adolf Hitler in the garden of the Chancellor's office in Berlin, talking to members of the Hitler Youth movement, who are being awarded the 'Iron Cross' for their courage. Filmed to be shown on the final weekly news round-up, Die Deutsche Wochenschau, *on 23 March 1945.*

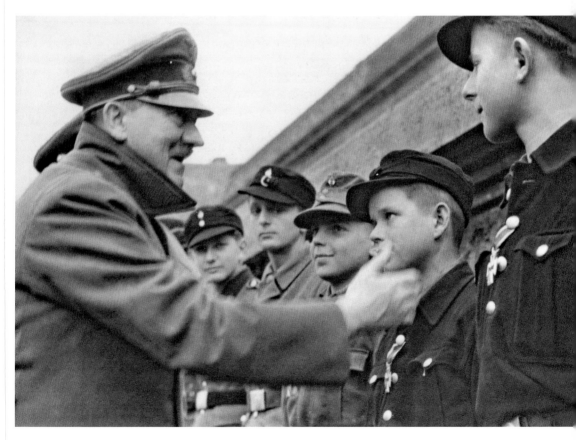

Einstein, Albert (1879–1955) Physicist. In Berlin from 1914 at the Prussian Academy of Science (without teaching commitments); emigrated in 1933 to the USA. Developed the Theory of Relativity; declared pacifist; winner of the Nobel Prize in 1921.

Eisler, Hanns (1898–1962) Composer. Pupil of A. > Schönberg; active in Berlin from 1925; collaborated with Bertolt Brecht; emigrated in 1933 (Vienna, Paris and the USA); moved back to East Berlin in 1949. Composed music for the stage and songs.

Finsterlin, Hermann (1887–1973) Painter and writer. Lived in south Germany; worked on fantastical architectural designs that were exhibited in Berlin (1917–24). (B. > Taut).

Fischer, Samuel (1859–1934) Publisher. Founded the publishing house of the same name in 1886, which continued under the management of Gottfried Berman (1887–1995); after 1936 lived in Vienna, Stockholm and Amsterdam, then in Frankfurt from 1950. One of the leading literary publishers of the time, along with E. > Rowohlt.

Flechtheim, Alfred (1878–1937) Gallery owner. Lived in Berlin from 1927; managed many different gallery branches in Germany; emigrated in 1933 (Paris and London). An important dealer in contemporary art as well as African and Oceanic sculpture. Co-publisher of the magazine *Der Querschnitt*.

Freund, Gisèle (1908–2000) Photographer and sociologist. Born in Berlin; emigrated to France in 1933. Specialized in portrait photographs of writers and intellectuals.

Freundlich, Otto (1878–1943) Painter. Lived in Cologne and Berlin between 1919 and 1924, exhibiting in the New Secession in Berlin, and was a member of the Novembergruppe there; based largely in Paris thereafter, until he was sent to the Majdanek concentration camp in 1943. Exponent of abstract art.

Gert, Valeska (1892–1978) Dancer and cabaret artist. Also involved in films from 1925; emigrated in 1933 (France, London and the USA); lived back in Germany from 1949, in Sylt, West Berlin. Achieved international recognition early on in her career.

Goebbels, Joseph (1897–1945) Member of the Nazi Party. Joined the NSDAP in 1925; worked as a gauleiter in Berlin from 1926; elected to the Reichstag in 1928; in 1933 appointed Minister of People's Enlightenment and Propaganda; committed suicide in 'Hitler's bunker' before his arrest. Close friend of A. > Hitler; responsible for the subjugation of art and culture to Nazi ideals.

Göring, Hermann (1893–1946) Member of the Nazi Party. Joined the NSDAP in 1922; elected to the Reichstag in 1928; fulfilled various political roles from 1933; sentenced to death in 1946 in the Nuremberg trials; committed suicide. Leading politician under A. > Hitler, and an avid art collector.

Gropius, Walter (1883–1969) Architect. Born in Berlin; worked for P. > Behrens from 1908; then independent from 1910; founded the Bauhaus movement in 1919 and led it until 1928 (in Weimar and Dessau); then in Berlin again until he emigrated in 1934 (England and the USA). Exponent of the new style of building: in Berlin he constructed the Sommerfeld log cabin (1920–21) and apartment blocks in Siemensstadt (1929–30).

Grosz, George (1893–1959) Painter and graphic artist. Born in Berlin; organized the 'First International Dada Fair' in 1920 with R. > Hausmann and J. > Heartfield; emigrated to the USA in 1933; returned to West Berlin in 1959. Exponent of Dada and the New Objectivity; especially influential through his portfolios of satirical drawings (including *The Face of the Ruling Class* [1921], *Ecce Homo* [1922]).

Gründgens, Gustaf (1899–1963) Actor, director and producer. In Berlin 1922–23, and then from 1928 in many different theatres; married to E. > Mann (1926–29); involved in films from 1930; from 1937 director of the Prussian State Theatre; post-1947 in Düsseldorf and Hamburg; presumed suicide. Particularly famous for his Mephisto in Goethe's *Faust*; controversial on account of his collaboration with the Nazis.

Haller, Hermann (1871–1943) Director and producer. Born in Berlin; took over management of the Admiral's Palace in 1923; turned to operetta in 1930; emigrated in 1933 (Vienna and London). One of Berlin's 'revue kings' along with E. > Charell and J. > Klein.

Harbou, Thea von (1888–1954) Screenwriter and author. Active in Berlin from 1918; married to F. > Lang (1922–33), during which time she wrote many screenplays for him until his emigration. Very popular author.

Hartlaub, Gustav F. (1884–1963) Art historian. Director of the Kunsthalle Mannheim until he was forced out in 1933. Developed the concept of the New Objectivity, and founded an exhibition of the same name in 1925.

Hasenclever, Walter (1890–1940) Writer and journalist. Worked as Paris correspondent for the Berlin *8 Uhr Abendblatt* from 1925; lived in Berlin from 1930; emigrated to France in 1933; committed suicide. Expressionist lyricist and dramatist (including *Der Sohn*, 1914).

Hausmann, Raoul (1886–1971) Painter, photographer and writer. Moved to Berlin with his parents in 1900; lived and worked with H. > Höch (1915–22); founded the 'First International Dada Fair' in 1920 with G. > Grosz and J. > Heartfield; emigrated in 1933 (Paris and Limoges). Dadaist; specialized in photo-collages.

Heartfield, John (1891–1968) Painter, graphic artist and set designer. Born in Berlin; active there from 1913; founded the publishing house Malik-Verlag in 1917 with his brother W. > Herzfelde, for which he produced many books. Founded the 'First International Dada Fair' in 1920 with G. > Grosz and R. > Hausmann; designed stage sets for E. > Piscator; emigrated in 1933 (Prague and London); returned to East Germany in 1950 (Leipzig and East Berlin). Pioneer of political photomontage.

Hegemann, Werner (1881–1936) Town planner and publicist. In Berlin between 1909 and 1913, and after 1922; organized the 'International Exhibition of Town Planning' in 1910; emigrated to the USA in 1933; works included *Das steinerne Berlin: Geschichte der grössten Mietkasernenstadt der Welt* (1930).

Helm, Brigitte (1906–96) Film star. Born in Berlin; made her debut as Maria and the robot girl in F. > Lang's *Metropolis* (1927); withdrew from the world of cinema in 1935. Acted in over 30 films, often playing the *femme fatale*.

Herrmann-Neiße, Max (1886–1941) Writer. Active in Berlin from 1917; emigrated to London in 1933. Wrote Expressionist-style poetry, drama and prose (the novel *Cajetan Schaltermann*, 1920).

Herzfelde, Wieland (1896–1988) Publisher and writer. In Berlin from 1913; founded the publishing house Malik-Verlag with his brother J. > Heartfield in 1917; emigrated in 1933 (Prague, London and New York); returned to East Germany in 1949 (Leipzig and East Berlin). Leading left-wing publisher of the Weimar Republic, publishing the satirical drawings by G. > Grosz, amongst others.

Hessel, Franz (1880–1941) Writer. Active in Berlin from 1919. Worked as an editor in E. > Rowohlt's publishing house (1924–33). Emigrated to France in 1938. The city was the central motif in his prose (*Heimliches Berlin* [1927], *Spazieren in Berlin* [1929]).

Heym, Georg (1887–1912) Writer. In Berlin from 1908. Expressionist poet (*Der ewige Tag*, 1911).

Himmler, Heinrich (1900–45) Member of the Nazi Party. Joined the NSDAP in 1923. Appointed Chief of Police by A. > Hitler in 1933. Became Minister of the Interior in 1943. Taken prisoner in 1945. Committed suicide. Held largely responsible for the Holocaust.

Hindenburg, Paul von (1847–1934) Officer and politician. Field Marshall in the German Army in the First World War. Reich President from 1925, and re-elected in 1932. Appointed A. > Hitler as Reich Chancellor in 1933.

Hitler, Adolf (1889–1945) Leader of the Nazis. Leader of the NSDAP from 1921. Reich Chancellor from 1933. Committed suicide in his 'bunker' in Berlin before his arrest. Responsible for causing the outbreak of the Second World War by attacking Poland in 1939; responsible for the Holocaust.

Höch, Hannah (1889–1978) Graphic artist and photographer. In Berlin between 1912 and 1926, and from 1929; lived and worked with R. > Hausmann (1915–22); her work was banned (1933–45). Specialized in collages.

Hollaender, Friedrich (1896–1976) Composer. Moved to Berlin with his parents in 1900; emigrated to Paris in 1933; lived in Munich from 1956. Composed music for Expressionist dramas, as well as songs for cabaret shows, revues and films (including compositions for M. > Dietrich in *The Blue Angel*, 1930).

Hubbuch, Karl (1891–1979) Painter. Studied under E. Orlik in Berlin (1908–12). In Karlsruhe from 1920. Exponent of the New Objectivity.

Huelsenbeck, Richard (1892–1974) Writer, journalist and doctor. In Berlin from 1914 and again from 1917 (1916 in Zurich); spent the Twenties as a ship's doctor and newspaper correspondent; emigrated to New York in 1936; moved to Switzerland in 1970. One of the founders and chroniclers of Dada (*Dadaist Manifesto* [1918], *Mit Witz, Licht und Grütze* [1957]).

Ihering, Herbert (1888–1977) Journalist. Lived most of his life in Berlin; worked for the *Berliner Börsen-Courier* (1918–33), amongst others; excluded from the Reich's Chamber of Literature in 1936. One of the most important theatre critics in Berlin, along with S. > Jacobsohn and A. > Kerr.

Itten, Johannes (1888–1967) Art professor, painter and graphic artist. Taught at the Bauhaus in Weimar (1919–23); founded and directed a private art academy in Berlin between 1926 and 1934; emigrated in 1938 (Netherlands and Zurich). Influential teacher and colour theorist (*Analysen alter Meister* [1921], *The Art of Colour* [1961]).

Jacobi, Lotte (1896–1990) Photographer. In Berlin from 1921; published in numerous different newspapers and magazines (including the *Berliner Illustrierte Zeitung*, *Die Dame*, *Uhu*); emigrated to the USA in 1935. Most famous portrait photographer in Berlin.

Jacobsohn, Siegfried (1881–1926) Journalist. Born in Berlin; founder and editor of the theatrical magazine *Die Schaubühne* until his death; the magazine later turned to political themes and published contributions by numerous eminent authors (in 1918 the name changed to *Die Weltbühne*; K. > Tucholsky; C. von > Ossietzky). One of the leading theatre critics in Berlin, along with A. > Kerr and H. > Ihering.

Jannings, Emil (1884–1950) Actor. Active at the Deutsches Theater and on other stages in Berlin from 1915; already involved in film work by 1914 (credits included

Massary, Fritzi (1882–1969) Singer. Wife of M. > Pallenberg; from 1904 appeared on stage at the Metropol Theatre and other Berlin theatres, predominantly in the works of P. > Lincke and F. > Hollaender; emigrated in 1933 (Austria, Switzerland, England and the USA). Star of the revues and an operetta diva.

Meidner, Ludwig (1884–1966) Painter, graphic artist and writer. Mainly in Berlin after 1905; exhibited at the Sturm Gallery in 1912 (H. > Walden); member of the Novembergruppe from 1918; in Cologne from 1935; emigrated to England in 1939; returned to West Germany in 1953. Expressionist (*Apocalyptic Landscapes*, 1912–13); written works included *Anleitung zum Malen von Großstadtbildern*, as well as poems and prose; after the First World War his works contained realistic and religious elements.

Mendelsohn, Erich (1887–1953) Architect. In Berlin from 1918; emigrated in 1933 (England and the USA). Extremely successful: in Berlin he constructed the Einstein Tower (1919–21), enlarged and renovated the > Mosse building (1921–23), built the shop and apartment complex Woga (1927–31), which included the Universum cinema (still a theatre today) in Lehniner Platz, and the headquarters of the German Metal Workers' Union (1928–30).

Mies van der Rohe, Ludwig (1886–1969) Architect. Worked in Berlin from 1905 (P. > Behrens), becoming independent in 1913; between 1930 and 1933, leader of the Bauhaus movement (Dessau, Berlin; W. > Gropius); emigrated to the USA in 1928. His style was epitomized by the use of glass, steel and concrete in reduced forms; built many apartment blocks in Berlin, and constructed the German Pavilion for the World's Fair in Barcelona (1929).

Moholy-Nagy, László (1895–1946) Painter, graphic artist and photographer. In Berlin from 1920; mounted his own exhibition in 1922 at the Sturm Gallery (H. > Walden); between 1923 and 1928 taught at the Bauhaus (Weimar and Dessau), then returned to Berlin; emigrated in 1933 (Amsterdam, London and the USA). Constructivist; produced many publications and mounted many exhibitions.

Molzahn, Johannes (1892–1965) Painter, graphic artist and photographer. From 1914 active in Weimar, Magdeburg and Breslau; in Berlin from 1932; emigrated to the USA in 1933; returned to West Germany in 1959. Influenced by Cubism and Futurism; published *Das Manifest des absoluten Expressionismus* (1919).

Mosse Publishing house. Founded in 1871 by Rudolf Mosse (1843–1920), the company was continued under the management of Hans Lachmann-Mosse (1885–1944); destroyed, or 'adopted' by the Nazis in 1933. One of the most powerful newspaper publishers in Berlin (*Berliner Tageblatt*, *Berliner Morgenzeitung*), along with > Ullstein and > Scherl.

Mueller, Otto (1874–1930) Painter. Mainly in Berlin after 1908; joined the artists' group Die Brücke in 1910, and then the Arbeitsrat für Kunst in 1919; based in Breslau after 1919. Influenced by Expressionism.

Munkácsi, Martin (1896–1963) Photographer. In Berlin from 1927, working for > Ullstein (*Berliner Illustrierte Zeitung*, *Die Dame*, *Uhu*); emigrated to the USA in 1934. Pioneer of photo-journalism and a new style of fashion photography.

Münzenberg, Willi (1889–1940) Politician. In Berlin from 1918; elected to the Reichstag in 1924 as a member of the German Communist Party; emigrated to France in 1933. As head of the propaganda department of the party he built up one of the largest media concerns of the Weimar Republic, using newspapers, magazines and public film showings.

Murnau, Friedrich W. (1889–1931) Film director. In Berlin from 1919; mainly in Hollywood after 1926. Key figure in Expressionist film in Germany, along with F. > Lang (films included *Nosferatu* [1922], *The Last Laugh* [1924], *Faust* [1926]).

Neuländer-Simon, Else, or 'Yva' (1900–42) Photographer. Born in Berlin; own studio from 1925; published in *Die Dame*, *Uhu* and *Berliner Illustrierte Zeitung* amongst others; banned from working in 1938; sent to the Majdanek concentration camp in 1942. Portrait photography and advertising.

Olden, Balder (1882–1949) Journalist and writer. Mainly in Berlin after the First World War; emigrated in 1933 (France and Uruguay); committed suicide. Published amongst other works *Dawn of Darkness* (1933).

Osborn, Max (1870–1946) Literary and art historian. Wrote as a critic for the *Vossische Zeitung* (1914–33); founded the Jewish Cultural Alliance in 1933 in Berlin; emigrated in 1938 (France and the USA). Publications included monographs (*Max Pechstein*, 1922) and guides to Berlin.

Ossietzky, Carl von (1889–1938) Journalist and writer. Lived in Berlin from 1919; worked for the *Berliner Volkszeitung* (1920–24); started writing for the weekly magazine *Die Weltbühne* in 1926, becoming its editor in 1927 (S. > Jacobsohn); imprisoned between 1933 and 1936. Radical pacifist; awarded the Nobel Peace Prize in 1935.

Pallenberg, Max (1877–1934) Actor. Married to F. > Massary; made his name at the Deutsches Theater from 1914 onwards; emigrated to Austria in 1933. Combined the comedy of a clown with underlying tragedy.

Papen, Franz von (1879–1969) Officer and politician. Member of the Prussian Chamber of Deputies from 1921 (Centre Party); became Reich Chancellor in 1932; then Vice-Chancellor (1933–34); then ambassador to Turkey in 1939; pronounced 'not guilty' in the Nuremberg trials in 1946. Helped pave the way for the rise to power of A. > Hitler.

Pechstein, Max (1881–1955) Painter and graphic artist. Joined the artists' group Die Brücke in 1906; mainly based in Berlin (1908–39); co-founded the New Secession in 1910 and also the Novembergruppe; taught at the Prussian Academy of Arts (1923–33), and after 1945 at the Berlin Academy for the Plastic Arts. Expressionist.

Péri, László (1899–1967) Architect and sculptor. Worked in the Berlin Architects' Department (1924–28); emigrated to London in 1934. Constructivist.

Pinthus, Kurt (1886–1975) Journalist and writer. Worked as an editor from 1911 at the publishing house of E. > Rowohlt, and also for K. > Wolff; based in Berlin from 1919; emigrated to the USA in 1937; lived in Marbach from 1967. Published the Expressionist anthology *Menschheitsdämmerung* (1919), and was an influential critic.

Piscator, Erwin (1893–1966) Director and producer. Based in Berlin from 1920; worked at the Proletarisches Theater and the Volksbühne; founded the first of three Piscator theatres in 1927; moved to the Soviet Union in 1931; emigrated to Paris and the USA in 1936; returned to West Germany in 1951 and became director of the Freie Volksbühne in Berlin in 1961. Key figure in political theatre; responsible for many new developments in stage technology (such as 'total' theatre and simultaneous stages); together with L. > Jessner and M. > Reinhardt, he was largely responsible for shaping the development of Berlin's theatre world.

Poelzig, Hans (1869–1936) Architect. Born in Berlin; based there from 1920; taught at the Prussian Academy of Arts as well as the Technical Academy; died shortly before his planned emigration to Ankara. Played a significant role in the development of the New Objectivity; his activities in Berlin included the renovation of the Großes Schauspielhaus (1918–19) and the radio headquarters (1929); he also created film sets (e.g. for the second *Golem* film by P. > Wegener).

Pommer, Erich (1889–1966) Film producer. Based in Berlin from 1913; co-founder of the Decla film company (1915); asked to join the executive committee of Ufa in 1923; emigrated in 1933 (Paris and Hollywood); after 1946 based in West Germany and the USA. An important figure in the German film industry, his film credits included productions for R. > Wiene, F. W. > Murnau and F. > Lang.

Reinhardt, Max (1873–1943) Actor, director and producer. At the Deutsches Theater in Berlin (1894–1902 and 1905–20), becoming its director in 1924; founded and directed a stage school in Berlin, along with several other stages dedicated to variety shows; emigrated in 1933 (Austria and the USA). Founder of modern theatre direction; co-founder in 1920 of the Festspiele in Salzburg; along with L. > Jessner and E. > Piscator, he was largely responsible for shaping the development of Berlin's theatre world.

Remarque, Erich M. (1898–1970) Journalist and writer. Lived in Berlin from 1924; emigrated in 1932 (Switzerland and the USA). Published his best-known and longest-selling anti-war novel in 1929, which became an international success: *All Quiet on the Western Front*.

Renger-Patzsch, Albert (1897–1966) Photographer. Lived mainly in West Germany. Exponent of the New Objectivity; involved in city, landscape and industrial photography; published more than 20 volumes of photographs (*Die Welt ist schön* [1928], *Eisen und Stahl* [1930]).

Richter, Hans (1888–1976) Painter, graphic artist and filmmaker. Born in Berlin; active there from 1922; emigrated to the USA in 1933; lived in Switzerland after 1958. Dadaist and Surrealist, and pioneer of abstract, experimental films.

Riefenstahl, Leni (1901–2003) Actress, dancer, film director and photographer. Born in Berlin; danced at the Deutsches Theater; active in Berlin from 1924; made her film debut in *Ways to Strength and Beauty* (1925); directed her first film, *The Blue Light*, in 1932; after the war she lived mostly in southern Germany and worked predominantly as a photographer. Controversial figure on account of her involvement with a Nazi propaganda film (*Triumph of the Will*, 1935).

Rosen, Fritz (1890–1980) Graphic artist. From 1925, manager of the Berlin studio belonging to L. > Bernhard; organized the exhibition on advertising in 1929; emigrated to England in 1933. Also created political posters.

Rowohlt, Ernst (1887–1960) Publisher. In 1908, founded the publishing house of the same name in Leipzig, with K. > Wolff as sleeping partner; opened a branch in Berlin in 1919; emigrated to Brazil in 1938; returned to Germany in 1940; re-founded the company in 1945 in Stuttgart, which has remained in Reinbek bei Hamburg since 1950. Most influential literary publisher, together with S. > Fischer.

Rübelt, Lothar (1901–90) Photographer. Based mainly in Austria; supplied international agencies from 1925. Photojournalist and leading sports photographer; illustrated amongst others *Beckmann's Sport-lexicon* (1933).

Ruttmann, Walter (1887–1942) Film director. Moved to Berlin after the First World War; key exponent of abstract, avant-garde film techniques (such as *Berlin: Symphony of a Great City* [1927], *Melody of the World* [1929]); also produced Nazi propaganda films.

Salomon, Erich (1886–1944) Photographer. Born in Berlin; became well known in 1928 as a photo-journalist; emigrated to the Netherlands in 1933; arrested in 1943 and deported first to the concentration camp at Theresienstadt, then to Auschwitz. Pioneer of the modern style of photojournalism; author of a volume of photographs showing famous people caught off-guard (*Berühmte Zeitgenossen in unbewachten Augenblicken*, 1931).

Salter, Georg (1897–1967) Graphic artist and stage designer. Worked at the Prussian State Opera and the Volkbühne (1921–25); active again in Berlin after 1927; emigrated to the USA in 1934. Internationally renowned as a designer of book jackets, he worked for dozens of publishing houses in Germany.

Sander, August (1876–1964) Photographer. Lived mainly in West Germany. Exponent of the New Objectivity; published a volume of pictures entitled *Antlitz der Zeit* (1929), as part of a long-term project on the people of the twentieth century.

Santho, Imre von (1900–45) Photographer and graphic artist. Began her career as a fashion designer and caricaturist, then worked as a fashion photographer in Berlin from 1929; committed suicide. Friend of Magda Goebbels.

Schad, Christian (1894–1982) Painter and graphic artist. Affiliated to the Zurich Dadaists (1915–16); moved to Berlin in 1928, later to southern Germany in 1943. Exponent of the New Objectivity; developed the concept of the so-called Schadograph or photogram (photographic image made without a camera); created many portraits.

Scheerbart, Paul (1863–1915) Writer. Lived in Berlin from 1887. His utopian fantasies influenced the Dadaists and Expressionists, and his essay on glass architecture (*Glasarchitektur*, 1914) influenced the ideas of B. > Taut.

Scheidemann, Phillip (1865–1939) Politician. Member of the Reichstag for the SPD (1903–33); in 1919 he became the first Minister-President of the Weimar Republic; emigrated in 1933 (USA and Denmark). Proclaimed the 'Republic' in 1918; opposed the signing of the Treaty of Versailles and resigned in 1919.

Scherl Publishing house. Founded in 1893 by August Scherl (1849–1921), the company published newspapers and books (including the *Berliner Abendzeitung* and *Die Woche*). One of Berlin's biggest newspaper concerns, along with > Mosse and > Ullstein.

Schlemmer, Oskar (1888–1943) Painter, graphic artist, sculptor and stage designer. Between 1921 and 1929 taught at the Bauhaus (Weimar and Dessau), then in Berlin (1932–33); after 1935, based in western and southern Germany. Produced a rich variety of works (including the premiere of the 'Triadic Ballet' in 1922, and the painting *Bauhaus Stairway* in 1932).

Schlichter, Rudolf (1890–1955) Painter and graphic artist. Based in Berlin from 1919; member of the Novembergruppe; excluded in 1934 from the Reich's Department of Plastic Arts; lived in Munich from 1939. Exponent of the New Objectivity, specializing in themes to do with the city, bohemian life and erotica; later turned to Surrealism.

Schmeling, Max (1905–2005) Boxer. Professional boxer from 1924; lived in Berlin from 1926; on 4 April 1928 won the German heavyweight boxing championship against F. > Diener; world champion between 1930 and 1932 (the first European); called up to join the Armed Forces in 1940; lived in Hamburg after 1946; last boxing tournament in 1948. The most popular German sportsman of his time.

Scholz, Georg (1890–1945) Painter and graphic artist. Lived mainly in southern Germany; forced to leave his teaching position in 1933. Took part in the 'First International Dada Fair' in Berlin in 1920, and in the 1925 'Mannheim Exhibition of the New Objectivity'.

Schönberg, Arnold (1874–1951) Composer and painter. Teacher of A. > Berg and H. > Eisler; worked for different periods at the Berlin Academy of Arts (1901–3, 1911–15 and after 1926); emigrated to the USA in 1933. Key figure in the development of modern music; co-founder of the twelve-tone musical concept; composed amongst other works the Third String Quartet (1927), the opera *Moses and Aeron* (1930–32, unfinished), and various articles on music theory (*Harmonielehre*, 1911). He painted around 70 pictures.

Shklovsky, Viktor (1893–1984) Literary scientist. Lived mainly in the Soviet Union; in Berlin (1922–23); co-founder of Russian Formulism; also influential in the realm of film theory.

Sintenis, Renée (1888–1965) Sculptress and graphic artist. In Berlin from 1908; the first woman to enter the Prussian Academy of Arts; removed by the Nazis in 1934. Created portrait busts, female groups, statuettes of sportspeople and, above all, figures of animals.

Siodmak, Robert (1900–73) Film director. Lived in Berlin from 1924; emigrated in 1933 to Paris and Hollywood; after 1951 lived in France, England, West Germany and Switzerland. Achieved recognition through his first film, shot in Berlin in 1929, *People on Sunday*; later became a successful director of *film noir*.

Sternberg, Josef von (1894–1969) Film director. Lived in the USA from 1908; directed his first film in 1924; achieved recognition through the film *Underworld* in 1927. Directed his first film with M. > Dietrich, *The Blue Angel*, in 1930; became a member of the Berlin Academy of Arts in 1960.

Stone, Sasha (1895–1940) Photographer. In Berlin from 1922; started own studio in 1924; published in *Die Dame*, *Uhu* and the *Berliner Illustrierte Zeitung*; lived in Belgium and France after 1931. Constructivist; pioneer of photo-journalism.

Stresemann, Gustav (1878–1929) Politician. Born in Berlin; member of the Reichstag periodically from 1907 to 1929 (National Liberal Party and the German People's Party); elected Chancellor in 1923, and then became Minister for Foreign Affairs in the next government. Advocated the

policy of détente regarding German–French relations; awarded the Nobel Peace Prize in 1926.

Tauber, Richard (1891–1948) Singer. Performed in Berlin after 1919; attacked by SA soldiers outside Hotel Kempinski in Berlin in 1933; emigrated to London in 1938. Lyric tenor; star of opera and operetta.

Taut, Bruno (1880–1938) Architect. In Berlin (1908–21 and after 1924); initiated the Work Council for Art in 1919, and the 'Glass Chain' of correspondence between artists; emigrated in 1933 (Switzerland, Japan and Turkey). Influenced by the Bauhaus, he was a pioneer of social architecture; in Berlin he designed a horseshoe-shaped estate (1925–33, with M. > Wagner) and the large-scale development 'Uncle Tom's Cabin' (1926–32).

Tucholsky, Kurt (1890–1935) Journalist and writer. Born in Berlin; contributed articles to over 100 different newspapers and magazines (after 1913, mainly for *Die Schaubühne/ Die Weltbühne*; S. > Jacobsohn; C. > Ossietzky); lived in Paris and Sweden after 1924; presumed to have committed suicide. Prodigious output of mainly satirical and critical texts (*Wir Negativen* [1919], *Germany? Germany!* [1929]); committed pacifist.

Ullstein Publishing house. Founded in Berlin in 1877 by Leopold Ullstein (1826–99), and continued by his five sons, (publications included *Berliner Illustrierte Zeitung*, *Berliner Morgenpost*, *BZ am Mittag*, *Vossische Zeitung*, *Tempo*, *Uhu* and *Der Querschnitt*); went into book publishing in 1903 (adding the Propyläen Verlag in 1919 and the theatrical publishing concern Arkadia in 1924); it began its own picture archive in 1908 (which became independent in 1929); under the Nazis the company was forced to sell up and the family to emigrate; the premises were destroyed in 1945, but the company began again in 1950 under the management of Rudolf Ullstein; since 1960 it has been a subsidiary of the Axel Springer Verlag. During the Weimar Republic it was the biggest newspaper publisher in Europe; in 1930 it had a permanent workforce of over 10,000 employees (> Mosse; > Scherl).

Wagner, Martin (1885–1957) Architect. Founded the 'Bauhütte Berlin' in 1919, and became the leader of a group involved in social building in 1920; in 1926 he became the city's architectural director; emigrated in 1933 (Turkey and the USA). Created the horseshoe-shaped estate in Berlin (1925–33, with B. > Taut), and the Exhibition Hall (1927–30, with H. > Poelzig).

Walden, Herwarth (1878–1941) Publisher, gallery-owner, author and composer. Born in Berlin; in 1910 he founded the weekly magazine *Der Sturm*, which he edited until 1932, along with the gallery of the same name (from 1912); lived in the Soviet Union after 1932. Promoter of the national and international avant-garde (including Expressionism, Dada, Futurism and Constructivism).

Wangenheim, Gustav von (1895–1975) Actor and director. Lived in Berlin from 1912, performing at various theatres and also involved in film work (including F. W. > Murnau's *Nosferatu* [1922]); leader of 'Truppe 31' (1928–33); emigrated to Moscow in 1933; returned to East Berlin in 1945. Active member of a socialist theatre workers' group.

Wegener, Paul (1874–1948) Actor and director. Active in Berlin from 1905, mostly at the Deutsches Theater; film debut in 1913 in *The Student of Prague*. Specialized in classical roles on stage; directed and starred in the three *Golem* films (1915, 1917 and 1920).

Weill, Kurt (1900–59) Composer. In Berlin from 1921; member of the Novembergruppe; collaborated with G. > Kaiser and B. > Brecht; emigrated in 1933 (Paris and the USA). Composed mainly operas, music for the stage and songs.

Wiene, Robert (1873–1938) Film director. Lived mainly in Vienna and Berlin; emigrated in 1934 (Budapest, London and Paris). Became famous for his Expressionist film *The Cabinet of Dr Caligari* (1920); later turned towards lighter films.

Wigman, Mary (1886–1973) Dancer. Lived mostly in Dresden; became internationally well known after 1919 for her expressive dance form and teaching methods; moved to West Berlin in 1949. Established dance as an art form in its own right.

Wilder, Billy (1906–2002) Film director. Active in Berlin after 1926 as a screenwriter and journalist; collaborated with R. > Siodmak on *People on Sunday* (1930); emigrated to Paris and Hollywood in 1933. Became world-famous for his comedies; frequent winner at the Oscars.

Wilhelm II (1859–1941) Kaiser and King of Prussia. Born in Berlin; became Regent in 1888; deposed in 1918 and fled into exile in the Netherlands. The last German Kaiser.

Wolff, Kurt (1887–1963) Publisher. Between 1913 and 1930 co-managed the publishing house founded by E. > Rowohlt, and continued it under his own name when it floundered (Leipzig, Munich); emigrated in 1933 (Italy, France and the USA); returned to West Germany in 1960. One of the leading publishers of Expressionism.

Yva > Neuländer-Simon, Else

Zander & Labisch Studio. Founded in 1885 by Albert Zander and Siegmund Labisch; lasted until 1939 in Berlin. The studio was a leading exponent in theatre photography.

Zuckmayer, Carl (1896–1977) Author. Mainly based in Berlin after 1920; director of the Deutsches Theater (1924–25); also active in Henndorf, near Salzburg from 1926; emigrated in 1938 to Switzerland. Mainly wrote dramas; his play *Der fröhliche Weinberg* (1925) became one of the most popular dramas of the Twenties.

Arnheim, Rudolf, *Film As Art*, London: Faber, 1958

Baudelaire, Charles, *Critique d'art*, Paris: Gallimard, 1992

Benjamin, Walter, *One-Way Street, and Other Writings*, translated by Edmund Jephcott and Kingsley Shorter, London: NLB, 1979

Benjamin, Walter, *Angelus Novus: Ausgewählte Schriften 2*, Frankfurt am Main, 1966

Benjamin, Walter, *Illuminations*, with an introduction by Hannah Arendt (ed.), translated by Harry Zohn, London: Fontana, 1992

Benjamin, Walter, *Berlin Childhood Around 1900*, translated by Howard Eiland, Cambridge, Mass., & London: Belknap Press, 2006

Benn, Gottfried, *Das Hauptwerk in vier Bänden*, Wiesbaden–Munich, 1980

Brecht, Bertolt, *Baal*, New York: Grove Press, 1964

Brecht, Bertolt, *Die Gedichte in einem Band*, Frankfurt am Main: Suhrkamp, 1981

Brecht, Bertolt, *Die Stücke von Bertolt Brecht in einem Band*, Frankfurt am Main: Suhrkamp, 1978

Brecht, Bertolt, *The Threepenny Opera*, London: Lorrimer, 1984

Canetti, Elias, *The Torch in My Ear*, translated by Joachim Neugroschel, New York: Farrar Straus Giroux, 1982

Döblin, Alfred, *Alexander-Platz, Berlin: The Story of Franz Biberkopf*, translated by Eugene Jolas, New York, 1931

Gay, Peter, *Weimar Culture: The Outsider as Insider*, London: Secker & Warburg, 1969

Haffner, Sebastian, *Defying Hitler: A Memoir*, translated by Oliver Pretzel, London: Weidenfeld & Nicolson, 2002

Kästner, Erich, *Werke in zehn Bänden*, Munich, 1998

Kästner, Erich, *Emil and the Detectives*, translated by Eileen Hall, London: Red Fox, 1995

Kessler, Count Harry, *The Diaries of a Cosmopolitan, 1918–1937*, translated and edited by Charles Kessler, etc.,
 London: Weidenfeld & Nicolson, 1971

Keun, Irmgard, *The Artificial Silk Girl*, translated by Basil Creighton, London: Chatto & Windus, 1933

Kisch, Egon Erwin, *Nichts ist erregender als die Wahrheit: Reportagen aus vier Jahrzehnten*, 2 volumes, Cologne: Kiepenheuer & Witsch, 1979

Kracauer, Siegfried, *The Salaried Masses: Duty and Distraction in Weimar Germany*, translated by Quintin Hoare and with an
 introduction by Inka Mülder-Bach, London: Verso, 1998

Kracauer, Siegfried, *The Mass Ornament: Weimar Essays*, translated, edited and with an introduction by Thomas Y. Levin,
 Cambridge, Mass., & London: Harvard University Press, 1995

El Lissitzky & Hans Arp (eds), *The Isms of Art*, Erlenbach–Zurich: Rentsch, 1925

Mann, Klaus, *Mephisto*, translated from the German by Robin Smyth, London: Penguin, 1995

Mann, Klaus, *Tagebücher 1931–1933*, Munich: Edition Spangenberg, 1989

Marcuse, Ludwig, *Mein zwanzigstes Jahrhundert: Auf dem Weg zu einer Autobiographie*, Zurich, 1975

Remarque, Erich Maria, *All Quiet on the Western Front*, translated by Brian Murdoch, London: Vintage, 1996

Tucholsky, Kurt, *Gesammelte Werke in drei Bänden*, Reinbek/Hamburg, 2005

Zuckmayer, Carl, *A Part of Myself*, translated by Richard & Clara Winston, London: Secker & Warburg, 1970

Zuckmayer, Carl, *The Captain of Köpenick*, London: Methuen, 1971

ANTHOLOGIES, CATALOGUES AND MAGAZINES

1929 – Ein Jahr im Fokus der Zeit, compiled by Ernest Wichner and Herbert Wiesner with the collaboration of Lutz Dittrich,
 Literaturhaus-Berlin, 2001

Best, Otto F. (ed.), *Expressionismus und Dadaismus: Die deutsche Literatur in Text und Darstellung*, Vol. 14, Stuttgart, 1974

Conrads, Ulrich (ed.), *Programmes and Manifestoes on 20th-Century Architecture*, trans. Michael Bullock, London: Lund Humphries, 1970

'Die tollen zwanziger Jahre' in *Magnum: Die Zeitschrift für das moderne Leben*, issue 35, April 1961

Frampton, Kenneth, *Modern Architecture: A Critical History*, London: Thames & Hudson, 1980

Frizot, Michel (ed.), *A New History of Photography*, Cologne: Könemann, *c.* 1998

Gumbrecht, Hans Ulrich, *In 1926: Living at the Edge of Time*, Cambridge, Mass., & London: Harvard University Press, 1997

Harrison, Charles, & Paul Wood (eds), *Art in Theory, 1900–1990: An Anthology of Changing Ideas, Vol. 1 (1895–1941)*, Oxford: Blackwell, 1992

Paris-Berlin, 1900–1933, Übereinstimmungen und Gegensätze Frankreich–Deutschland, catalogue for the exhibition in the Centre Pompidou (Paris, 1978), Munich: Prestel Verlag, 1979

Paucker, Henri R. (ed.), *Neue Sachlichkeit. Literatur im „Dritten Reich" und im Exil: Die deutsche Literatur in Text und Darstellung*, Vol. 15, Stuttgart, 1974

Rochard, Patricia (ed.), *Der Traum von einer neuen Welt: Berlin 1910–1933*, catalogue of an exhibition at the Museum-Altes-Rathaus (Ingelheim am Rhein), Mainz: P. von Zabern, 1989

Schrader, Bärbel, & Jürgen Schebera (eds), *Kunstmetropole Berlin 1918–1933*. Berlin: Aufbau, 1987

FURTHER READING

Haffner, Sebastian, *Die deutsche Revolution 1918/19*, Reinbek bei Hamburg: Rowohlt, 2004

Hein, Peter Ulrich, *Die Brücke ins Geisterreich. Künstlerische Avantgarde zwischen Kulturkritik und Faschismus*, Reinbek bei Hamburg: Rowohlt, 1992

Klotz, Heinrich, *20th-Century Architecture: Drawings, Models, Furniture*, from the exhibition of the Deutsches Arkitekturmuseum (Frankfurt am Main), Rizzoli, 1989

Nipperdey, Thomas, *Wie das Bürgertum die Moderne fand*, Berlin: W. J. Siedler, 1988

Paret, Peter, *Berlin Secession: Modernism and Its Enemies in Imperial Germany*, Cambridge, Mass.: Harvard University Press, 1980

Schivelbusch, Wolfgang, *The Culture of Defeat: On National Trauma, Mourning, and Recovery*, translated by Jefferson Chase, London: Granta, 2004

Schwaiger, Michael (ed.), *Bertolt Brecht und Erwin Piscator. Experimentelles Theater in Berlin der Zwanziger Jahre*, Vienna: Brandstätter, 2004

Willett, John, *The New Sobriety, 1917–1933: Art and Politics in the Weimar Period*, London: Thames & Hudson, 1978

Fritz Adolphy: *Es kommt der neue Fotograf!*, 1929. © VBK, Vienna, 2006: pp. 190–91

akg-images, Berlin–London–Paris: pp. 96, 106, 108, 254, 269, 329, 350

Max Beckmann: *The Night*, 1919. © VBK, Vienna, 2006: pp. 108–9; *Self-portrait in Dinner Jacket*, 1927. © VBK, Vienna, 2006: p. 178; *Self-portrait with Saxophone*, 1930. © VBK, Vienna, 2006: p. 179

Lucian Bernhard: *Reklameschau*, 1929. © VBK, Vienna, 2006: p. 332

Cinetext Bild- und Textarchiv, Frankfurt am Main: pp. 87, 88, 89, 197, 200, 201, 204 (2), 205, 206, 207, 306

Rosemarie Clausen: © Rosemarie Clausen – The Artist's Estate: p. 379 above.

Ernst Deutsch-Dryden: © Bildarchiv Preußischer Kulturbesitz (BPK), Berlin: pp. 228, 231

Otto Dix: *To Beauty*, 1922. © VBK, Vienna, 2006: p. 30; *The Match Vendor I*, 1920. © VBK, Vienna, 2006: p. 110; *Portrait of the Journalist Sylvia von Harden*, 1926. © VBK, Vienna, 2006: p. 215; *Sadists*, 1922. © VBK, Vienna, 2006: p. 238; *Salon I*, 1921. © VBK, Vienna, 2006: p. 274 above; *The Ill-matched Lovers*, 1925. © VBK, Vienna, 2006: p. 275; *City*, central panel, 1927–28. © VBK, Vienna, 2006: pp. 290–91; *City*, left-hand panel, 1927–28. © VBK, Vienna, 2006: p. 292; *City*, right-hand panel, 1927–28. © VBK, Vienna, 2006: p. 293

Gisèle Freund: © Agency Nina Beskow, Paris: p. 304

George Grosz: *City–Metropolis (Berlin)*, 1916–17. © VBK, Vienna, 2006: p. 21; *Untitled*, 1920. © VBK, Vienna, 2006: p. 31; *Daum'Marries Her Pedantic Automaton George in May 1920. John Heartfield is Very Glad of It*, 1920. © VBK, Vienna, 2006: p. 44; *The Lovesick Man*, c. 1925. © VBK, Vienna, 2006: p. 55; *The Funeral Procession (Dedication to Oskar Panizza)*, 1917–18. © VBK, Vienna, 2006: p. 76; *Untitled (Nudes)*, 1919. © VBK, Vienna, 2006: p. 81; *Republican Automatons*, 1920. © VBK, Vienna, 2006: p. 82; *Beauty, Thee Will I Praise!*, c. 1920. © VBK, Vienna, 2006: p. 83; *Schutzhaft* cover, 1919. © VBK, Vienna, 2006: p. 100; *End of the Day's Work*, 1919. © VBK, Vienna, 2006: p. 102; *The Faith Healers*, 1918. © VBK, Vienna, 2006: p. 103; *Toads of Property*, 1921. © VBK, Vienna, 2006: p. 104; *Das Gesicht der herrschenden Klasse*, 1921. © VBK, Vienna, 2006: p. 105; *Pillars of Society*, 1926. © VBK, Vienna, 2006: p. 106; *The White General*, 1922. © VBK, Vienna, 2006: p. 107 above; *Portrait of the Writer Max Herrmann-Neiße*, 1925 © VBK, Vienna, 2006: p. 159

Raoul Hausmann: *L'esprit de notre temps. Mechanical Head*, 1921. © VBK, Vienna, 2006: p. 95; *Typographical Arrangement: Poster Poem*, 1918. © VBK, Vienna, 2006: p. 97 above; *Hurrah! Hurrah! Hurrah!*, 1921. © VBK, Vienna, 2006: p. 98

John Heartfield: *Kurt Tucholsky. Deutschland, Deutschland über alles, 1929*. © VBK, Vienna, 2006: p. 74; cover of catalogue for the 'First International Dada Fair' in Berlin, 1920. © VBK, Vienna, 2006: p. 97 below; *The Meaning of the Hitler Salute*, 1932. © VBK, Vienna, 2006: p. 329

Hannah Höch: *Cut with the Cake Knife of Dada through the Last Pocket of Weimar Beer-Belly Culture in Germany*, 1919–20. © VBK, Vienna, 2006: p. 96

Hans Hofmann: *Franz Hessel. Spazieren in Berlin*, 1929. © VBK, Vienna, 2006: p. 301

Jürgen Holstein, Berlin: pp. 29 (2), 45, 46 below, 54, 68, 69, 72, 73, 74, 94, 98, 100, 105, 114–15, 118, 120 above, 133, 151, 172, 180, 181 below, 190, 202, 203, 208–9, 296–97, 301, 302–3, 305, 324, 326 below, 327 above, 349

IMAGNO Brandstätter Images/Artothek: pp. 11, 12, 154, 159, 178, 179, 215, 238, 278

IMAGNO Brandstätter Images/Austrian Archives: pp. 2, 8, 9, 10, 16 (3), 16–17, 18–19, 20, 21, 26–27, 30, 31, 36 above, 37, 38 below left, 38 right, 39, 40, 41, 42, 43, 44, 51, 52 above, 55, 59, 66, 67, 71, 76, 78, 81, 82, 83, 84, 85, 91, 95, 97 above, 102, 103, 104, 107 above, 110, 113, 132 below, 145 above, 148, 149, 155, 158, 161, 162, 166 below, 170, 173, 175, 181 above, 183, 192, 193, 194–95, 196, 198, 199, 210–11, 213, 246 above, 255, 256, 260, 262, 263, 264, 267, 270 above, 271, 272–73, 274 (2), 275, 279 below, 280, 282, 286, 287, 288, 290, 292, 293, 298–99, 304, 310 below, 312 below, 313, 314, 315, 316, 320–21, 326 above, 327 below, 328 below, 330, 331 (3), 332, 333, 334, 335, 336, 337, 338, 339, 340, 341 (2), 342, 343, 344, 345, 346 below left, 348, 352, 354, 356, 358–59, 361, 363, 365 above, 369, 371, 372, 373, 377 above, 378 (2), 379 (2), 380, 381 (2), 382

IMAGNO Brandstätter Images/Bildarchiv der Österreichischen Nationalbibliothek, Vienna: p. 375 (Lothar Rübelt)

IMAGNO Brandstätter Images/Thomas Sessler Verlag, Vienna: pp. 62–63, 64 below, 64–65

IMAGNO Brandstätter Images/SV-Bilderdienst, Munich: pp. 46 above, 58, 312 above, 367

IMAGNO Brandstätter Images/ullstein bild, Berlin: pp. 6–7, 13, 14–15, 22, 23, 24, 25, 32, 33 (2), 34–35,

36 below, 38 above left, 47 (2), 48–49, 50, 52 below, 53, 56 (2), 57 (2), 60, 61, 64 above, 70, 75, 80, 86, 90, 97 below, 107 below, 111, 117, 119, 121, 122 below, 126, 128, 129, 132 above, 135, 136 (2), 137 (2), 138–39, 140, 141, 142, 143, 144, 145 below, 146–47, 150 (2), 152 (KPA), 153, 156, 157, 164, 166 above, 167, 168, 169, 174, 176, 184, 185, 212, 214, 216, 217, 218, 219, 220 (Elli Marcus), 221, 222, 223, 224–25, 226–27, 227 (2), 228, 229, 230 (2), 231, 232, 233 (3), 234, 235 (2), 236, 239, 240, 242, 243, 244–45, 246 below, 247, 248, 249, 250, 252, 253, 258, 259 (2), 266, 268, 270 below, 276–77, 279 above, 283, 284 (2), 285 (Elli Marcus), 294, 295, 307, 308, 309, 310 above, 311, 317 (2), 318, 319 (3), 321 (2), 322 (ADN Picture Library), 323 (2), 325 (3), 328 above, 346 above left, 346 above right, 346 centre left, 346 centre right, 346 below right, 347, 351, 357, 360 (2), 362 (2), 364, 365 above, 366 (2), 368, 370, 374, 376, 377 above, 383

Lotte Jacobi: © Lotte Jacobi Archives, Photographic Services, University of New Hampshire, USA: pp. 107 below, 137 above, 138, 166 above, 193, 222, 294, 295, 364, 374

Ernst Ludwig Kirchner: © Ingeborg and Dr Wolfgang Henze-Ketterer, Wichtrach/Berne (for Ernst Ludwig Kirchner): pp. 2, 11, 12

Oskar Kokoschka: *Portrait of Herwarth Walden*, 1910. © VBK, Vienna, 2006: p. 85

El Lissitzky: *Das entfesselte Theater*, 1927. © VBK, Vienna, 2006: p. 118; *The Isms of Art*, 1925. © VBK, Vienna, 2006: p. 170; 'First Russian Art Exhibition', Berlin, *1922*. © VBK, Vienna, 2006: p. 172

Jeanne Mammen: *Revue Girls*, 1928–29. © VBK, Vienna, 2006: p. 269

Ludwig Meidner: © Ludwig Meidner-Archiv, Jüdisches Museum der Stadt Frankfurt am Main: pp. 68, 78, 158

Ludwig Mies van der Rohe: *Skyscraper Design, Friedrichstraße Station, Berlin, c.* 1921. © VBK, Vienna, 2006: p. 135; *Skyscraper Design in Glass and Steel, c.* 1925. © VBK, Vienna, 2006: p. 351

László Moholy-Nagy: *Erwin Piscator. Das politische Theater*, 1929. © VBK, Vienna, 2006: p. 114

Martin Munkácsi: © Joan Munkácsi, Woodstock, USA: p. 279 above.

Österreichisches Theatermuseum, Vienna: pp. 92, 93, 116 (2), 120 below, 122 above, 123, 124, 127, 130 (3), 131

Max Pechstein: *An alle Künstler!*, 1919. © VBK, Vienna, 2006: p. 69; *Hammock I*, 1919. © VBK, Vienna, 2006: p. 71

Albert Renger-Patzsch: © VBK, Vienna, 2006: p. 196

Dr Erich Salomon: © Bildarchiv Preußischer Kulturbesitz (BPK), Berlin: p. 194

August Sander: Die Photographische Sammlung/SK Stiftung Kultur, August Sander Archive, Cologne; © VBK, Vienna, 2006: pp. 186 (2), 187, 188, 189

Christian Schad: *Egon Erwin Kisch*, 1928. © Bettina Schad, Christian Schad Archive and Estate/VBK, Vienna, 2006: p. 154; *Count St Genois d'Anneaucourt*, 1927. © Bettina Schad, Christian Schad Archive and Estate/VBK, Vienna, 2006: p. 183

Sasha Stone: © J. S. A. St. D. S. Stone, Zwaluwenweg 27a, 1261 GH Blaricum, Netherlands: pp. 117, 137 below, 144, 145 below, 253, 302

Liselotte Strelow: *Gustaf Gründgens as Mephisto*, 1941. © VBK, Vienna, 2006: p. 366 below.

INDEX

Figures in *italic* refer to illustrations.

HE SCALA THEATRE · HEINRICH MANN · DIE NEUE SACH
RNOLD SCHOENBERG · DADA · KARL ZUCKMAYER · WI
RIEDRICH SCHILLER · EXPRESSIONISM · LION FEUCHTWA
L LISSITZKY · CARL WEGENER · BRIGITTE HELM · ERNST
RNST JÜNGER · WILLIAM TELL · FRITZI MASSARY · GEOR
OUNT HARRY KESSLER · DER QUERSCHNITT · YVA · ELIA
DLON HOTEL · CARL ZUCKMAYER · OSKAR KOKOSCHKA
DOLF HITLER · ALBERT RENGER-PATZSCH · ANTON MEN
ENI RIEFENSTAHL · KURT WOLFF · LEOPOLD ULLSTEIN ·
ACK SHEA'S AMERICAN JAZZ BAND · HERWARTH WALD
LBAN BERG · ERWIN PISCATOR · JOSEPH GOEBBELS ·
ERTHA SCHROETER · METROPOLIS · FRITZ LANG · HAN
RANZ VON PAPEN · ERNST KRENEK · LIL DAGOVER · E
AX SCHMELING · OTTO DIX · KARLSTRAßE · THE KARLST
ARALD KREUTZBERG · KURT PINTHUS · HUGO HÄRING
UDWIG MIES VAN DER ROHE · M · ERICH MARIA REMA
OSFERATU · THE NOVEMBER GROUP · PAUL LINCKE · M
AUL VON HINDENBURG · MAX PECHSTEIN · PAUL HIN
OMANISCHES CAFÉ · MARY WIGMAN · RAOUL HAUSM,
ICHARD HUELSENBECK · FILM AS ART · OSKAR SCHLEMM
HE STAATSOPER · SPARTACISTS · VOSSISCHE ZEITUNG
HE THREE-PENNY OPERA · ALFRED FLECHTHEIM · UFA S
ILLI FRITSCH · ALEXANDER-PLATZ, BERLIN · ALFRED
IERGARTEN · ANNEMARIE SCHWARZENBACH · AN APPE
UDOLF BELLING · THE RISE AND FALL OF THE CITY OF
ANS ARP · VALESKA GERT · THE CABINET OF DR CALIG
AMILLO SITTE · THE EL DORADO BAR · ERICH MENDELS
ÁNDOR ÉK · ERNST LUBITSCH · HANNAH HÖCH · GE
OTSDAMER PLATZ · BERLINER MORGENPOST · GISÈLE
HE GROßES SCHAUSPIELHAUS · FRANZ HESSEL · HARR
AX REINHARDT · ULLSTEIN VERLAG · ERIKA MANN · W

KEIT · LOTTE JACOBI · ARBEITER ILLUSTRIERTE ZEITUNG
ÜNZENBERG · BERLINER TAGEBLATT · ERNST ROWOHL
R · AUGUST SANDER · BAUHAUS · CARL VON OSSIETZK
WIG KIRCHNER · JOSEPHINE BAKER · HERMAN GÖRING
EYM · BRUNO TAUT · HANS POELZIG · CHRISTIAN SCHAD
ANETTI · DIE WELTBÜHNE · FRIEDRICH-WILHELM MURNAU
AX OSBORN · THE BLUE ANGEL · BRANDENBURG GATE
R · FRIEDRICHSTRASSE · FRITZ KORTNER · EMIL JANNINGS
LENE DIETRICH · GEORG W. PABST · HERBERT JHERING
AUFRUF ZUR ELEMENTAREN KUNST · JOHN HEARTFIELD
BECKMANN · ALBERT EINSTEIN · LÁSZLÓ MOHOLY-NAG
CHTER · IRMGARD KEUN · KARL HUBBUCH · KURT WEILL
KÄSTNER · DIE ROTE FAHNE · KARL-LIEBKNECHT HOUSE
DEPARTMENT STORE · KLAUS MANN · GUSTAV HARTLAUE
ANNE MAMMEN · KURT TUCHOLSKY · RUDOLF ARNHEIN
E · FRANZ ROH · ILSE MAY · JERRY GIRLS · MAX ERNST
PALLENBERG · RUDOLF ULLSTEIN · KDP · OTTO MUELLER
ITH · LUDWIG MARCUSE · REICHSTAG · ERICH KLEIBER
· NSDAP · LUDWIG MEIDNER · THE KURFÜRSTENDAMM
MAX LIEBERMAN · TILLER GIRLS · WALTER GROPIUS · SPD
ALTER BENJAMIN · TEGEL PRISON · ROBERT SIODMAK
OS · THOMAS MANN · WALTER ULBRICHT · THE WANNSE
LIN · VORWÄRTS · ALL QUIET ON THE WESTERN FRONT
O REASON · OTTO FREUNDLICH · GUSTAV STRESEMANN
HAGONNY · HANNAH ARENDT · PHILIPP SCHEIDEMANN
SIEGFRIED KRACAUER · BILLY WILDER · BERTOLT BRECHT
N · PAUL SCHEERBART · ROBERT WIENE · ERICH POMMER
E GROSZ · THE EINSTEIN TOWER · EGON ERWIN KISCH
ND · ERICH SALOMON · THE GOLEM · GOTTFRIED BENN
RAF KESSLER · WALTER RUTTMANN · HEINRICH HIMMLER
ECK · GRAF ZEPPELIN · BERLINER ILLUSTRIER ZEITUNG